ART SPOKE

ART SPOKE

A Guide to Modern Ideas, Movements, and Buzzwords, 1848–1944

Robert ATKINS

Abbeville Press Publishers New York London Paris

This book is dedicated to Sylvia Atkins, who has lived to see it completed; and to my friends Robert Di Matteo and Barry Nelson, who have not.

Front and back cover photographs, frontispiece: Scott W Santoro/Eugene Weisberg

Editor: Nancy Grubb
Designer: Scott W Santoro/Worksight
Production Editor: Sarah Key
Picture Editors: Anne Manning and Lori Hogan
Production Manager: Matthew Pimm

First edition

Library of Congress Cataloging-in-Publication Data
Atkins, Robert.
 Artspoke: a guide to modern ideas, movements, and buzzwords, 1848–1944/Robert Atkins.
 p. cm.
 Includes index.
 ISBN 1-55859-389-6 (HC). — ISBN 1-55859-388-8 (PB)
 1. Art, Modern—19th century. 2. Art Modern—20th century.
I. Title. II. Title: Art spoke.
n6447 A85 1993 92-25982
709'.03'4—dc20 CIP

CONTENTS

MOVEMENTS	1750	1800	1850	1900	1950	
NEOCLASSICISM						1760-1830
ROMANTICISM						1770-1840
BARBIZON SCHOOL						1840-1849
LUMINISM						1845-1880
REALISM						1845-1880
PRE-RAPHAELITISM						1848-1854
MACCHIAIOLI						1850-1870
ARTS AND CRAFTS MOVEMENT						1859-1900
IMPRESSIONISM						1870-1890
GLASGOW SCHOOL						1870-1900
THE WANDERERS						1870-1923
THE NEW SCULPTURE						1875-1895
POST-IMPRESSIONISM						1880-1893
NEO-IMPRESSIONISM						1880-1900
TONALISM						1880-1910
ART NOUVEAU						1880-1914
LES VINGT						1883-1893
PICTORIALISM						1886-1914
NATURLYRISMUS						1889-1905
NABIS						1890-1899
SYMBOLISM						1890-1899
WORLD OF ART						1898-1906
THE EIGHT						1900-1910
STRAIGHT PHOTOGRAPHY						1900-1979
FAUVISM						1903-1908
DIE BRÜCKE						1905-1913
BLOOMSBURY GROUP						1906-1918
OSMA						1907-1914
NEO-PRIMITIVISM						1908-1912
CUBISM						1908-1918
FUTURISM						1909-1929
PUTEAUX GROUP						1910-1914
DER BLAUE REITER						1911-1914
ORPHISM						1911-1914
RAYONISM						1912-1914
CUBO-FUTURISM						1913-1914
SYNCHROMISM						1913-1918
SCUOLA METAFISICA						1913-1919
CONSTRUCTIVISM						1913-1929
VORTICISM						1914-1915
DADA						1915-1923
SUPREMATISM						1915-1923
DE STIJL						1917-1931
PURISM						1918-1925
PRECISIONISM						1918-1930
ART DECO						1918-1939
GROUP OF SEVEN						1919-1933
NEUE SACHLICHKEIT						1920-1932
MEXICAN MURALS						1920-1940
SURREALISM						1924-1945
NEO-ROMANTICISM						1926-1941
AMERICAN SCENE PAINTING						1930-1939
CONCRETE ART						1930-1959
ABSTRACTION-CREATION						1931-1936
GROUP F/64						1932-1935

Words in CAPITALS are defined in the entries (pages 43–214).

REALISM

1845–1880

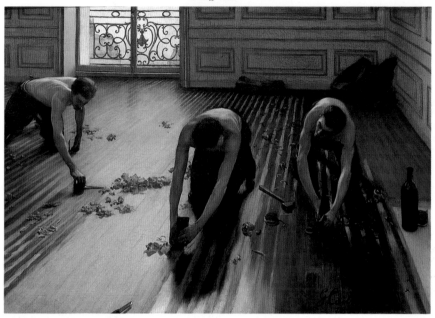

1848–1849

GUSTAVE CAILLEBOTTE (1848–1894).
The Floorscrapers, 1875. Oil on canvas, 40 1/8 x 57 5/8 in.
(101.9 x 146.4 cm). Musée d'Orsay, Paris.

1848

THE WORLD

Revolutions break out in Berlin, Copenhagen, Venice, Vienna, Paris, Parma, Rome, Hungary, and Bohemia. The French monarch Louis Philippe abdicates, and Prince Louis Napoleon is elected president of the new French Republic. Pope Pius IX flees Rome. Austrian Emperor Ferdinand I abdicates in favor of his nephew, the future Emperor Francis Joseph I.

Treaty of Guadalupe Hidalgo ends Mexican-American War and largely establishes present-day border.

German philosophers Karl Marx and Friedrich Engels issue *The Communist Manifesto*.

Modern feminist movement begins with women's rights convention in Seneca Falls, New York, led by Lucretia Mott and Elizabeth Cady Stanton.

David Hale and James Gordon Bennett found the New York News Agency (known as Associated Press after 1856).

THE ART WORLD

William Holman Hunt, John Everett Millais, Dante Gabriel Rossetti, and others found the PRE-RAPHAELITE Brotherhood in London.

PRE-RAPHAELITISM

1848–1854

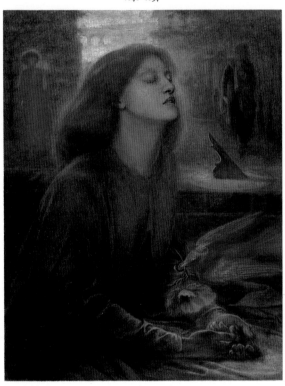

DANTE GABRIEL ROSSETTI (1828–1882).
Beata Beatrix, c. 1864–70. Oil on canvas, 34 x 26 in. (86.4 x 66 cm).
Tate Gallery, London.

1849

THE WORLD

French physicist Armand Fizeau measures speed of light.

Russian novelist Fyodor Dostoyevsky receives death sentence for his socialist activities; it is commuted to nine years in Siberian labor camp.

1850–1859

1850

THE WORLD

France establishes insurance for the elderly.

Taiping Rebellion in China pits provincial forces against the Manchu dynasty; the emperor prevails in 1864.

THE ART WORLD

Charles Dickens and others accuse Millais of blasphemy for his painting *Christ in the House of His Parents.*

1851

THE WORLD

English philosopher Herbert Spencer publishes *Social Statics,* the basis of modern sociology.

U.S. novelist Herman Melville publishes *Moby Dick.*

THE ART WORLD

Joseph Paxton builds the Crystal Palace in London for the first INTERNATIONAL EXPOSITION.

English philosopher John Ruskin publishes the first volume of *The Stones of Venice,* which inspires the ARTS AND CRAFTS MOVEMENT.

1852

THE WORLD

President Louis Napoleon of France proclaims himself Emperor Napoleon III, establishing the Second Empire, which lasts until 1870.

1853

THE WORLD

Crimean War between Russia and the Ottoman Turks (allied with Great Britain and France) results in "neutralization" of the Black Sea in 1856.

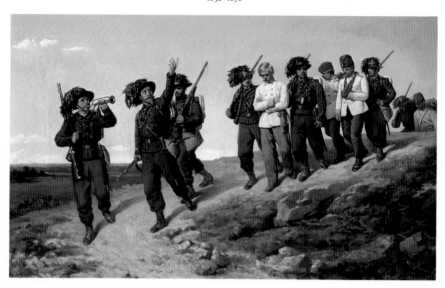

U.S. fleet under Commodore Matthew Perry arrives in Edo (now Tokyo) Bay, leading to commercial opening of Japan in 1854.

SILVESTRO LEGA (1826–1895).
Prisoners of War (Bersaglieri), c. 1860. Oil on canvas, 22 3/4 x 37 in. (58 x 94 cm). Galleria d'Arte Moderna, Palazzo Pitti, Florence.

French urban planner Georges Haussmann begins reconstruction of Paris, creating broad boulevards to deter insurrection.

U.S. arms manufacturer Samuel Colt revolutionizes production of handguns.

1854

THE WORLD

Pope Pius IX declares doctrine of the Immaculate Conception of the Virgin Mary to be an article of faith.

1855

THE WORLD

Czar Nicholas I of Russia dies and is succeeded by Alexander II, who immediately begins negotiations to end the Crimean War.

First Cunard steamer crosses Atlantic Ocean, in nine and a half days.

U.S. poet Walt Whitman anonymously publishes *Leaves of Grass.*

THE ART WORLD

Gustave Courbet organizes his Pavillon du Réalisme at the Paris Exposition Universelle and issues one of the first art MANIFESTOS.

1856

THE WORLD

U.S. adventurer William Walker leads overthrow of Nicaraguan government and makes himself president; he is forced out in 1857 by a coalition of Central American states.

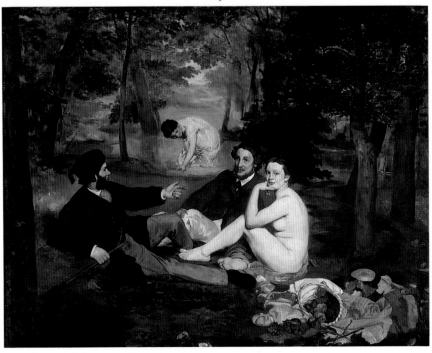

EDOUARD MANET (1832–1883).
Luncheon on the Grass, 1863. Oil on canvas, 81 3/4 x 104 1/8 in. (208 x 264.5 cm). Musée d'Orsay, Paris.

1857

THE WORLD

Indian Mutiny (Sepoy Rebellion) against British rule breaks out; it is put down in 1858. The Crown assumes the powers of the East India Company.

French microbiologist Louis Pasteur proves that fermentation is caused by living organisms and that yeast can reproduce without oxygen; this leads to his invention of pasteurization of wine in 1864.

French writer Charles Baudelaire publishes his collection of poems entitled *Les Fleurs du mal* (*The Flowers of Evil*) and is fined for offending public morality.

1858

THE WORLD

Lionel de Rothschild becomes the first Jewish member of British Parliament.

1859

THE WORLD

After China refuses to admit foreign diplomats into Beijing, British and French troops occupy the city; in 1860 the Chinese allow foreign legations to inhabit one neighborhood in the city.

French engineer Ferdinand de Lesseps begins construction of Suez Canal (completed in 1869).

English naturalist Charles Darwin publishes *Origin of Species,* outlining theories of evolution and natural selection.

Industrialist Edwin Drake drills the first oil well, at Titusville, Pennsylvania.

1860–1869

1860

THE WORLD

Abraham Lincoln is elected U.S. president; South Carolina secedes from the Union in protest, leading to Civil War (1861–65) between Union and slaveholding Confederate states.

Giuseppe Garibaldi conquers Sicily and Naples, then joins forces with King Victor Emmanuel II of Sardinia to defeat the papal army. Plebescites throughout Italy sanction union with Sardinia.

Maoris of New Zealand refuse to sell their lands, leading to a war with British settlers, which lasts until 1870.

French engineer Etienne Lenoir builds the first practical internal-combustion engine.

English nurse Florence Nightingale founds the world's first school of nursing, after having introduced hygienic standards into military hospitals during the Crimean War.

THE ART WORLD

Swiss art historian Jakob Burckhardt publishes *The Civilization of the Renaissance in Italy.*

1861

THE WORLD

Czar Alexander II emancipates serfs.

English novelist George Eliot publishes *Silas Marner.*

THE ART WORLD

Photographer Mathew Brady begins photographic documentation of U.S. Civil War.

William Morris and others establish Morris, Marshall, Faulkner and Co., to elevate the public's taste and to sell ARTS AND CRAFTS wares.

1862

THE WORLD

King Otto I of Greece abdicates after a military revolt prompted by his unconstitutional grab for power; George I, a Danish prince, is chosen to succeed him in 1863.

Actress Sarah Bernhardt makes her debut at the Comédie Française in Paris in Racine's *Iphigénie en Aulide.*

THE ART WORLD

Japanese arts and crafts are first seen by a large Western audience at the London Exposition.

1863

THE WORLD

The French capture Mexico City and proclaim Archduke Maximilian of Austria emperor of Mexico.

THE ART WORLD

Salon des Refusés is established by French imperial decree to show works rejected by the official SALON. Edouard Manet's *Déjeuner sur l'herbe* (*Luncheon on the Grass,* 1863) is the exhibition's *succès de scandale.*

Association for the Advancement of Truth in Art—inspired by the PRE-RAPHAELITE Brotherhood—is established in the U.S.

French photographer Nadar makes photo-shooting ascent in his balloon *Le Géant.*

1864

THE WORLD

Russia reforms its judiciary, establishes local assemblies (*zemstvos*) in which all classes are represented, and begins an aggressive Russification program in Poland.

Pope Pius IX issues *Syllabus Errorum,* condemning liberalism, socialism, and rationalism.

Karl Marx and others found International Workingmen's Association in London and, in 1872, New York.

1 8 6 5

THE WORLD

Thirteenth Amendment abolishes slavery in U.S. following end of Civil War. President Lincoln is assassinated and succeeded by Vice President Andrew Johnson.

English writer Lewis Carroll publishes *Alice's Adventures in Wonderland.*

1 8 6 6

THE WORLD

Ku Klux Klan is founded as an officer's social club in Pulaski, Tennessee.

U.S. surgeon J. Marion Sims performs the first successful artificial insemination of a human being, at New York Women's Hospital.

Swedish chemist Alfred Nobel invents dynamite.

Russian novelist Fyodor Dostoyevsky publishes *Crime and Punishment.*

1 8 6 7

THE WORLD

British North America Act establishes Dominion of Canada.

Napoleon III withdraws support from Mexico's puppet emperor, Maximilian, who is executed. Benito Juarez is elected president.

1 8 6 8

THE WORLD

Meiji Restoration in Japan: Shogunate (military rule) is disbanded in favor of a modernizing emperor, and the capital is moved from Kyoto to Edo (Tokyo).

Revolution topples Spanish monarchy and establishes universal suffrage and a free press; a constitutional monarchy is inaugurated in 1869.

1 8 6 9

THE WORLD

English scientist Sir Francis Galton publishes *Hereditary Genius,* in which he posits the genetic basis of mental and physical capacities.

First transcontinental railroad line spanning North America is completed at Promontory, Utah.

1 8 7 0 – 1 8 7 9

1 8 7 0

THE WORLD

Franco-Prussian War breaks out and results, in 1871, in France's cession of Alsace and Lorraine and payment of a five-billion-franc indemnity to Germany.

Italian troops enter Rome, achieving reunification. Rome becomes the Italian capital in 1871.

First Vatican Council pronounces doctrine of papal infallibility.

John D. Rockefeller founds Standard Oil Company.

THE ART WORLD

The Metropolitan Museum of Art is founded in New York.

THE WANDERERS—officially called the Society for Traveling Art Exhibitions—is established in Saint Petersburg.

1 8 7 1

THE WORLD

The French Commune rules Paris for two months, in opposition to National Assembly; some twenty thousand people are killed when the military regains control of the city.

Labor unions are legalized in Great Britain.

1 8 7 2

THE WORLD

German botanist Ferdinand Cohn publishes *Researches in Bacteria,* originating bacteriology.

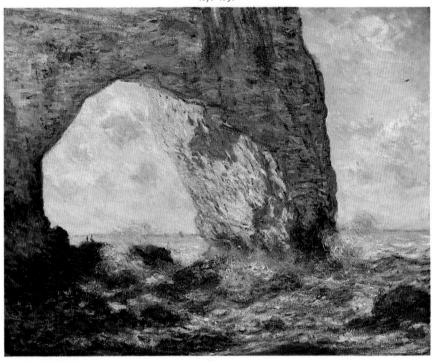

1873

THE WORLD

Scottish physicist James Clerk Maxwell publishes *A Treatise on Electricity and Magnetism,* initiating modern electromagnetic theory.

U.S. writers Mark Twain and Charles Dudley Warner publish *The Gilded Age,* whose title becomes an epithet for the acquisitive late nineteenth century in the U.S.

THE ART WORLD

Walter Pater publishes *Studies in the History of the Renaissance.*

CLAUDE MONET (1840–1926).
The Manneporte (Etretat), 1883. Oil on canvas, 25 3/4 x 32 in. (65.4 x 81.3 cm). The Metropolitan Museum of Art, New York; Bequest of William Church Osborn, 1951.

1874

THE WORLD

British defeat Ashantis in Ghana.

THE ART WORLD

Louis Leroy invents the term IMPRESSIONISM after seeing the first of eight exhibitions organized by the Impressionists between 1874 and 1886.

1875

THE WORLD

Charles Stewart Parnell is elected to British Parliament and catalyzes Irish independence movement.

Russian novelist Leo Tolstoy publishes *Anna Karenina.*

Madame Helena P. Blavatsky founds Theosophical Society in New York.

1 8 7 6

THE WORLD

Liberal Young Turks install Abd al-Hamid II as Ottoman sultan after deposing his uncle and brother.

Scottish-American inventor Alexander Graham Bell patents the telephone. U.S. inventor Thomas Alva Edison establishes first industrial-research laboratory in Menlo Park, New Jersey, where he invents the phonograph, mimeograph machine, electric light bulb, electric trolley, and discovers the "Edison effect"—the capacity of electrical current to travel through space, which is the basis of electronics.

Richard Wagner's Festspielhaus opens in Bayreuth, Germany, with first complete performance of Wagner's music drama The Ring of the Nibelung.

THE ART WORLD

Centennial of Declaration of Independence triggers a four-decade era of cultural nationalism in U.S. known as the AMERICAN RENAISSANCE.

1 8 7 7

THE WORLD

French writer Emile Zola publishes The Drunkard.

Swiss theologian Louis Lucien Rochet founds the Blue Cross to fight alcoholism.

THE ART WORLD

James McNeill Whistler sues the English philosopher John Ruskin for libel for having denigrated Whistler's Nocturne in Black and Gold: The Falling Rocket (1874).

Auguste Rodin's Age of Bronze (1876) is shown in the Paris Salon; some viewers erroneously believe that it was cast directly from a live model.

1 8 7 8

THE WORLD

Antisocialist laws are passed in Germany.

1 8 7 9

THE WORLD

French Panama Canal Co. is organized under Ferdinand de Lesseps (goes bankrupt in 1889).

George Eastman patents a process for making dry photographic plates.

Anglo-American moving-picture pioneer Eadweard Muybridge designs a crude movie projector known as a zoopraxiscope.

German historian Heinrich von Treitschke publishes first volume of Deutsche Geschichte Neunzehnten Jahrhundert (Treitschke's

History of Germany in the Nineteenth Century), beginning racist anti-Semitic movement.

Norwegian playwright Henrik Ibsen's A Doll's House is the first portrayal of a woman leaving an unhappy marriage for a life of her own.

War of the Pacific pits Chile against Bolivia and Peru; it ends in 1884 with Chilean annexation of rich copper fields.

1 8 8 0 – 1 8 8 9

1 8 8 0

THE WORLD

Boers declare the Transvaal independent and, in 1881, Great Britain recognizes the Transvaal Republic.

1 8 8 1

THE WORLD

U.S. President James Garfield and Russian Czar Alexander II are assassinated; they are replaced by Chester Alan Arthur and Alexander III, respectively.

First cabaret, Le Chat Noir (The Black Cat), opens in Paris.

American expatriate novelist Henry James publishes The Portrait of a Lady.

U.S. educator Booker T. Washington, a former slave, organizes Tuskegee Normal

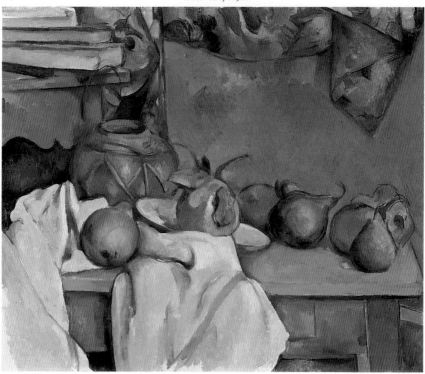

and Industrial Institute (later the Tuskegee Institute) in U.S.

PAUL CEZANNE (1839–1906).
Ginger Pot with Pomegranate and Pears, 1890–93. Oil on canvas, 18 1/4 x 21 7/8 in. (46.4 x 55.6 cm). The Phillips Collection, Washington, D.C.

1882

THE WORLD

U.S. Congress passes Chinese Exclusion Act, which bars Chinese laborers from entering U.S. for ten years. It is extended for ten years in 1892 and again in 1902.

German philosopher Friedrich Nietzsche proclaims death of god in *Thus Spake Zarathustra.*

1883

THE WORLD

German Chancellor Otto von Bismarck introduces illness, accident, and old-age insurance to improve the lives of German workers.

U.S. army scout William "Buffalo Bill" Cody produces his Wild West Show, signifying the end of the real frontier and its rebirth as a subject of popular culture and national mythology.

THE ART WORLD

LES VINGT is founded in Brussels.

1884

THE WORLD

France establishes protectorates over Annam (central

17

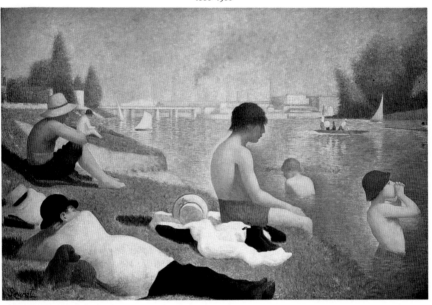

GEORGES SEURAT (1859–1891).
Bathers at Asnières, 1884. Oil on canvas, 79 x 119 1/2 in. (200.7 x 303.5 cm).
The National Gallery, London.

Vietnam) and Tonkin (northern Vietnam), having already colonized Cochin China (southern Vietnam) in 1867. Along with Cambodia, they will be reconstituted by France as the union of Indochina in 1887.

The London "tube," the first underground railroad, is built.

William Le Baron Jenney builds the first skyscraper, in Chicago.

THE ART WORLD

Salon des Indépendants debuts in Paris.

1885

THE WORLD

British General Gordon is massacred in Khartoum, signaling defeat of Anglo-Egyptian forces in Sudan.

King Leopold II of Belgium personally takes possession of the Congo; Germany, Great Britain, Italy, Spain, Portugal, and France escalate the pace of their empire building throughout Africa.

Second volume of Karl Marx and Friedrich Engel's *Das Kapital* is published posthumously.

THE ART WORLD

The Rijksmuseum opens in Amsterdam.

1886

THE WORLD

Labor unrest in Chicago over treatment of strikers leads to Haymarket Square riot and eleven deaths. American Federation of Labor—comprising twenty-five trade unions—is founded with Samuel Gompers as its president. Congress establishes Department of Labor in 1888.

THE ART WORLD

Félix Fénéon coins the term NEO-IMPRESSIONISM.

Jean Moréas makes the first published reference to SYMBOLISM.

Peter Henry Emerson invents the term PICTORIALISM.

The Statue of Liberty, a gift from the people of France, is dedicated in New York Harbor.

JAN TOOROP (1858–1928).
Song of the Times, 1893. Pencil and black crayon on paper, 30 11/16 x 38 9/16 in. (77.9 x 97.9 cm). Kröller-Müller Museum, Otterlo, the Netherlands.

1887

THE WORLD

Queen Victoria of Great Britain celebrates her Golden Jubilee after fifty years of rule.

Yellow River overflows in China, killing more than 900 thousand people.

1888

THE WORLD

First beauty contest held in Spa, Belgium.

Jack the Ripper murders six women in London.

George Eastman perfects hand-held Kodak box camera, making possible amateur photography.

THE ART WORLD

The NABI group is founded.

1889

THE WORLD

Brazilian military leaders overthrow Emperor Pedro II and proclaim a republic.

Loie Fuller creates her "serpentine dance," utilizing silk and electric lights.

First safety bicycles are produced in quantity, leading to international rage for bicycling.

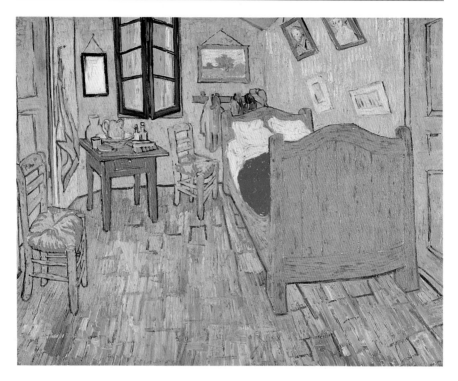

THE ART WORLD

James Ensor's *Entry of Christ into Brussels* results in his near-expulsion from LES VINGT.

Gustave Eiffel designs 1,056-foot-high Eiffel Tower for the Paris Exposition Universelle.

Worpswede painters found association.

9 X 5 is the first show of modernist art in Australia.

VINCENT VAN GOGH (1853–1890).
Van Gogh's Bedroom at Arles, 1889. Oil on canvas, 22 1/2 x 29 1/4 in. (57 x 74 cm). Musée d'Orsay, Paris.

1890–1899

1890

THE WORLD

U.S. journalist Jacob Riis publishes *How the Other Half Lives,* a shocking and influential portrayal of slum life.

THE ART WORLD

GLASGOW SCHOOL exhibition held at Grosvenor Gallery in London.

1891

THE WORLD

Germany, Austria-Hungary, and Italy renew the Triple Alliance for twelve years; France and Russia negotiate their terms of entente—completed in 1893—as a counterbalance.

Construction begins on the Trans-Siberian railroad.

Dutch anthropologist Eugene Dubois discovers *Pithecanthropus erectus*, or Java Man.

THE ART WORLD

Paul Gauguin arrives in Tahiti.

20

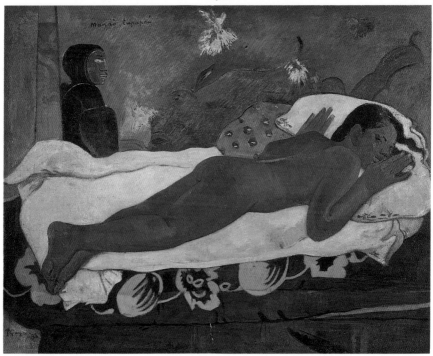

Posthumous retrospective exhibitions of Vincent van Gogh are held in Brussels and Paris.

PAUL GAUGUIN (1848–1903).
Spirit of the Dead Watching, 1892. Oil on burlap mounted on canvas, 28 1/2 x 36 3/8 in. (72.4 x 92.4 cm). Albright-Knox Art Gallery, Buffalo, New York; A. Conger Goodyear Collection, 1965.

1892

THE WORLD

U.S. inventor Henry Ford builds his first motorcar; Ford Motor Company begins production of the Model T in 1908.

THE ART WORLD

Munich SECESSION is founded.

Joséphin Péladan organizes first Salon de la Rose + Croix in Paris.

The LINKED RING is established in London.

1893

THE WORLD

British Independent Labour Party is founded in Bradford, England.

New Zealand and Colorado adopt woman suffrage.

British novelist Arthur Conan Doyle kills off Sherlock Holmes in *The Memoirs of Sherlock Holmes;* an angry public successfully pleads for his resurrection (in 1905).

THE ART WORLD

The Dachau group is founded.

The World's Columbian Exposition is held in Chicago.

1894

THE WORLD

Sino-Japanese War (1894–95) establishes Japan as the dominant power in the Far East.

French army captain Alfred Dreyfus is falsely convicted of treason. The scandalous Dreyfus Affair unfolds

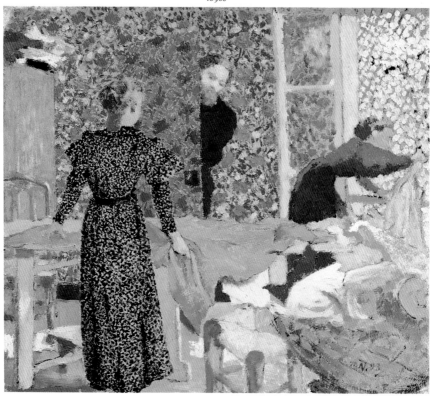

throughout the decade, involving forgery and anti-Semitism. Dreyfus is exonerated in 1906.

EDOUARD VUILLARD (1868–1940).
The Suitor (formerly called *Interior at l'Etang-la-Ville*), 1893. Oil on millboard panel, 12 1/2 x 14 15/16 in. (31.8 x 36.4 cm). Smith College Museum of Art, Northampton, Massachusetts; Purchased, Drayton Hillyer Fund, 1938.

Committee to organize modern Olympic games is founded by Baron de Coubertin; the first games are held in Athens in 1896.

Anarchist and art critic Félix Fénéon is acquitted of murdering President Sadi Carnot of France in trial of the Trente (Thirty).

THE ART WORLD

Gustave Caillebotte's collection of Impressionist paintings is rejected by the Musée du Luxembourg, Paris.

1895

THE WORLD

Oscar Wilde is tried and imprisoned on charges of homosexual practices; he writes *The Importance of Being Earnest*.

French film pioneers Auguste and Louis Lumière give first public showing of a movie, *Lunch Break at the Lumière Factory*.

THE ART WORLD

S. Bing opens his Galerie de l'Art Nouveau in Paris, which gives ART NOUVEAU its French name.

Venice Biennale debuts.

1896

JAPONISME

THE WORLD

Nobel Prizes are established in the will of Alfred Nobel, the Swedish inventor of dynamite; the first prizes are awarded in 1901.

Zionism originates with publication of Hungarian Zionist Theodor Herzl's *Jewish State;* first Zionist World Congress held in Basel, Switzerland, in 1897.

1897

THE WORLD

Scottish physicist Joseph J. Thomson discovers the electron.

English sexologist Havelock Ellis publishes first volume of *Studies in the Psychology of Sex.*

U.S. cartoonist Rudolph Dirks produces *Katzenjammer Kids,* the first modern newspaper comic strip.

THE ART WORLD

Gustav Klimt founds the Vienna SECESSION.

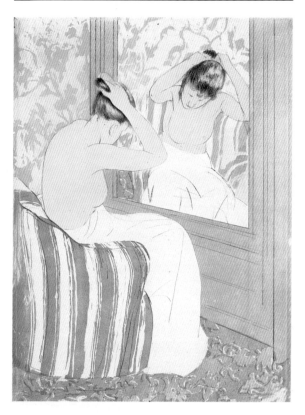

MARY CASSATT (1844–1926).
The Coiffure, 1891. Drypoint, soft-ground aquatint printed in colors, 14 3/8 x 10 1/2 in. (36.5 x 26.7 cm). The Cleveland Museum of Art; Bequest of Charles T. Brooks.

1898

THE WORLD

Spanish-American War, ostensibly to aid Cuban revolt against Spain, results in Spain's ceding Cuba, Puerto Rico, Guam, and the Philippines to U.S. in exchange for $20 million.

French scientists Marie and Pierre Curie discover radium.

THE ART WORLD

Sergey Diaghilev founds the WORLD OF ART in Saint Petersburg.

1899

THE WORLD

First international peace conference, held at The Hague, draws twenty-six nations; it establishes Permanent Court of International Justice and Arbitration.

23

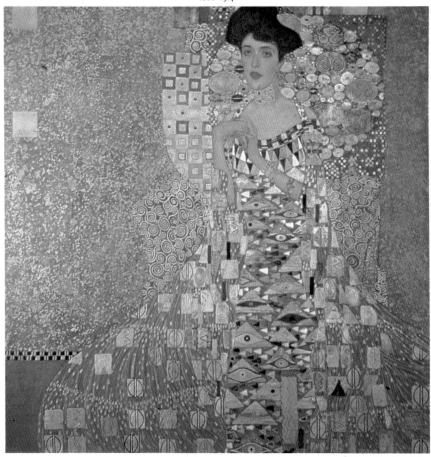

GUSTAV KLIMT (1862–1918).
Adele Bloch-Bauer I, 1907. Oil on canvas, 54 5/16 x 54 5/16 in. (138 x 138 cm).
Österreichische Galerie im Belvedere, Vienna.

Boer War in South Africa pits British against Boers; British prevail in 1902.

THE ART WORLD

Berlin SECESSION is founded as delayed response to controversial exhibition of Edvard Munch's work in 1892.

Paul Signac publishes *From Eugène Delacroix to Neo-Impressionism*.

1900–1909

1900

THE WORLD

The Commonwealth of Australia is proclaimed.

German physicist Max Planck formulates quantum theory.

Austrian psychoanalyst Sigmund Freud publishes *The Interpretation of Dreams*, the cornerstone of his views on the unconscious.

Count Zeppelin successfully tests first dirigible, in Germany.

Archaeologist Sir Arthur Evans excavates Minoan palace of Knossos in Crete.

1 9 0 1

THE WORLD

Italian inventor Guglielmo Marconi transmits telegraphic radio messages across Atlantic Ocean.

THE ART WORLD

Henry van de Velde is appointed head of Weimar Academy of Arts and Crafts, which is later incorporated into the BAUHAUS.

1 9 0 2

THE WORLD

U.S. philosopher William James publishes *The Varieties of Religious Experience.* Italian philosopher Benedetto Croce begins to publish the multipart *Philosophy of the Spirit.*

1 9 0 3

THE WORLD

At its London congress the Russian Social Democratic Labor Party splits into Mensheviks (led by Georgy Plekhanov and Leon Trotsky) and Bolsheviks (led by Vladimir Lenin).

U.S. bicycle makers Orville and Wilbur Wright successfully test the first manned, motor-driven airplane.

Colombia refuses to recognize Panama's declaration of independence; U.S. acquires control over future Panama Canal.

THE ART WORLD

Alfred Stieglitz founds PHOTO-SECESSION in New York and begins publishing *Camera Work;* opens Little Galleries of the Photo-Secession at 291 Fifth Avenue in 1905.

Paul Gauguin retrospective is held at the first Salon d'Automne in Paris.

1 9 0 4

THE WORLD

Russo-Japanese war breaks out. Japan defeats Russia in 1905 and begins drive into Manchuria.

A woman is arrested in New York for smoking a cigarette in public.

1 9 0 5

THE WORLD

A general strike in support of Russian workers forces Czar Nicholas II to promise liberal reforms. The Duma, a representative assembly, is formed in 1906 but is dissolved after ten weeks.

U.S. labor organizer William Haywood and others found International Workers of the World ("Wobblies").

German physicist Albert Einstein publishes his special theory of relativity, replacing Euclidean notions of space and time with the model of a four-dimensional universe.

British playwright George Bernard Shaw's *Mrs. Warren's Profession* opens in New York; it is closed by the police censor after a single performance.

THE ART WORLD

Louis Vauxcelles applies the word FAUVES (wild beasts) to a group of French painters with work on view at the Salon d'Automne.

DIE BRÜCKE is founded in Dresden, Germany.

1 9 0 6

THE WORLD

U.S. muckraker Upton Sinclair publishes *The Jungle,* a book about the meat-packing industry that leads to almost immediate passage of food-inspection laws.

1 9 0 7

THE WORLD

Great Britain and France agree on independence for Siam (now Thailand) but claim spheres of influence in Southeast Asia. Russia and Japan claim spheres of influence in Manchuria.

German astronomer Karl Schwarzschild suggests existence of black holes in space.

J. M. Synge's *The Playboy of the Western World* causes a riot at its premiere at the Abbey Theatre in Dublin.

HENRI MATISSE (1869–1954).
Landscape at Collioure—Study for "The Joy of Life," 1905. Oil on canvas, 18 1/8 x 21 5/8 in. (46 x 54.9 cm). Statens Museum for Kunst, Copenhagen.

THE ART WORLD

Paul Cézanne retrospective is held at the Salon d'Automne.

Wilhelm Worringer publishes *Abstraction and Empathy.*

The Deutscher Werkbund is founded in Germany.

The Blue Rose, a SYMBOLIST group, is formed in Moscow.

OSMA is founded in Prague.

1908

THE WORLD

The weakened Ottoman Empire causes increased tensions in Balkans: Ferdinand I of Bulgaria proclaims his country's independence; Crete proclaims union with Greece; Austria occupies Bosnia and Herzogovina; revolution by Young Turks in the Ottoman Empire forces restoration of 1876 constitution.

THE ART WORLD

THE EIGHT is founded in New York.

Louis Vauxcelles dubs Georges Braque's work CUBISM.

Alfred Stieglitz shows drawings by Auguste Rodin, marking the first exhibition of modernist art in the U.S.

1909

THE WORLD

Persian Shah Mohammed Ali is deposed; Anglo-Persian Oil Company is founded.

U.S. explorer Robert Peary heads first team to reach the North Pole.

W.E.B. Du Bois founds the National Association for the Advancement of Colored People in U.S.

Sergey Diaghilev founds the Ballets Russes in Paris.

THE ART WORLD

Filippo Tommaso Marinetti issues FUTURIST manifesto.

Wassily Kandinsky, Alexey von Jawlensky, and others found Neue Künstlervereinigung (New Artists' Association) in Munich, Germany.

1910–1919

1910

THE WORLD

Japan annexes Chosen (now Korea).

Mann Act in U.S. prohibits interstate transportation of women for immoral purposes.

DIE BRÜCKE

1905–1913

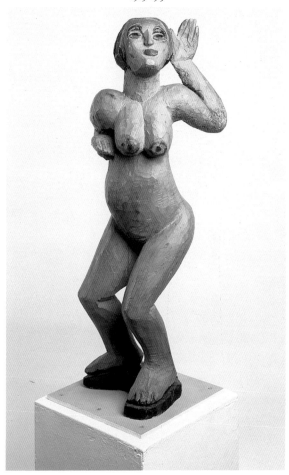

ERNST LUDWIG KIRCHNER (1880–1938).
Dancing Woman, 1911. Wood painted yellow and black, 34 1/2 x 14 x 10 7/8 in. (87.6 x 35.6 x 27.6 cm). Stedelijk Museum, Amsterdam.

THE ART WORLD

Roger Fry coins the term POST-IMPRESSIONISM for the first of two important exhibitions at Grafton Galleries that bring recent French painting to London.

Der Sturm magazine and Galerie der Sturm are founded in Berlin.

27

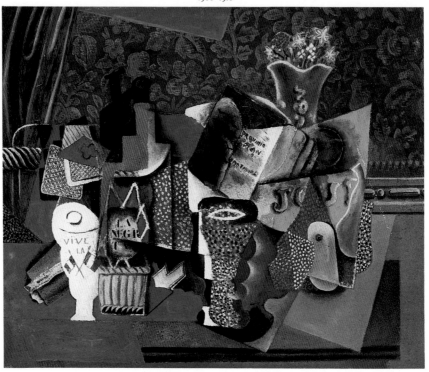

PABLO PICASSO (1881–1973).

Still Life with Cards, Glasses and Bottle of Rum ("Vive France"), 1914–15.
Oil and sand on canvas, 21 3/8 x 25 3/4 in. (54.3 x 65.4 cm). Private collection.

1911

THE WORLD

Revolutionary army overthrows the Manchu dynasty in China. A republic is proclaimed, Sun Yat-sen is elected president, and the emperor abdicates in 1912.

U.S., Great Britain, Japan, and Russia sign treaty abolishing seal hunting for fifteen years in northern Pacific Ocean.

THE ART WORLD

Leonardo da Vinci's Mona Lisa is stolen from the Louvre; it is returned in 1913.

First BLAUE REITER exhibition is held in Munich.

SKUPINA VÝTVARNÝCH UMĚLCŮ group is founded in Prague.

1912

THE WORLD

Rudolf Steiner founds Anthroposophical Society.

Polish biochemist Casimir Funk discovers vitamins.

Millions of Americans visit cinemas weekly; French photographer Charles Pathé produces first newsreel.

THE ART WORLD

SECTION D'OR exhibition is held at Galerie la Boétie in Paris.

FUTURIST exhibition in Paris directs international attention to the group.

Wassily Kandinsky publishes *On the Spiritual in Art.*

Albert Gleizes and Jean Metzinger publish *On Cubism*.

Guillaume Apollinaire coins the term ORPHISM.

Sonderbund exhibition of modernist art is held in Cologne.

Pablo Picasso invents COLLAGE and ASSEMBLAGE.

1913

THE WORLD

Danish physicist Niels Bohr formulates theory of atomic structure.

Ford Motor Company sets up first moving assembly line, capable of producing one thousand Model T's each day.

German philosopher Edmund Husserl publishes *Ideas for a Pure Phenomenology*.

Russian composer Igor Stravinsky's controversial ballet score, *The Rite of Spring*, debuts in Paris.

French writer Marcel Proust publishes *Swann's Way*, the first part of *Remembrance of Things Past*.

THE ART WORLD

ARMORY SHOW in New York introduces POST-IMPRESSIONIST and CUBIST art to huge U.S. audiences.

Vladimir Tatlin sees Picasso's sheet-metal-and-wire constructions, which are the catalysts for Tatlin's development of CONSTRUCTIVISM.

ABSTRACTION

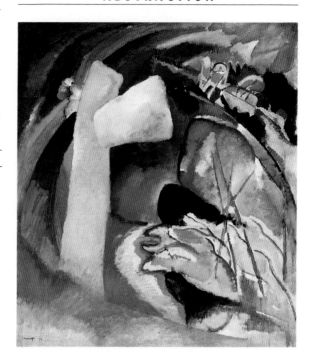

WASSILY KANDINSKY (1866–1934).
Painting with White Form, 1913. Oil on canvas, 39 1/4 x 34 1/4 in. (99.7 x 87 cm). The Detroit Institute of Arts; Gift of Mrs. Ferdinand Mueller.

Mikhail Larionov issues the "RAYONIST Manifesto."

The CUBO-FUTURIST experimental opera *Victory over the Sun* produced in Moscow.

Marcel Duchamp creates the first READYMADE and KINETIC SCULPTURE.

BLOOMSBURY GROUP artists establish Omega Workshops for production of functional art.

1914

THE WORLD

Assassination of Austrian Archduke Francis Ferdinand and his wife at Sarajevo by a Serbian nationalist triggers World War I. Great Britain, France, Russia, Belgium, Serbia, Japan, and Montenegro are allied against Central Powers of Austria-Hungary, Germany, and Turkey. The Allies are soon joined by Italy, Portugal, and Rumania, as war spreads

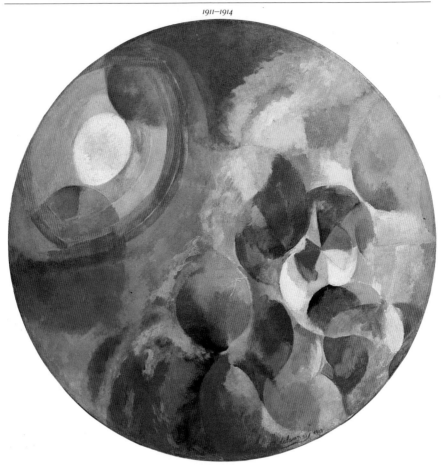

throughout Mediterranean, Middle East, and even China. U.S. enters in 1917. War ends in 1918; Treaty of Versailles—which many believe made World War II inevitable—is signed in 1919.

Panama Canal opens.

THE ART WORLD

Diego Velázquez's *Rokeby Venus* in National Gallery,

ROBERT DELAUNAY (1885–1941).
Simultaneous Contrasts: Sun and Moon, 1913. Oil on canvas, diameter: 53 in. (134.6 cm). Collection, The Museum of Modern Art, New York; Mrs. Simon Guggenheim Fund.

London, is damaged by a suffragette.

VORTICIST group is formed in London.

Roger Fry invents the term *significant form.*

Auction of La Peau de l'Ours collection in Paris marks first instance of speculation in modern art by a group of investors.

THE WORLD

Poison gas is first used in warfare, by the Germans.

U.S. birth-control advocate Margaret Sanger is jailed for sending *Family Limitation,* the first book about birth control, through the U.S. mail.

U.S. dancers Ruth St. Denis and Ted Shawn found the Denishawn School of Dance and Related Arts, which pioneers the teaching of modern dance.

THE ART WORLD

Kazimir Malevich proclaims SUPREMATISM.

1916

THE WORLD

Easter Rebellion in Dublin marks escalation of Irish independence movement.

Treatment of war casualties leads to development of plastic surgery.

U.S. forces chase Mexican revolutionary Pancho Villa into Mexico after a New Mexico raid but fail to find him.

U.S. troops land in Dominican Republic to settle internal strife; they remain until 1924.

Swiss psychoanalyst Carl Jung publishes *The Psychology of the Unconscious.*

THE ART WORLD

The term DADA is coined in Zürich.

NATALIA GONCHAROVA (1881–1962).
Rayonist Garden: Park, 1912–13. Oil on canvas, 55 3/8 x 34 3/8 in. (140.7 x 87.3 cm). Art Gallery of Ontario, Toronto; Gift of Sam and Ayala Zacks, 1970.

1917

THE WORLD

Czar Nicholas II of Russia abdicates and is succeeded by a liberal regime under Alexander Kerensky, which is overthrown by Bolsheviks under Lenin. Russia and Germany sign armistice ending hostilities.

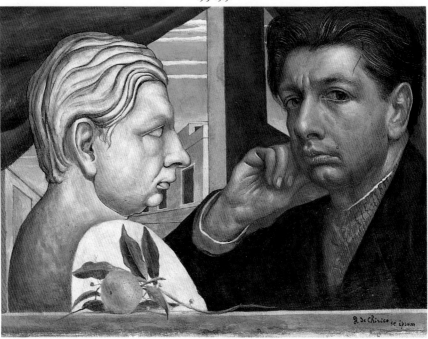

GIORGIO DE CHIRICO (1888–1978).
Self-Portrait, c. 1922. Oil on canvas, 15 1/8 x 20 1/8 in. (38.4 x 51.1 cm).
The Toledo Museum of Art, Toledo, Ohio; Purchased with funds from the Libbey Endowment, Gift of Edward Drummond Libbey.

Balfour Declaration on Zionism, by British, promises a Jewish national homeland in Palestine.

Allies execute Dutch dancer Mata Hari as a spy.

French composers Georges Auric, Louis Edmond Durey, Arthur Honegger, Darius Milhaud, Francis Poulenc, and Germaine Tailleferre form a group known as Les Six.

First jazz recordings made by Original Dixieland Jazz Band in New York.

THE ART WORLD

The review *De Stijl* is founded in Leiden, the Netherlands.

Society of Independent Artists organizes exhibition in New York; Marcel Duchamp pseudonymously submits a signed urinal entitled *Fountain*.

Carlo Carrà, Giorgio de Chirico, and Filippo de Pisis form the SCUOLA METAFISICA in Ferrara, Italy.

Pablo Picasso contributes set and costumes for Ballets Russes production of *Parade*.

Guillaume Apollinaire invents the term SURREALISM.

1918

THE WORLD

World War I ends on November 11, after 9 million battlefield deaths. Emperor William II abdicates; the German Republic is founded. Austria, Hungary, Poland, and Czechoslovakia are proclaimed independent republics.

Influenza kills 20 million people throughout the world.

Women over thirty get the vote in Great Britain.

SUPREMATISM
1915–1923

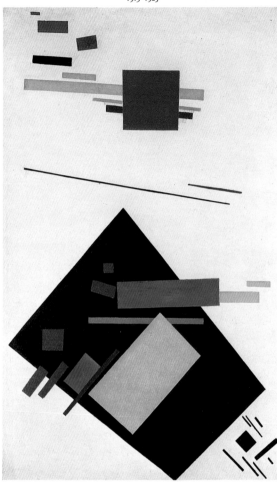

KASIMIR MALEVICH (1878–1935).
Suprematist Painting, 1917–18. Oil on canvas, 41 3/4 x 27 3/4 in. (106 x 70.5 cm).
Stedelijk Museum, Amsterdam.

THE ART WORLD

Le Corbusier and Amédée Ozenfant publish *After Cubism*, their manifesto of PURISM.

Novembergruppe is founded in Berlin.

1919

THE WORLD

Liberal German constitution adopted at Weimar; leaders of German left—Karl Liebknecht, Rosa Luxemburg, and Kurt Eisner—are murdered by rightists.

U.S. President Wilson spearheads establishment of League of Nations, which isolationist U.S. Congress refuses to join.

U.S. constitutional amendment prohibiting consumption of alcoholic beverages—known as Prohibition—is ratified; it is repealed in 1933.

German film maker Robert Wiene directs classic EXPRESSIONIST film *The Cabinet of Dr. Caligari*. Charlie Chaplin, D. W. Griffith, Douglas Fairbanks, and Mary Pickford combine their assets to form the Hollywood giant United Artists Corporation.

THE ART WORLD

BAUHAUS is established in Weimar, Germany, with Walter Gropius as director.

GROUP OF SEVEN is founded in Toronto.

1920–1929

1920

THE WORLD

U.S. Constitution is amended to give women the right to vote.

League of Nations convenes in Geneva, Switzerland.

German Workers' Party is renamed the National Socialist German Workers' (or Nazi) Party.

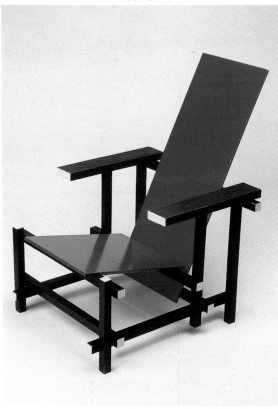

GERRIT RIETVELD (1888–1965).
Red/Blue Chair, 1918. Painted plywood, 33 7/8 x 25 3/16 x 26 3/4 in.
(86 x 64 x 68 cm). Stedelijk Museum, Amsterdam.

Guglielmo Marconi opens public radio station in Great Britain. First commercial radio station in U.S. begins broadcasting in Pittsburgh.

THE ART WORLD

Katherine Dreier, Marcel Duchamp, and Man Ray form the SOCIETE ANONYME in New York.

First International Dada Fair is held in Berlin.

Naum Gabo and Antoine Pevsner issue "Realistic Manifesto" in Moscow, advocating CONSTRUCTIVISM.

Piet Mondrian publishes *Neo-Plasticism*.

1921

THE WORLD

First Fascists are elected to Italian parliament; after March on Rome in 1922, Mussolini becomes prime minister.

Ireland is granted independence from Great Britain as Irish Free State; Northern Ireland remains part of Great Britain.

Austrian philosopher Ludwig Wittgenstein publishes *Tractatus Logico-philosophicus*.

English novelist D. H. Lawrence publishes *Women in Love*.

Italian playwright Luigi Pirandello publishes *Six Characters in Search of an Author*.

THE ART WORLD

Marcel Duchamp and Man Ray edit the magazine *New York Dada*.

1922

THE WORLD

Egypt gains independence from Great Britain; Turkey becomes a republic under President Kemal Ataturk.

Mahatma Gandhi is arrested and sentenced to six years' imprisonment for civil disobedience in India; he is released in 1924 after twenty-one-day fast protesting Hindu-Moslem feuds.

Irish novelist James Joyce publishes *Ulysses* in Paris; U.S. Post Office burns 500 copies upon their arrival in U.S.

English archaeologist Howard Carter's discovery of Tutankhamen's tomb in Egypt sparks international Egyptomania.

The cocktail debuts.

THE ART WORLD

SEMANA DE ARTE MODERNA ("Week of Modern Art") in São Paulo exposes Brazilian audiences to modernism.

NOVECENTO ITALIANO is founded.

CONSTRUCTIVISTS hold congress in Weimar, Germany.

1923

THE WORLD

Nazi Party leader Adolf Hitler leads unsuccessful coup d'état ("Beer Hall Putsch") in Munich and is imprisoned.

Ku Klux Klan's tristate meeting in Kokomo, Indiana, draws 200,000. Martial law is established in Oklahoma to protect people and property from the white supremacist group.

German poet Rainer Maria Rilke publishes *The Duino Elegies.*

Austrian philosopher Martin Buber publishes *I and Thou.*

THE ART WORLD

G. F. Hartlaub coins the term NEUE SACHLICHKEIT.

1924

THE WORLD

The first British Labour government is formed; it is brought down after the Zinoviev Letter incident, in which the Third International supposedly instructed Britons to foment revolution.

First elections under Fascist control yield a 65 percent majority for Mussolini.

German novelist Thomas Mann publishes *The Magic Mountain.*

George and Ira Gershwin's *Lady Be Good*—which includes the songs "Fascinating Rhythm" and "The Man I Love"—is one of the decade's many popular Broadway musicals. Paul Whiteman commissions George Gershwin to write *Rhapsody in Blue.*

Opening of Tsukiji Little Theater in Tokyo marks beginning of modern Japanese theater.

THE ART WORLD

André Breton issues "Manifesto of Surrealism."

Galka Scheyer forms the BLUE FOUR.

1925

THE WORLD

Reza Khan is proclaimed Shah of Iran, establishing the Pahlavi dynasty.

Japan grants universal male suffrage; India adopts female suffrage.

U.S. novelist F. Scott Fitzgerald publishes *The Great Gatsby,* about the so-called Jazz Age.

THE ART WORLD

First SURREALIST group show is held at Galerie Pierre, Paris.

Andre Breton founds SURREALIST journal *La Révolution surréaliste.*

Exposition internationale des arts décoratifs et industriels modernes in Paris gives ART DECO its name.

The Communist Party Central Committee in USSR attacks ABSTRACTION.

1926

THE WORLD

General Strike, precipitated by miners' strike, paralyzes Great Britain.

Fascist youth organizations emerge in Italy (Ballilla) and Germany (Hitlerjugend).

Ibn Saud proclaims himself king of Hejaz and, in 1927, Najd; he changes kingdom's name to Saudi Arabia in 1932.

THE ART WORLD

NEO-ROMANTICISM is named.

1927

THE WORLD

Josef Stalin gains control of Communist party in USSR and expels Trotsky and his followers to provinces.

SURREALISM

1924–1945

RENE MAGRITTE (1898–1967).
The Red Model, 1935. Oil on canvas, 22 x 18 1/16 in. (55.9 x 45.8 cm).
Musée National d'Art Moderne, Centre Georges Pompidou, Paris.

Socialist uprising and general strike occur in Vienna after acquittal of Nazis for political murder.

U.S. aviator Charles Lindbergh flies from New York to Paris in 33 1/2 hours. Lester Maitland and Albert Hegenberger make first successful San Francisco-to-Honolulu flight.

1928

THE WORLD

Civil war between Communists and Nationalists rages in China. Nationalist leader Chiang Kai-shek becomes president; opposition Chinese Red Army is founded.

Kellog-Briand Pact, which outlaws war, is signed in Paris by sixty-five countries.

English novelist Radclyffe Hall publishes *The Well of Loneliness,* the first lesbian novel.

1929

THE WORLD

U.S. stock market crashes, triggering international economic crisis and Great Depression.

U.S. physicist Ernest Lawrence invents the cyclotron.

THE ART WORLD

Museum of Modern Art opens in New York.

FILM UND FOTO exhibition is held in Stuttgart, Germany.

CONSTRUCTIVIST CERCLE ET CARRE group and magazine founded in Paris; it is supplanted by the ABSTRACTION-CREATION group in 1931.

1930–1939

1930

THE WORLD

U.S. astronomer Clyde Tombaugh discovers Pluto.

U.S. novelist Dashiell Hammett publishes *The Maltese Falcon,* establishing the "noir" detective genre.

Austrian novelist Robert Musil publishes first volume of *The Man without Qualities.*

Luis Buñuel and Salvador Dalí collaborate on SURREALIST film *L'Age d'or*.

Theo van Doesburg invents the term CONCRETE ART.

1931

THE WORLD

King Alfonso XIII of Spain is deposed; the Second Republic is established.

Japan invades southern Manchuria after Mukden Incident; renames Manchuria Manchukuo, in 1932, and claims it as protectorate.

English writer Virginia Woolf publishes *The Waves*.

Two of the world's most famous skyscrapers are completed in New York: the 77-story Chrysler Building and the 102-story Empire State Building.

THE ART WORLD

Whitney Museum of American Art opens in New York.

1932

THE WORLD

Catalonia in Spain is made autonomous, with its own parliament and language. Basques demand similar treatment.

English writer Aldous Huxley publishes the satirical novel *Brave New World*.

THE ART WORLD

A. E. ("Chick") Austin curates first important group show of SURREALIST art in U.S., at Wadsworth Atheneum in Hartford, Connecticut.

Ansel Adams and Willard Van Dyke form GROUP F/64 in San Francisco.

The Mostra della Rivoluzione Fascista, a cultural fair, commemorates ten years of Mussolini's rule in Italy.

1933

THE WORLD

Reichstag building burns and Nazis accuse Communists of having set the fire. Weimar Republic falls; Hitler's Nazi party wins a majority of seats in the Reichstag. German government outlaws freedom of press, labor unions, and non-Nazi political parties. Hitler begins to re-arm Germany.

The Falange Española (Spanish fascist party) is founded.

American expatriate author Gertrude Stein publishes *The Autobiography of Alice B. Toklas*.

Spanish playwright Federico Garcia Lorca publishes *The Blood Wedding*.

THE ART WORLD

BAUHAUS closes in Germany after Hitler gains power. Sixty thousand artists—including writers, painters, and musicians—emigrate from Germany during 1930s. Hans Hofmann opens an art school in New York.

Diego Rivera's mural at Rockefeller Center is destroyed because it includes an image of Lenin.

SURREALIST review *Minotaure* is founded in Paris by Albert Skira and E. Tériade.

1934

THE WORLD

Chinese Red Army under Mao Tse-tung withstands Nationalist army attacks and begins 6,000-mile "Long March" from southern to northern China.

King Alexander I of Yugoslavia, French Foreign Minister Louis Bartho, and Austrian Chancellor Engelbert Dollfuss are assassinated. Sergey Kirov, Stalin's collaborator, is assassinated in Leningrad, triggering Great Purge of Communist party.

Hitler combines offices of chancellor and president to become *Führer* (leader); he meets Mussolini in Venice.

THE ART WORLD

SOCIAL REALISM becomes official Soviet style.

U.S. painter Florine Stettheimer collaborates with writer Gertrude Stein, U.S. composer Virgil Thomson, and English choreographer Frederick Ashton on opera *Four Saints in Three Acts,*

1931–1936

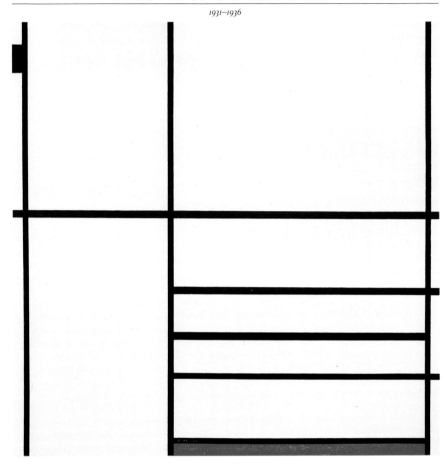

which opens at Wadsworth Atheneum and moves on to Broadway.

PIET MONDRIAN (1872–1944).
Composition in White, Black and Red, 1936. Oil on canvas, 40 1/4 x 41 in. (102.2 x 104.1 cm). The Museum of Modern Art, New York; Gift of the Advisory Committee.

1935

THE WORLD

Italy invades Ethiopia; League of Nations votes sanctions.

Nazis renounce Treaty of Versailles, reintroduce military draft, and issue Nuremberg Laws, which deprive German Jews of their civil rights.

Austrian zoologist Konrad Lorenz identifies animal learning process known as imprinting.

Iraq–Tripoli oil pipeline opens.

Alcoholics Anonymous is founded in New York.

W. H. Auden and Christopher Isherwood collaborate on play *The Dog beneath the Skin.*

THE ART WORLD

Works Progress Administration is established in U.S.; Holger Cahill heads FEDERAL ART PROJECT.

Joseph Goebbels, Nazi minister of propaganda, orders German artists to produce "racially conscious" popular art.

1936

THE WORLD

Spanish general Francisco Franco, with support of Germany and Italy, starts Spanish Civil War. After bitter fighting in what is widely regarded as a prelude to World War II, Spanish Republic collapses in 1939.

British King George V dies and is succeeded by Edward VIII, who abdicates to marry Mrs. Wallis Simpson; he is succeeded by his brother, who becomes George VI.

China declares war on Japan.

Germany hosts Olympics in Berlin. Filmmaker and Nazi propagandist Leni Riefenstahl directs *Triumph of the Will* and, in 1938, *Olympia*.

Henry Luce starts publishing *Life,* the U.S. weekly photo-news magazine.

THE ART WORLD

AMERICAN ABSTRACT ARTISTS is founded in New York.

Joaquín Torres-García forms ASOCIACION DE ARTE CONSTRUC-TIVO, the Latin-American incarnation of the Cercle et Carré group, in Montevideo, Uruguay.

1937

THE WORLD

Japanese seize Shanghai, Beijing, and other major Chinese cities. Nationalist Chiang Kai-shek and Communists Mao Tse-tung and Chou En-lai join forces. Japan sinks U.S. gunboat *Panay* in Chinese waters and apologizes.

British Royal Commission on Palestine recommends establishment of Arab and Jewish states.

British, French, Italian, and German warships help Franco blockade Spanish coast. Germans, in support of Falangists, savagely bomb the Basque city of Guernica.

THE ART WORLD

Pablo Picasso paints *Guernica* for Pavilion of the Spanish Republic at Exposition Universelle, Paris.

Nazi-organized "DEGENERATE ART" exhibition opens in Munich.

1938

THE WORLD

Germany invades Austria and makes it part of German Reich. Germany occupies Sudetenland in Czechoslovakia; the annexation is ratified by Italy, Great Britain, and France in the Munich Pact.

Anti-Semitic legislation is enacted in Italy.

French existentialist Jean-Paul Sartre publishes *Nausea,* his first novel.

Orson Welles's U.S. radio production of H. G. Wells's *War of the Worlds* causes widespread panic.

THE ART WORLD

Emil Bisstram, Lawren Harris, Raymond Jonson, and Agnes Pelton found New Mexico TRANSCENDENTAL PAINTING GROUP.

1939

THE WORLD

World War II begins. Germany invades Poland; Great Britain and France declare war on Germany. Italy signs military alliance with Germany. USSR invades Poland from the east; Soviet forces seize Baltic states and invade Finland. U.S. declares neutrality but is drawn into the war in 1941, following German invasion of USSR and Japanese attack on Pearl Harbor. By 1940 war is being waged in North Africa and the Pacific as well as Europe. Mussolini is overthrown and Italy surrenders in 1943. Germany is defeated in 1945, and Japan surrenders the same year, after the U.S. drops the first atomic bombs on Hiroshima and Nagasaki.

Weak U.S. economy booms from orders for armaments.

U.S. writer John Steinbeck publishes *The Grapes of Wrath.*

EXHIBITION I, the first group show of abstract art in Australia, is held in Sydney.

Erwin Panofsky publishes *Studies in Iconology*.

Solomon R. Guggenheim Foundation Museum of Non-Objective Painting opens in New York.

1940–1944

1940

THE WORLD

Winston Churchill becomes British prime minister.

Leon Trotsky is assassinated in Mexico by agents of Josef Stalin.

Charlie Chaplin makes his first "talkie," *The Great Dictator*.

THE ART WORLD

Prehistoric drawings are discovered in Lascaux caves, near Montignac, France.

Charles Henri Ford publishes SURREALIST magazine *View*.

1941

THE WORLD

Manhattan Project to develop atomic bomb begins in U.S.

German dramatist Bertolt Brecht writes *Mother Courage and Her Children*.

THE ART WORLD

Gutzon Borglum completes sixty-foot-high presidential portraits (begun in 1927) at Mount Rushmore National Memorial in South Dakota.

National Gallery opens in Washington, D.C.

1942

THE WORLD

Women's auxiliary corps is established in U.S. military.

French existentialist Albert Camus publishes *The Stranger* and *The Myth of Sisyphus*.

THE ART WORLD

Peggy Guggenheim opens Art of This Century gallery in New York, which showcases SURREALIST and ABSTRACT EXPRESSIONIST artists.

André Breton and Marcel Duchamp organize *First Papers of Surrealism* exhibition in New York.

1943

THE WORLD

Penicillin is first used on a large scale to combat infection.

THE ART WORLD

Leonardo da Vinci's *Last Supper* barely escapes destruction during bombing of Milan.

Piet Mondrian paints *Broadway Boogie Woogie*.

1944

THE WORLD

Franklin Roosevelt is elected to unprecedented fourth term as U.S. president.

Ho Chi Minh declares Vietnam independent.

Dumbarton Oaks Conference in Washington, D.C., proposes United Nations.

THE ART WORLD

Picasso's play *Desire Caught by the Tail* premieres.

When I visited museums as a child, I tuned out the art historical conversations that buzzed around me. Terms like *Secession* and *japonisme, Merz* and *Scuola Metafisica* delighted me for their music and poetry but otherwise meant very little. Not until later did I realize the difficulty of communicating my thoughts and feelings about art without command of its language.

Modern art—like every professional discipline—requires a specialized vocabulary for all but the most rudimentary communication. Even the term *modern* needs deciphering: in the context of this book it refers to the *modern* or *modernist* period, encompassing the mid-nineteenth through the mid-twentieth century. It is this century-long span that *ArtSpoke* surveys, identifying and defining the terminology essential for understanding modern art.

Although the terms *modern* and *contemporary* can both be used to describe a newly made artwork, *contemporary* is most accurately used to describe art produced since World War II. That art is the subject of *ArtSpoke's* companion volume, *ArtSpeak: A Guide to Contemporary Ideas, Movements, and Buzzwords. ArtSpoke* begins with 1848, the year when revolution swept Europe and catalyzed profound social changes that contributed to the development of modern art. A few of the earlier movements, such as Romanticism, that proved crucial to the emergence of modern art are also included here.

The terms discussed in this volume comprise art movements (such as Constructivism and Fauvism); art forms (found object, kinetic sculpture); critical terminology (formalism, psychoanalysis); and a smattering of key events and institutions (Armory Show, Bauhaus). It also includes influential social phenomena, such as spiritualism and anarchy, that were central to the formulation of modern art. Each term is explained in a concise essay, and the essays are arranged in alphabetical order. The entries that deal with groups and movements are divided into the journalistic categories of *Who, When, Where,* and *What.*

WHO is a list of the principal artists involved. Those whose names are capitalized are the pioneers or virtuosos of that approach. The nationality of the artist appears in parentheses after the name. In cases of artists who have lived and worked in more than one country, the nation with which they are most associated is the one cited. Thus, the Spanish-born Pablo Picasso is identified as French. Certain artists appear in several entries.

The Russian artist Wassily Kandinsky, for instance, is listed under abstraction, Abstraction-Création, Bauhaus, Der Blaue Reiter, Die Brücke, and spiritualism.

WHEN signifies the moment of greatest vitality for a particular attitude toward, or method of, art making. The entry for Impressionism, for example, gives the dates 1870–1890, but some Impressionist artists carried on with the style well into the twentieth century.

WHERE identifies the cities, countries, or continents in which a movement was centered. It does not mean that artists involved in that movement did not live or work in other places.

WHAT defines the origins, nature, and implications of the group or movement. Cross references to other entries are CAPITALIZED.

What is the best way to use this volume? That depends on who you are. *ArtSpoke* has been designed for different kinds of readers. The expert can use it to find specific facts—say the name of the critic who coined the term *Neo-Impressionism* or the location of the first international exposition. The student, collector, or casual art buff will find it useful to read the book from beginning to end, then return to it as needed, guidebook fashion. A timeline and an artchart put the material in chronological perspective; cross references and an extensive index ensure easy access to the information. The purpose of all these elements is to offer a new understanding of modern art—and a new pleasure in it.

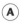

ABSTRACT/ABSTRACTION

The adjective *abstract* usually describes artworks—known as *abstractions*—without recognizable subjects. Synonyms for *abstract* include *nonobjective* and *nonrepresentational.*

Abstract painting was pioneered between 1910 and 1913 by the Russian-born Wassily Kandinsky in Munich and, in Paris, by the Czech František Kupka and the Frenchman Robert Delaunay. Kandinsky, the most influential of the three, was the first to plunge into pure or total abstraction (see page 29). The Russian CONSTRUCTIVIST Vladimir Tatlin was the first artist to create three-dimensional abstractions, which assumed the form of reliefs produced between 1913 and 1916.

The development of abstraction should, however, be seen as the logical extension of ideas first formulated at the end of the nineteenth century by the POST-IMPRESSIONISTS. By the outbreak of World War I these ideas had culminated in abstractions by the ORPHISTS Delaunay and Kupka and by the BLAUE REITER artist Kandinsky, as well as in work by the RAYONISTS and SUPREMATISTS in Russia and by the SYNCHROMISTS, American artists living in Paris. Since then, abstract paintings and sculptures have been produced by thousands of MODERN artists, in styles ranging from EXPRESSIONISM to DE STIJL.

Many people, in fact, equate modern art with abstraction. But even though the modernist mainstream has tended toward the abstract, artists associated with such movements as SCUOLA METAFISICA, SOCIAL REALISM, and NEUE SACHLICHKEIT created exclusively representational art. Many other modern artists not affiliated with specific movements—including Balthus, Georgia O'Keeffe, and Florine Stettheimer—also produced nonabstract works.

In addition to its meaning as an adjective, *abstract* is also a verb. *To abstract* is to generalize. For instance, imagine a dozen drawings of the same face that grow increasingly abstract as particulars are deleted. The first drawing shows the subject in detail—wrinkles, freckles, and all. The second is more sketchy and focuses on the subject's eyes. By the tenth drawing, even the subject's sex is indeterminate. Finally, the twelfth drawing is a perfect oval with no features, which we take to be a face. This is the *process* of abstraction. Abstraction and representation are at the opposite ends of a continuum. The first drawing described is representational, the twelfth is abstract, and the others fall somewhere in between. The tenth drawing is more abstract than the second. The adjective *abstract* and the noun *abstraction*

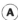

often refer to works, like the twelfth drawing, that are entirely abstract. But the *entirely* is usually omitted.

An abstract image can be grounded in an actual object, like the twelve drawings of the face. Or it can give visual form to something inherently nonvisual, like emotions or sensations. Red, for example, can represent anger or passion. The idea that a musical, visual, or literary sensation has an equivalent in another medium of expression was a popular nineteenth-century idea called *synesthesia.* To suggest this correspondence the painter James McNeill Whistler, for instance, titled his increasingly abstract compositions Nocturnes, and Kandinsky called his abstractions Improvisations, Lyricals, and the like.

Also central to the development of abstract art were the concept of empathy and the variety of unorthodox spiritual beliefs that were popular at the end of the nineteenth century. Numerous artists, from Kupka and Kandinsky to Piet Mondrian and Kazimir Malevich, translated their often mystical beliefs into nonrepresentational arrangements of form and color intended to evoke the nonmaterial realm. The concept of empathy—predicated on the idea that effective art demands the viewer's active identification with it— also helped advance the concept of the work of art as a representation of an autonomous reality divorced from nature. With the emergence of increasingly abstract styles such as ART NOUVEAU, empathy again became part of art's critical and theoretical vocabulary, especially in conjunction with expressionist styles.

Abstractions come in two basic variations. The first is geometric, or hard-edge, which often suggests rationality and is associated with such modern movements as Constructivism and CONCRETE ART. The second is the looser and more personal style usually known as *organic.* Works in this style that evoke floral, phallic, vaginal, or other animate forms are termed *biomorphic.* Organic abstraction is associated with such modern movements as German Expressionism and SURREALISM.

ABSTRACTION-CREATION

▷ **WHO** Jean (Hans) Arp (Germany), Theo van Doesburg (Netherlands), Naum Gabo (USSR), Jean Hélion (France), Barbara Hepworth (Great Britain), Auguste HERBIN (France), Wassily Kandinsky (USSR), František Kupka (Czechoslovakia), El Lissitzky (USSR), Piet Mondrian (Holland), Ben Nicholson

(Great Britain), Antoine Pevsner (USSR), Joaquín Torres-García (Uruguay), Georges VANTONGERLOO (Belgium)

▷ **WHEN** 1931 to 1936

▷ **WHERE** Paris

▷ **WHAT** Abstraction-Création was an association of painters and sculptors who banded together in Paris in 1931. Led by Auguste Herbin and Georges Vantongerloo, the group succeeded the short-lived Cercle et Carré, a discussion and exhibition society for CONSTRUCTIVIST artists founded in 1929. The goal of Abstraction-Création was the promotion of many kinds of ABSTRACT art—including CUBIST- and SURREALIST-derived abstraction—but the predominance of CONCRETE and DE STIJL artists in the group put the emphasis on geometric abstraction rather than images abstracted from nature (see page 38).

The loosely constituted group was open to artists of all nationalities; some, like the English artists Barbara Hepworth and Ben Nicholson, were even invited to join from afar. Regular exhibitions were held between 1932 and 1936, and an illustrated annual, entitled *Abstraction-Création, Art non-figuratif,* was published during the same years. At its peak Abstraction-Création numbered four hundred artists. Its membership dwindled after 1936 partly because some of the non-French members left Paris for England.

A similar organization, the American Abstract Artists, was formed in New York in 1936. That same year Cercle et Carré was reincarnated by Joaquín Torres-García in Montevideo, Uruguay, as the Asociación de Arte Constructivo. In Sydney, eight artists mounted *Exhibition I* in 1939, the first group show of abstract art in Australia. Its emphasis on Constructivist- and Cubist-derived painting and sculpture marked the short-lived appearance of non-EXPRESSIONIST abstraction in Australia.

ACADEMIC ART

Academic art once meant simply the "art of the Academy"—that is, art based on academic principles. Having now acquired a negative connotation, it is often used to describe an artist or artwork that is long on received knowledge and technical finesse but short on imagination or genuine emotion. It was academic art—and the system of official support for it—against which MODERNIST, avant-garde artists rebelled.

Art academies originated in late sixteenth-century Italy, replacing the medieval guild-apprentice system previously used to train artists and raising

ADOLPHE WILLIAM BOUGUEREAU (1825–1905).
Return of Spring, 1886. Oil on canvas, 84 1/2 x 50 in. (214.6 x 127 cm).
Joslyn Art Museum, Omaha, Nebraska; Gift of Francis T. B. Martin.

artists' social status in the process. The academies quickly proliferated: in 1720 there were nineteen academies of painting and sculpture; by 1790 there were more than one hundred. Academies such as London's Royal Academy of Art and Paris's Académie des Beaux-Arts organized public exhibitions of contemporary art popularly known as SALONS, institutionalized art training, and established a strict hierarchy of subjects. History painting (biblical or classical subjects) ranked first, then portraits and landscapes, and finally still lifes and genre paintings, which were scenes of everyday life. Academic artists—who were almost invariably men—were initially taught to draw from white plaster casts of classical statues and then progressed to drawing from nude models, acquiring additional skills in a carefully programmed sequence.

1850

By the second half of the nineteenth century the nature of academic artworks had changed. The didactic morality of subjects drawn from classical history or literature gave way to titillating depictions of mythological nudity by noted artists such as Adolphe William Bouguereau and Alexandre Cabanel. Biblical and genre scenes offered displays of maudlin sentimentality rather than authentic feeling. Even the hierarchy of subjects had blurred: history paintings were often little more than genre scenes peopled by figures scantily clad in antique garb, as in the images of ancient baths by Lawrence Alma-Tadema.

At the same time, artists affected by contemporary social conditions and epochal events—such as industrialization and the Revolutions of 1848—rejected the historicism of the academy and its centuries-old conventions. The French REALISTS and British PRE-RAPHAELITES were among the first to assault academic standards and practices. Such artists objected not only to the academic aesthetic but also to the Academies' control of patronage. They established alternative exhibitions such as the SALON DES REFUSES and, at the end of the nineteenth century, more-liberal art institutions such as the SECESSIONS and *Kunsthalle*s, which exhibit, but do not collect, art. By World War I the importance of academic art had largely ended.

AESTHETICISM—*see* ART FOR ART'S SAKE

ALLEGORY

An allegory is an image or a story that refers to something else entirely—usually concepts such as good or evil. Although symbols and allegories are related—the term *symbolize* rather than *allegorize* is standard usage—a cru-

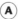

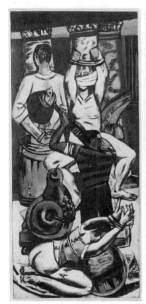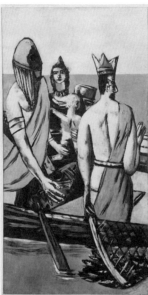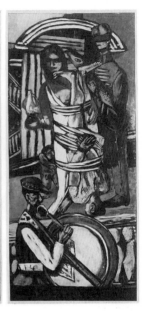

MAX BECKMANN (1884–1950).
Departure, 1932–33. Oil on canvas, side panels: 84 3/4 x 45 3/8 in.
(215.3 x 115.2 cm), each; center panel: 84 3/4 x 39 1/4 in. (215.3 x 99.7 cm).
The Museum of Modern Art, New York; Given anonymously (by
exchange).

cial distinction separates them. Many symbols have their origins in visual reality: the cross symbolizing Christianity, for instance, and the heart symbolizing love. Allegories, on the other hand, have no such basis: consider the correspondence between Venus and romantic love or the triumph of reason over brute physicality embodied in the myth of Pallas Athena and the centaur. The most straightforward allegories are known as *personifications,* figures that stand for ideas like good government or the seven deadly sins. Use of such imagery deepened an artwork's meaning by referring to information outside the work, but it also demanded that the audience be educated enough to understand those references.

The allegory was a staple of Western art, and during the second half of the nineteenth century it was used by ACADEMIC and AVANT-GARDE artists alike. Typical of the former are the French painter Adolphe William Bouguereau's allegorical representations of spring in the form of young female nudes (see page 46) and the American sculptor Daniel Chester French's virtuoso FIGURATIVE handling of the difficult program of *Science Controlling the Forces of Steam and Electricity* (1882) for the Boston Post Office. Typical of the latter are allegories of spiritual renewal embodied as infants by SYMBOLIST painters such as Jan Toorop and Ferdinand Hodler and an allegorical figure of winged death drawn by the young Pablo Picasso in *The End of the Road* (1898).

The emergence of complete ABSTRACTION in the early twentieth century simultaneously eliminated recognizable imagery and the possibility of allegorical meanings, but the international return to figuration that followed World War I yielded widespread interest in allegory once again. Modern allegories tended to be more obscure and psychological than their nineteenth-century counterparts—especially in the hands of such stylistically diverse artists as Max Beckmann, Georges Braque, Giorgio de Chirico, Max Ernst, Fernand Léger, and José Clemente Orozco. Although FORMALIST theory attempted to purge modern art of literary—or allegorical—content, which it deemed old-fashioned, allegory remained modern art's preferred way to comment on the human condition.

AMERICAN ABSTRACT ARTISTS—*see* ABSTRACTION-CREATION

AMERICAN RENAISSANCE

▷ **WHO** (All from the United States) Kenyon Cox, Daniel Chester FRENCH, Albert Herter, John LA FARGE, William H. LOW, Augustus SAINT-GAUDENS, Abbott Thayer

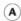

▷ **WHEN** 1876 to 1917

▷ **WHERE** United States

▷ **WHAT** The term *American Renaissance* first appeared in print in the June 1880 issue of the *Californian*. It refers not to a single STYLE but to the dominant cultural values of the four decades sandwiched between the Centennial of 1876 and the United States' entry into World War I in 1917.

This tumultuous period was characterized by labor strife, the accumulation of vast industrial wealth, the Census Office's announcement of the closing of the frontier, the acquisition of an American empire through the Spanish-American War, the proliferation of the popular press, and an influx of immigrants from eastern and southern Europe. The American Renaissance was a nationalistic response to these disorienting social conditions. It proclaimed the nation's maturity by simultaneously focusing attention on the American past and acknowledging Europe's cultural tradition (which earlier generations of Americans had rejected). Brilliantly captured by the novelist Henry James, this was the era when the affluent routinely made the "grand tour" of Europe and the artistic expatriated to Paris or London.

The United States' changing national identity was both recorded and advanced by the art and architecture of the day. Robber barons commissioned public and private buildings in styles derived from the past: Beaux-Arts classicism—an eclectic approach that paid homage to ancient Greek, Roman, and other revivalist styles—predominated by 1890, but the long-lived American Renaissance encompassed a number of other styles as well. The newly built structures were often adorned with ALLEGORICAL murals or architectural sculptures of the human figure, most notably by the painters Kenyon Cox and John La Farge and the sculptors Daniel Chester French and Augustus Saint-Gaudens. The buildings typically housed recently established museums based on the American Renaissance ideals of education and uplift, inspired by the secular humanism of the European Renaissance. This ideology was also spread by the numerous nationwide fairs that followed the World's Columbian Exposition in Chicago in 1893.

Because of the American Renaissance's emphasis on community, its influence on architecture and city planning was far greater than its impact on painting and sculpture. Its use of historical imagery and its cultivation of a mass audience made the American Renaissance nearly antithetical to the AVANT-GARDE attitude of ART FOR ART'S SAKE and to the everyday REALISM that would emerge in the work of THE EIGHT.

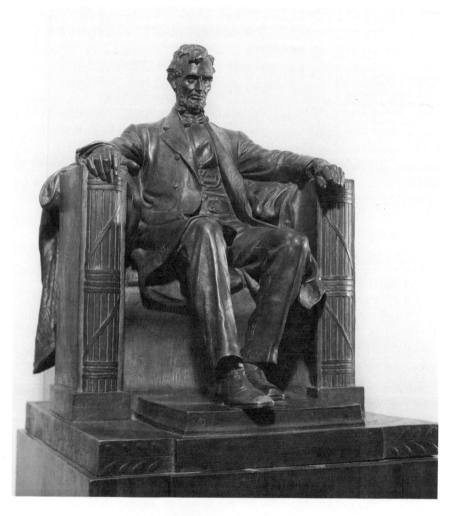

DANIEL CHESTER FRENCH (1850–1931).
Seated Lincoln, 1924–25. Bronze, 32 3/8 x 27 3/4 x 28 1/4 in.
(82.2 x 70.5 x 71.7 cm). Heckscher Museum, Huntington, New York;
August Heckscher Collection.

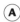

AMERICAN SCENE PAINTING

▷ **WHO** (All from the United States) Thomas Hart BENTON, Isabel Bishop, John Steuart Curry, Edward HOPPER, Yasuo Kuniyoshi, Reginald Marsh, Moses Soyer, Raphael Soyer, Grant WOOD

▷ **WHEN** 1930s

▷ **WHERE** United States

▷ **WHAT** Rejecting European MODERNISM, American Scene painters mounted the last of the fitful attempts to create a native American style prior to the internationalism that accompanied World War II. Although the slightly earlier PRECISIONISTS had depicted distinctively American subjects, they did so in a modern STYLE. American Scene Painting's devotion to American subjects and antipathy to the ABSTRACTION of the SCHOOL OF PARIS mirrored the country's isolationism and nationalism in the face of the wrenching social changes of the interwar period.

American Scene painters can be loosely divided into two groups: the midwestern Regionalists Thomas Hart Benton, John Steuart Curry, and Grant Wood; and the mostly New York–based urban REALISTS such as Isabel Bishop, Yasuo Kuniyoshi, Reginald Marsh, and the brothers Moses and Raphael Soyer. (Edward Hopper is more difficult to classify, since his American scenes are both urban and rural.) Despite the nationalistic rhetoric, Benton's swashbuckling murals depicting subjects like the settlement of the West were painted in a virtuosic style reminiscent of sixteenth-century Italian Mannerism, and Wood's nostalgic images of fast-disappearing farm life were painted in a late medieval manner. The urban realists were similarly traditional. Some, like Bishop and Marsh, looked to the Renaissance for stylistic inspiration; others, to the two-decades-old realism of THE EIGHT (based, in turn, on nineteenth-century European models). The Eight's dedication to the underdog was an even more important influence on the urban realists; Marsh and the Soyers, for instance, sympathetically depicted the Depression's hard-pressed everyman-and-woman. Some art historians regard these painters as The Eight's second generation.

Others pigeonhole the urban realists as politically liberal and the Regionalists as politically reactionary, but such designations for these loose associations of artists are too simplistic. Benton, for example, held unorthodox views that are evident in his satirical paintings of midwestern life.

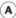

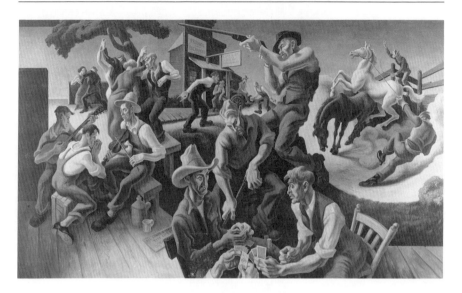

THOMAS HART BENTON (1889–1975).
Arts of the West, 1932. Tempera on gessoed canvas adhered to wood panel, 94 x 161 in. (238.8 x 408.9 cm). New Britain Museum of American Art, Connecticut; Harriet Russell Stanley Fund.

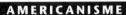

AMERICANISME

Américanisme is the fascination with "Americanness" displayed by both Europeans and Americans beginning just prior to World War I. The German equivalent of the French term is *Amerikanismus,* the Italian is *americanismo,* and the Russian is *amerikanizim.*

What "Americanness" meant was an instinctive and unequivocal yearning for modernity, which was characterized by innocence, inventiveness, energy, materialism, and indifference to the past. Although this somewhat caricatured vision of American culture—matched by an equally caricatured view of Europe as the enfeebled repository of history—might logically have made the United States the quintessential site of MODERN art, European regard for the United States did not extend to its artists until after World War II. Instead Europeans admired American engineering, skyscrapers, and product design, as well as American popular culture in the form of jazz, movies, and comic books. The American hostesses Muriel Draper and Gertrude Stein helped make being an American chic in London and Paris, respectively, overturning the earlier image of Americans abroad as uncultivated provincials.

Américanisme among European artists manifested itself in numerous ways during the second decade of the twentieth century. COLLAGES and paintings by Georges Braque and Gino Severini incorporated images of aggressively marketed American products—Gillette razor blades and Quaker Oats, for instance; Francis Picabia painted *I Too Have Lived in America* (1914) after his first visit to the United States; Pablo Picasso created an emblematic costume for the "American manager" in the ballet *Parade* (1917); and artists such as Marcel Duchamp, Albert Gleizes, and Picabia journeyed to the United States during World War I, when traveling was no simple matter.

American pride in America—stimulated by the AMERICAN RENAISSANCE—was also evident. In postwar New York the arch-modernist Alfred Stieglitz lauded Georgia O'Keeffe and John Marin as "supremely American." And American artists in Paris such as Gerald Murphy—whose house in Antibes was called Villa America—reveled in praise by European critics and artists of their works' Americanness.

Américanisme signified the international recognition of the United States as the preeminent capitalist power after World War I. It also suggests that the conventional notion of Paris as the unchallenged center of the world's

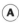

arts until the Hitler-forced migration of artists to New York in the late 1930s is too reductive.

ANALYTIC CUBISM—*see* CUBISM

ANARCHISM

Anarchy comes from the Greek *anarchos,* meaning the absence of authority or government. The term first appeared in print in 1703 as a description by the French writer Louis Armand de Lahontan of native American societies without laws or private property. It derived its modern meaning from mid-nineteenth-century philosophers such as Pierre Joseph Proudhon and Mikhail Bakunin, but by the early twentieth century it also began to be used colloquially as a synonym for chaos and disorder.

Anarchism is a philosophy and a political doctrine that values individual freedom above all and opposes the coercive power of individuals and governments. Liberalism, too, originated in a concern for freedom, but anarchists maintained that liberty could not be attained without socioeconomic equality, achievable through "mutual aid." Anarchist impulses are evident in a wide variety of nineteenth-century writings that run the gamut from the nonviolent views of Leo Tolstoy and Henry David Thoreau to the blueprints for social engineering by Charles Fourier, who founded communities in France based on his visionary social theories. Linked with the labor movement and Marxism, anarchism and communism shared a vision of an economically determined society that would ultimately be replaced by a classless, stateless utopia.

The Revolutions of 1848 inspired increased interest in anarchism among artists and nonartists alike. The REALIST painter Gustave Courbet produced portraits of the anarchist pioneer Proudhon and the Fourierist patron Alfred Bruyas, as well as his renowned *Painter's Studio* (1855), which has been convincingly interpreted as a Fourierist ALLEGORY about capital, labor, and the role of the artist or intellectual. In 1885 the incendiary theorist Pyotr Kropotkin spelled out that role: "Narrate for us in your vivid style or in your fervent pictures the titanic struggles of the masses against their oppressors. . . . Tell us what a rational life would have been if it had not been blocked at each step by the ineptness and ignominies of the present social order."

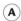

In addition to supplying drawings for anarchist papers and periodicals, the anarchist-artist could contribute to the cause by depicting class differences and the conditions of industrialism. Virtually all of the NEO-IMPRESSIONISTS—including Henri Edmond Cross, Lucien Pissarro, Théo van Rysselberghe, and Paul Signac—embraced such programmatic goals, as did the artists Kees van Dongen, Camille Pissarro, and Maurice de Vlaminck. Many Parisian SYMBOLIST artists—and DADAISTS and SURREALISTS after them—were also anarchists, although their activism was expressed in public demonstrations of principle rather than in artworks. Perhaps the most interesting example of anarchist content in MODERN art was Pablo Picasso's use in many of his COLLAGES produced between 1912 and 1914 of newspaper clippings from leftist publications detailing the events leading up to World War I and the anarchist response to them. Undoubtedly the most active anarchist in the art world was the influential critic Félix Fénéon, who in 1894 was acquitted of murdering the French president, Sadi Carnot, in the famous trial of the Trente (Thirty).

Commentators of all political persuasions frequently discussed modern art as if it were exclusively an offspring of radical politics. The comment by Charles Vezin, president of the Art Students League, about the ARMORY SHOW was typical: "There rest under the same blanket (or rather, toss feverishly) anarchists, terrorists, degenerates, rowdies, scavengers, dreamers, poets, liberators and patriots."

ANDROGYNY

Androgyny, also known as hermaphrodism, is the union of male and female sexual characteristics in one individual. The idea of human nature as androgynous dates back at least as far as Plato's *Symposium*. Androgynous characters appeared frequently in mid-nineteenth-century French novels, the best known being the cross-dressing protagonists of Théophile Gautier's *Mademoiselle de Maupin* and of Honoré de Balzac's *Séraphita,* both published in 1835. Rigid definitions of male and female roles were also challenged by the gender-blurring behavior of female artists. Some, such as the pseudonymous novelist George Sand, obscured their public identities as women to neutralize the impact of gender on the reception of their work. Those who preferred to wear men's clothes, including the REALIST painter Rosa Bonheur, were forced to secure official permits in order to do so.

The nineteenth-century interest in androgyny, as well as in the FEMME FATALE and the DANDY, reflected changing conceptions of gender in industrial society. But androgyny also had a SPIRITUAL dimension in its use as a symbol

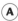
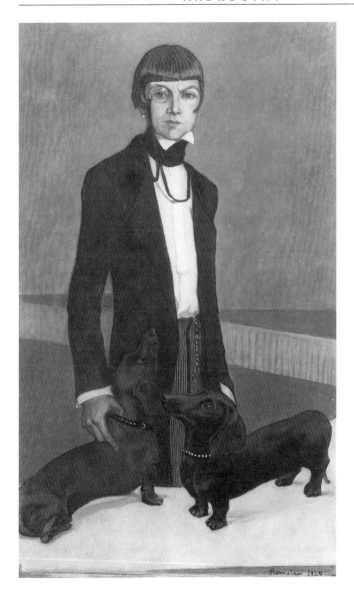

ROMAINE BROOKS (1874–1970).
Una, Lady Troubridge, 1924. Oil on canvas, 50 1/8 x 30 1/8 in.
(127.3 x 76.5 cm). National Museum of American Art, Smithsonian
Institution, Washington, D.C.

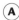

of unity in many Eastern religions and the Western occult traditions. Madame Helena P. Blavatsky, founder of the extraordinarily influential Theosophical Society, referred to androgyny many times in her writings; the prolific Rosicrucian writer Joséphin Péladan wrote a book called *The Gynander* (1891), in which he suggested that the most fully developed artistic natures were androgynous.

Péladan was also the organizer of the Rosicrucian SALON, held in Paris between 1892 and 1897, which showcased visionary SYMBOLIST works. Among those exhibiting paintings containing androgynous figures—a languorous, effeminate Orpheus was especially popular—were Gustave Moreau, Jean Delville, and Fernand Khnopff. Their works, in turn, recall the androgynous figure-types of NEOCLASSICISM, PRE-RAPHAELITISM, and the paintings of Pierre Puvis de Chavannes. Had Péladan known the sexually ambiguous drawings by the English artist Aubrey Beardsley, they too might have been exhibited at the Salon de la Rose + Croix.

Around the time of World War I the DADAIST Marcel Duchamp created a number of pieces that reflected his reading about the spiritual aspects of androgyny. He assumed a female persona named Rrose Sélavy (thought to be a pun for "Eros, c'est la vie"), who was photographed by Man Ray and appeared in well-known artworks by Duchamp and others. A few years later, other artists put androgyny to more confrontational uses. Romaine Brooks's engaging portraits of women in male garb are unapologetic announcements of her sitters' lesbian sexuality. They provide an intriguing contrast with the Mexican SURREALIST painter Frida Kahlo's meditation about gender and power—an iconic self-portrait in a mannish suit and a close-cropped haircut (see page 105).

The renewal of interest in androgyny and gender during the nineteenth century also relates to that era's passion for classification. The 1890s saw the notorious Oscar Wilde trial, which first codified homosexual identity as opposed to homosexual activity, and the publication of much of Charles Darwin's writing about evolution, which gave rise to dangerous notions about eugenics that would later inspire the Nazi attempt to liquidate Jews, homosexuals, and other "undesirables."

ARMORY SHOW

The International Exhibition of Modern Art—known as the Armory Show—was presented in New York's Sixty-ninth Regiment Armory between February 17 and March 15, 1913. One of the most spectacular cultural events in twentieth-century history, the controversial show of approximately twelve hundred works was seen by more than 400,000 people in New York, Boston, and Chicago. (Students at Chicago's School of the Art Institute burned the exhibitors Henri Matisse and Constantin Brancusi in effigy.) The show's artist-organizers were Walt Kuhn, Walter Pach, and Arthur B. Davies—one of THE EIGHT and a surprisingly successful mediator between the ACADEMIC and AVANT-GARDE factions. As planning for the exhibition progressed, its focus became increasingly European and modernist—an unexpected development not welcomed by most of the American participants.

The show was originated to compete with the annual exhibitions at New York's National Academy of Design, but it quickly grew into a historical survey of modern art reminiscent of the Sonderbund exhibition, which Kuhn and Pach visited in Cologne in 1912. (The better-selected Sonderbund was more calmly received because it was seen in the context of an avant-garde milieu then lacking in the United States.) The Armory Show's sometimes spotty presentation effectively showcased IMPRESSIONISM, NEO-IMPRESSIONISM, POST-IMPRESSIONISM, SYMBOLISM, FAUVISM, and CUBISM, while virtually ignoring German EXPRESSIONISM, FUTURISM, and modern sculpture. Very few of the hundreds of American paintings and sculptures on view could be considered modern and fewer still could rival the quality of their more sophisticated European counterparts.

The Armory Show generated plaudits and pans of unprecedented vehemence. Even former President Theodore Roosevelt turned critic, unfavorably comparing Marcel Duchamp's *Nude Descending a Staircase* (1912) to a Navajo blanket. If the extensive media coverage revealed the philistinism of American audiences, it also implied their interest. The effect of the show on the public is difficult to gauge, but it was a beacon of inspiration to American artists, including Stuart Davis, Man Ray, and Joseph Stella; and to American collectors of modern art such as Walter Arensberg, Lillie P. Bliss, and John Quinn.

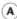
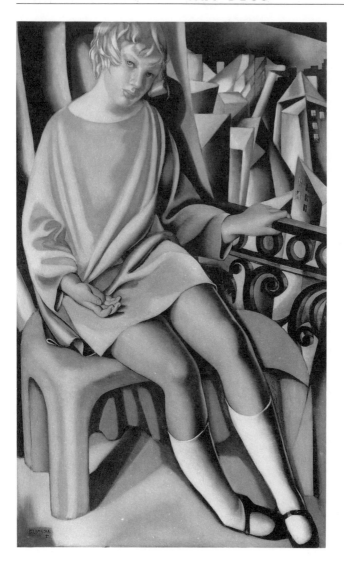

TAMARA DE LEMPICKA (1898–1980).
Kizette on the Balcony, 1927. Oil on canvas, 31 13/16 x 11 13/16 in.
(80.8 x 30 cm). Musée National d'Art Moderne, Centre Georges
Pompidou, Paris.

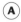

ART DECO

▷ **WHO** Norman Bel Geddes (United States), Pierre Chareau (France), Clarice Cliff (Great Britain), Donald DESKEY (United States), Raymond Hood (United States), René LALIQUE (France), Maurice MARINOT (France), Robert MALLET-STEVENS (France), Timothy PFLEUGER (United States), Hans Poelzig (Germany), Armand Albert Rateau (France), Jacques Emile RUHLMANN (France)

▷ **WHEN** 1918 to 1939

▷ **WHERE** Europe and the United States

▷ **WHAT** Art Deco derives its name from *L'Exposition internationale des arts décoratifs et industriels modernes,* an exhibition held in Paris in 1925. During the period between the world wars, Art Deco was the predominant STYLE in the decorative arts, associated largely with mass-produced domestic goods, apparel, and graphic design rather than with architecture or art. (A few exceptions are William Van Alen's Chrysler Building in New York and paintings by Tamara de Lempicka.)

An exuberantly eclectic blend, Art Deco incorporates the abstraction and fragmentation of ART NOUVEAU and CUBISM, the angular ornamentation of Southeast Asian and Mayan architecture, and the stripped-down, architectural geometry of DE STIJL and Frank Lloyd Wright. Art Deco's fashionably streamlined fusion of these elements became the style of choice for the modern marvels that transformed kitchens and parlors after World War I. The most treasured achievements of Art Deco include the exquisitely inlaid furniture of Jacques Emile Ruhlmann and the fantastic interiors of movie palaces by Timothy Pfleuger, but Art Deco is epitomized not by its one-of-a-kind objects but by its mass-produced ones. The image of machine age efficiency—rather than the reality—motivated Art Deco designers, who prettified and popularized the severely modern designs of De Stijl and the BAUHAUS. A late phase of Art Deco is, in fact, known as *moderne.*

Until the wave of enthusiasm for them that began during the 1960s, virtually all Art Deco wares were dismissed from the outset as junk or kitsch. The Art Deco era marks the coming-of-age of the product designer, whose job was to entice consumers with up-to-date-looking goods.

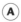

ART FOR ART'S SAKE

The phrase "art for art's sake" ("*l'art pour l'art*" in French) was coined by the French philosopher Victor Cousin in 1818. It referred to the belief that art need serve no moral or social purpose, or—as the American painter James McNeill Whistler put it later in the century—that art "should stand alone and appeal to the artistic sense of eye and ear without confounding this with emotions entirely foreign to it, as devotion, pity, love, patriotism and the like." The opposite of art for art's sake is SOCIAL REALISM.

Art for art's sake ultimately derives from the eighteenth-century German philosopher Immanuel Kant, whose conviction that art was to be judged by its own standards was taken up by such French critics of the mid-nine-teenth century as Théophile Gautier. The most complete expression of the attitude is the SYMBOLIST artist's withdrawal from the world in pursuit of a subjective, even mystical, vision. The NABI artist Maurice Denis's dictum that "a picture—before being a war horse, a female nude, or some anecdote— is essentially a flat surface covered with colors assembled in a particular order" translated that subjectivity into formal terms.

The reaction against art for art's sake came swiftly. Three years after the Revolutions of 1848, the writer Charles Baudelaire damned *"l'art pour l'art"* as a "puerile utopia" and proclaimed that art was "hitherto inseparable from morality and utility." The mid-nineteenth-century English philosopher and critic John Ruskin (and his ARTS AND CRAFTS MOVEMENT followers) deplored artists out of touch with everyday life and attacked Whistler specifically, accusing the artist of "flinging a pot of paint in the public's face" with the painting *Nocturne in Black and Gold: The Falling Rocket* (1874). (Whistler sued for libel in 1877 and collected one farthing in damages.) Ruskin's char-acteristically English puritanism was countered by the exaggerated cult of beauty and aestheticism that sprang up in London during the last quarter of the nineteenth century among second-generation PRE-RAPHAELITE painters, the writer Oscar Wilde, and the artist Aubrey Beardsley. Their attitude was known as Aestheticism, and its exemplars were sometimes referred to as Aesthetics or even Decadents.

Such extremes are, however, rather rare. Although the history of MODERN art is populated by both adherents to and detractors of art for art's sake, its pro-ponents' view that art should be judged on its own terms and that it requires no extra-aesthetic justification has become increasingly widespread during the twentieth century.

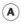

ART NOUVEAU

▷ **WHO** Walter Crane (Great Britain), Luis Doménech y Montaner (Spain), August Endell (Germany), Emile Gallé (France), Antonio Gaudí (Spain), Hector Guimard (France), Josef Hoffmann (Austria), Victor Horta (Belgium), René Lalique (France), Charles Rennie Mackintosh (Great Britain), Arthur H. Mackmurdo (Great Britain), Koloman Moser (Austria), Joseph Maria Olbrich (Austria), Giuseppe Sommaruga (Italy), Louis Sullivan (United States), Louis Comfort Tiffany (United States), Eugène Vallin (France), Henry van de Velde (Belgium), Charles F. Voysey (Great Britain), René Wiener (France)

▷ **WHEN** 1880 to 1914

▷ **WHERE** Europe and the United States

▷ **WHAT** S. Bing's shop L'Art Nouveau (the New Art), which opened in Paris in 1895, is the source of the name for this distinctive STYLE of late nineteenth-century architecture, design, and art. The style itself, however, originated more than a decade earlier, and by the end of the century it boasted a multitude of names: in Germany it was known as *Jugendstil* (named after the journal *Die Jugend,* meaning "youth"); in Italy, as *Stile Liberty* (after the London department store that printed and retailed Art Nouveau fabrics); in Spain, as *Modernista;* and in Austria, as *Sezessionstil* (SECESSION style). What these names share is their apt evocation of the self-consciously new and modern.

Art Nouveau works are characterized by the use of organic imagery, emphasis on sinuous line, and union of ornament and structure. Examples range from Josef Hoffmann's luxurious Palais Stoclet in Brussels, adorned with Gustav Klimt's sensuous mosaics, to Hector Guimard's cast-iron entrances to the Paris Métro, which seem to radiate from underground. On a smaller scale, the flora and fauna portrayed in stained glass by Louis Comfort Tiffany contrast sharply with the severe geometry of Charles Rennie Mackintosh's angular, elongated chairs. The efficacy of these two approaches—the depiction of natural forms versus their stylization into ABSTRACTIONS—was widely debated. The latter approach helped pave the way for the geometric abstraction of twentieth-century art and design. The organic imagery of Art Nouveau became popular at precisely the moment when damage caused by industrialization began to threaten the European landscape.

Art Nouveau's radical accomplishment was its rejection of the ACADEMIC revivalism that dominated nineteenth-century art and design. Its sources are nonetheless eclectic: elements from the slightly earlier British ARTS AND CRAFTS MOVEMENT, SYMBOLISM, and JAPONISME were seasoned with dashes of the

past dating back to ancient Egypt and eighteenth-century rococo. An erotic undercurrent is also common. It frequently took the form of a coupling between nature and the feminine "principle," in contrast to the association of masculinity with the creation of Western culture.

Art Nouveau is a term usually applied only to design and architecture, but it is impossible to understand art by Aubrey Beardsley, Paul Gauguin, Gustav Klimt (see page 24), Edvard Munch, and Henri de Toulouse-Lautrec, among many others, without taking it into account.

See FEMME FATALE

ARTS AND CRAFTS MOVEMENT

▷ **WHO** (All from Great Britain) Charles R. ASHBEE, Walter Crane, William R. Lethaby, Arthur Mackmurdo, William MORRIS, Norman SHAW, Charles F. Voysey, Philip WEBB

▷ **WHEN** 1861 to 1914

▷ **WHERE** Great Britain

▷ **WHAT** Although its name can be traced only as far back as the Arts and Crafts Exhibition Society, founded in 1888, the Arts and Crafts movement was inspired by the mid-nineteenth-century writings of the philosopher and critic John Ruskin. Damning the social and artistic effects of industrialization, Ruskin advocated the organization of medieval-style guilds that would ensure high standards of design in handicrafts and decent standards of living for workers. (Several guilds were founded in Great Britain during the 1880s, including the Century Guild, the Art Workers' Guild, and the Guild of Handicraft.) The Arts and Crafts movement was an ambitious attempt to reassert the aesthetic and spiritual importance of the handmade in a society suddenly awash in the shoddy, mechanically produced goods that signaled the arrival of the machine age.

The charismatic reformer and designer William Morris translated Ruskin's utopian, sometimes nostalgic theories into practice. In 1861 he founded Morris and Co. with the architect Philip Webb and the PRE-RAPHAELITE painters Ford Madox Brown, Edward Burne-Jones, and Dante Gabriel Rossetti. The London-based firm produced medieval-looking textiles, stained glass, wallpaper, and heavy oak furniture. Although exceedingly handsome, the products made by Morris and Co. were expensive and therefore never reached the mass audience for which they were intended. The firm's furni-

ture and accessories established the sturdy, rough-hewn STYLE that has come to be associated with the Arts and Crafts movement, and its textiles and wallpapers decisively influenced the development of ART NOUVEAU.

The Arts and Crafts movement was not only a style; it was a world view. It advocated the establishment of universal education, philanthropic institutions such as settlement houses, and varied—rather than numbingly repetitive—labor. Such humane ideas quickly spread from England to other industrialized nations. In the United States they were disseminated during the second half of the 1890s by the publishers and craftsmen Elbert Hubbard and Gustav Stickley. Arts and crafts societies formed in major cities, starting in Boston, and dozens of potteries and crafts colonies sprang up, which sometimes took the form of utopian communities. American artists, architects, and designers such as Charles and Henry Greene, John La Farge, Lucia and Arthur Mathews, George Ohr, and Louis Comfort Tiffany embraced the egalitarian vision of Arts and Crafts.

The Arts and Crafts philosophy also inspired the founding of crafts workshops as far afield as the Wiener Werkstätte, in Vienna, and educational institutions as geographically dispersed as the Cranbrook Academy in Bloomfield Hills, Michigan, and the BAUHAUS in Weimar, Germany. The curricula of these influential art schools incorporated both the Arts and Crafts discipline-spanning approach to designing a total environment and Morris's belief that a work of art might also be functional.

ARTISTS BOOKS—*see* BOOK ART

ASH CAN SCHOOL—*see* THE EIGHT

ASSOCIACION DE ARTE CONSTRUCTIVO—*see* ABSTRACTION-CREATION

ASSEMBLAGE

The three-dimensional counterpart of COLLAGE, assemblage similarly traces its origin to Pablo Picasso. In 1912 he created the first assemblage—his sheet-metal-and-wire *Guitar*—a year before the DADA artist Marcel Duchamp attached a bicycle wheel to a stool and called it an Altered READYMADE. Known simply as "objects," assemblages remained otherwise unnamed until the 1961 exhibition *The Art of Assemblage*, which was organized by Peter Selz and William Seitz for the Museum of Modern Art, New York.

ASSEMBLAGE

MERET OPPENHEIM (1913–1985).
Object, 1936. Fur-covered cup, saucer, and spoon; cup diameter:
4 3/8 in. (11.1 cm); saucer diameter: 9 3/8 in. (23.8 cm); spoon length:
8 in. (20.3 cm); overall height: 2 7/8 in. (7.3 cm). Collection, The Museum
of Modern Art, New York; Purchase.

Assemblage—a technique, not a STYLE—involves the transformation of nonart objects and materials into sculpture by techniques such as gluing or welding. This radically new way of making sculpture through combining or constructing rejected the traditional practices of carving stone or modeling a shape to be cast in bronze.

Although Picasso originated assemblage in order to investigate the representation of three-dimensional objects in his Cubist paintings, the use of nonart elements or even junk from the real world often gives assemblages a disturbing rawness. Dada artists shocked viewers with works such as *God* (1918), by the American Morton Schamberg, which consisted only of a U-shaped plumbing pipe mounted on a miter box; SURREALIST artists mined the potential of enigmatic juxtapositions of FOUND OBJECTS.

AUTOMATIC ART—*see* SURREALISM

AUTOMATISM—*see* SURREALISM

AVANT-GARDE—*see* MODERN/MODERNISM

BARBIZON SCHOOL

▷ **WHO** (All from France) Camille COROT, Charles François Daubigny, Narcisse Virgile Diaz, Jules Dupré, Charles Emile Jacque, Jean François MILLET, Théodore ROUSSEAU, Constant Troyon

▷ **WHEN** 1830 through 1860

▷ **WHERE** France

▷ **WHAT** The village of Barbizon in the forest of Fontainebleau, thirty miles southeast of Paris, gave its name to a group of French painters led by Théodore Rousseau. Fleeing the hectic pace and unremitting squalor of the French capital, they sought arcadian calm in an unremarkable stretch of weedy marshes and dense underbrush. "Homer and Virgil wouldn't have disdained sitting there to muse over their poetry," Jean François Millet observed of the local scene. But such romanticism—also apparent in the atmospheric, often twilight, illumination that pervades Barbizon School paintings—was coupled with a radical NATURALISM inspired by contemporary English landscape art. Landscapists like John Constable and Richard Parkes

Bonington took Paris by storm during the 1820s—thirty British paintings, including Constable's *Hay Wain* (1821), were shown at the Salon of 1824. Such work provided an Anglo-Dutch alternative, based on close observation and humble subject matter, to the Mediterranean tradition of the noble land-scape based on classical literary sources, which was prevalent in France.

Like their British counterparts, the Barbizon School painters would usually sketch out of doors but return to their studios to paint. After mid-century, however, direct studies from nature or the human figure were increasingly exhibited. The gap separating the study from the finished picture narrowed until, during the 1860s, IMPRESSIONIST painters exhibited works painted entirely *en plein air*. Rousseau pioneered many of the techniques for paint-ing out of doors that were employed by later artists. He invented a special easel on which paper could be stretched and constructed lean-tos from which he could observe and paint.

Barbizon School images of thatched-roof huts, unpeopled forests, and peas-ants tending cattle evoked what some considered a still-viable agrarian way of living that contrasted sharply with an urban existence seen as largely unnatural. The dark, melancholic paintings by Barbizon School artists—including Millet's fatalistic portrayals of heroic peasants—constitute one of the first manifestations of the nostalgic, back-to-the-land sentiment so familiar today. This approach influenced painters in Germany—especially those associated with NATURLYRISMUS—as well North America.

BAUHAUS

The Bauhaus school of art, craft, and design was founded by the architect Walter Gropius in Weimar, Germany, in 1919. Its name—loosely "building house"—reflects its origins in the socialist thinking of the ARTS AND CRAFTS MOVEMENT. Unlike that earlier attempt to reinvigorate crafts production, how-ever, the Bauhaus's program eventually embraced industrial technology. This was in part a legacy of Gropius's close connections with the Deutscher Werkbund, an association of German artists and crafts firms founded in 1907 to advocate the adoption of mass production. Gropius and other artists asso-ciated with the Bauhaus had also been members of the Novembergruppe, a leftist organization formed in 1918 (and disbanded in 1924) to promote closer contact between the public and progressive artists, in part through the cre-ation of the Arbeitsrat für Kunst (Workers' Councils for Art), in 1919.

The Bauhaus, which incorporated the two royal schools of arts and crafts in Weimar, was also the product of ongoing attempts to upgrade applied-art

LASZLO MOHOLY-NAGY (1895–1946).
Light Space Modulator, 1923–30. Kinetic sculpture of steel, plastic, wood, and other materials with electric motor, 59 1/2 x 27 1/2 x 27 1/2 in. (151.1 x 69.9 x 69.9 cm). The Busch-Reisinger Museum, Harvard University, Cambridge, Massachusetts; Gift of Sibyl Moholy-Nagy.

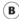

education in Germany. Founded at a moment of extreme political instability in Germany, the period between the world wars, the Bauhaus initially offered its students a resolutely anti-ACADEMIC but nostalgic curriculum intended to "embrace architecture and sculpture and painting in one unity." Devised by the charismatic and mystical Swiss artist Johannes Itten, it united the CONSTRUCTIVIST interest in modern materials with EXPRESSIONISM and SPIRI-TUALISM. The Bauhaus masters constituted a stellar group of artists and designers from northern Europe and Russia, including Josef Albers, Herbert Bayer, Marcel Breuer, Theo van Doesburg, Lyonel Feininger, Wassily Kandinsky, Paul Klee, El Lissitzky, Gerhard Marcks, László Moholy-Nagy, Oskar Schlemmer, and Gunta Stölzl.

In 1923, under the increasing influence of the DE STIJL artist van Doesburg and the pressure of a worsening economy, Gropius rejected the handcraft orien-tation of the original program in favor of an alliance between craft design and industrial production. Itten resigned and was replaced by László Moholy-Nagy, who brought with him the latest Russian Constructivist think-ing imported, in part, from the Vkhutemas (Higher Technical and Artistic Studios) of the Soviet Union. The new orientation toward industrial produc-tion and functionalism was also linked to the objective detachment of the NEUE SACHLICHKEIT movement in painting. The emblem of this shift was the new Gropius-designed Bauhaus campus in the inhospitable city of Dessau, completed in 1926. Housed in sleekly modern glass-and-steel buildings, the school now had the credo "Art and technology, a new unity."

During the decade between the adoption of Moholy-Nagy's curriculum and the closing of the Bauhaus by the Nazis in 1933 (its final director was the architect Ludwig Mies van der Rohe), some of the most revolutionary—and now familiar—designs of the twentieth century were produced. They include: tubular steel furniture by Breuer, typography by Bayer and Moholy-Nagy, functional ceramic forms by Marcks, and woven tapestries by Stölzl. The other accomplishments of Bauhaus faculty members have tended to get short shrift because the image of the Bauhaus as an incubator of industrial design has obscured the output of faculty members who were not primarily designers. Worthy of mention are Moholy-Nagy's experiments in abstract film, photography, and sculpture, and Oskar Schlemmer's brilliant avant-garde theater and dance performances, as well as the paintings of Klee, Kandinsky, and Feininger.

Even though few products of any kind were being manufactured in the hyperinflationary economy of Germany during the 1920s, Bauhaus designs became widely known through the school's aggressive publishing program.

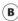

Bauhaus achievements were also disseminated through the international dispersal of its faculty, whose leftist views attracted Hitler's ire and forced their emigration from Germany during the mid-1930s. Moholy-Nagy founded the New Bauhaus (now the Institute of Design of the Illinois Institute of Technology) in Chicago in 1937, Josef Albers took his investigations of color theory first to Black Mountain College in North Carolina and then to Yale, and the architecture schools of Harvard and the Institute of Design in Ulm, Germany, adopted Bauhaus methods, to cite just a few examples.

BIENNIAL EXHIBITIONS—*see* SALON

BIOMORPHISM—*see* ABSTRACT/ABSTRACTION

BLAUE REITER—*see* DER BLAUE REITER

BLAUEN VIER—*see* DER BLAUE REITER

BLOOMSBURY GROUP

▷ **WHO** (All from Great Britain) Clive Bell, Vanessa Bell, Roger FRY, Duncan Grant (along with the writers E. M. Forster, Maynard Keynes, Desmond MacCarthy, Lytton Strachey, Leonard Woolf, Virginia Woolf)

▷ **WHEN** 1906 to 1918

▷ **WHERE** England

▷ **WHAT** The Bloomsbury Group was an informal association of writers, artists, and critics that took its name from the location in London of houses owned by Virginia Stephen (Woolf) and Vanessa Stephen (Bell). The bonds among the group originated in student friendships formed by the male writers at Cambridge at the turn of the century and were later strengthened by shared interests and a tangle of romantic relationships. Together these accomplished individuals played a decisive role in introducing MODERN literature and art to Great Britain.

The key figure within the group's art circle was the critic and curator Roger Fry, who was converted to modern art in 1906 by an encounter with paintings by Paul Cézanne. Fry organized two influential shows of POST-IMPRESSION-

VANESSA BELL (1879–1961).
Bathers in a Landscape, 1913. Gouache on paper, 70 1/4 x 82 in.
(178.4 x 208.3 cm). Victoria and Albert Museum, London.

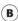

IST art at Grafton Galleries in London in 1910 and 1912; and along with Clive Bell he pioneered a new and radically modern critical approach known as FORMALISM. Paintings made by Bell, Vanessa Bell, Duncan Grant, and Fry reveal the influence of Cézanne's weighty figures, FAUVISM'S vivid hues and simplified compositions, and CUBISM'S fragmentation.

In 1913 the group began to apply this aesthetic to functional handmade forms—expensive furniture, rugs, tableware, and so on—produced by the Omega Workshops. A curious amalgam of the idealistic socialism of the ARTS AND CRAFTS MOVEMENT and chic AESTHETICISM, the workshop was founded by Fry with the help of the Bloomsbury artists and the financial assistance of the playwright George Bernard Shaw. The Omega Workshops folded in 1919, a casualty of World War I, when little income was available for nonessentials. Ironically, British taste seemed finally to be modernizing at that point: along with VORTICISM, the Bloomsbury Group can be considered largely responsible for undermining England's Francophobic antimodernism during the period between the wars.

BLUE FOUR—*see* DER BLAUE REITER

BLUE RIDER—*see* DER BLAUE REITER

BOOK ART

Artists have long been associated with literature. One-of-a-kind medieval manuscripts were invariably illustrated with elaborately painted letters and pictures; Renaissance painting itself is thought to have evolved from this tradition of manuscript illumination. Following Johannes Gutenberg's invention of movable type during the fifteenth century, a new breed of illustrated didactic and scientific books began to be produced; it was not until the nineteenth century that many works of fiction were illustrated.

The French term *livre d'artiste* (artist's book) is often used to describe literary works produced in limited editions and illustrated with original prints by well-known painters or sculptors (as opposed to illustrators). Before the nineteenth century the difficulties of producing metal-engraved plates for printing meant that it was primarily artist-printmakers, such as Rembrandt, who devoted much attention to illustrating books. The development of simpler printmaking techniques—LITHOGRAPHY in particular—encouraged the flowering of the *livre d'artiste* during the second quarter of the nineteenth

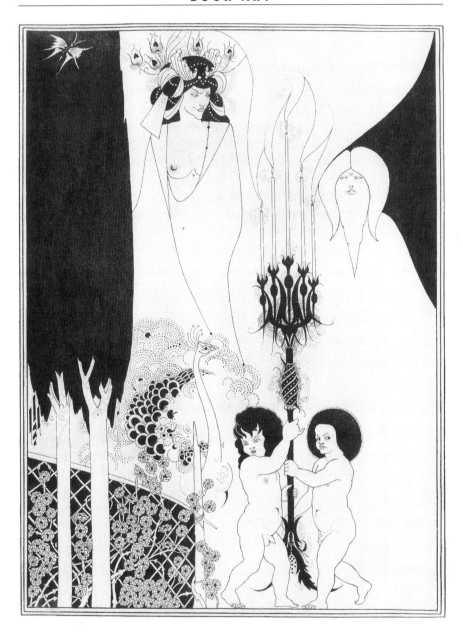

AUBREY BEARDSLEY (1872–1898).
The Eyes of Herod, 1893. Illustration for *Salome,* 1894. Pen, brush, and black ink with traces of graphite on white paper, 9 x 6 11/16 in. (22.9 x 16.9 cm). The Fogg Art Museum, Harvard University, Cambridge, Massachusetts; Bequest of Grenville L. Winthrop.

century. A landmark of that era, published in 1828, was the ROMANTIC artist Eugène Delacroix's illustrated version of *Faust,* by Johann Wolfgang von Goethe, a project that coupled the greatest painter and the greatest writer of an era that worshiped genius.

From then on, historical and contemporary writings alike were suitable material for the expensive *livre d'artiste,* resulting in notable turn-of-the-century works such as Henri Matisse's etchings for the poems of Stéphane Mallarmé and André Derain's woodcuts for Guillaume Apollinaire's novel *L'Enchanteur pourrissant.* The popularity of the *livre d'artiste* was astonishingly widespread. Among the artists who created images for such volumes were Jean Arp, Aubrey Beardsley, Hans Bellmer, Emile Bernard, Pierre Bonnard, Georges Braque, Marc Chagall, Jean Cocteau, Honoré Daumier, Sonia Delaunay, Maurice Denis, Kees van Dongen, Raoul Dufy, Max Ernst, Leonor Fini, Eric Gill, Natalia Goncharova and Mikhail Larionov, Juan Gris, Paul Klee, Fernand Léger, Aristide Maillol, Edouard Manet, Joan Miró, Paul Nash, Pablo Picasso, Odilon Redon, Auguste Rodin, Georges Rouault, Max Slevogt, and Jacques Villon. That this roster of artists is dominated by SCHOOL OF PARIS painters reflects the close alliance between French art and literary movements—including Romanticism, SYMBOLISM, and SURREALISM—and the unstinting commitment to book art by French fine-art publishers such as Ambroise Vollard.

Artists were also central to the development of other aspects of book art. In England, William Morris established Kelmscott Press, which simultaneously spread the ideals of the ARTS AND CRAFTS MOVEMENT and stimulated the development of new typefaces and the production of high-quality books. This emphasis on fine craftsmanship set a high standard for the development of ART NOUVEAU type and binding designs, which were pioneered by Henry van de Velde and the virtuoso craftsman René Wiener. The utilitarian bent of Russian CONSTRUCTIVISM found expression in new designs for books and type, which were carried to the BAUHAUS by artists such as El Lissitzky. There they formed the point of departure for László Moholy-Nagy and Herbert Bayer, whose designs still infuse contemporary book production.

BRIDGE—see DIE BRÜCKE

BRÜCKE—see DIE BRÜCKE

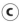

CALOTYPE

The calotype was invented in 1840 by the Englishman William Henry Fox Talbot. The term, which refers both to the process and to the resulting photographic print, derives from the Greek for "beautiful picture." Although Talbot had been beaten in the international race to develop an effective photographic process by Louis Jacques Mandé Daguerre, inventor of the DAGUERREOTYPE, the calotype ultimately proved more significant. Unlike the daguerreotype process, which yielded a unique metal plate, the calotype produced a paper negative from which virtually unlimited numbers of photographic prints could be reproduced, making possible the use of photography in publishing. Even more important, the underlying principle of the calotype—the notion of a latent image made visible through a development process—proved central to later advances in photographic technology. The calotype, however, had a fatal flaw—its intrusively grainy texture—and by 1860 it had been supplanted by the glass-plate negative.

CAMDEN TOWN GROUP—*see* VORTICISM

CERCLE ET CARRE—*see* ABSTRACTION-CREATION

CLOISONISM—*see* SYMBOLISM

COLLAGE

The term *collage* comes from the French verb *coller* (to glue). In English it is both a verb and a noun: *to collage* is to affix papers or objects to a two-dimensional surface, thus creating a collage. Collage is a technique, not a STYLE.

Pablo Picasso produced the first high-art collage, *Still Life with Chair Caning*, in 1912, when he glued onto his canvas a real piece of oilcloth printed with a pattern of woven chair caning. By doing that instead of painting the pattern directly on his canvas, he blurred the distinction between reality and illusion in art. A few months later he and Georges Braque invented a type of collage known as *papiers collés* (cut papers), which refers to collages made entirely of paper elements affixed to a support.

After World War I, DADA artists incorporated debris from the street into their gritty and sometimes poetic collages; a few years later SURREALIST artists cre-

COLLAGE

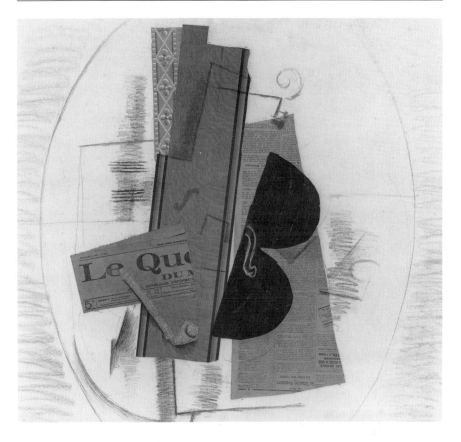

GEORGES BRAQUE (1882–1963).
Violin and Pipe: "Le Quotidien," 1913–14. Charcoal, chalk, and pasted paper on paper, 29 1/8 x 41 3/4 in. (74 x 106 cm). Musée National d'Art Moderne, Centre Georges Pompidou, Paris.

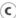
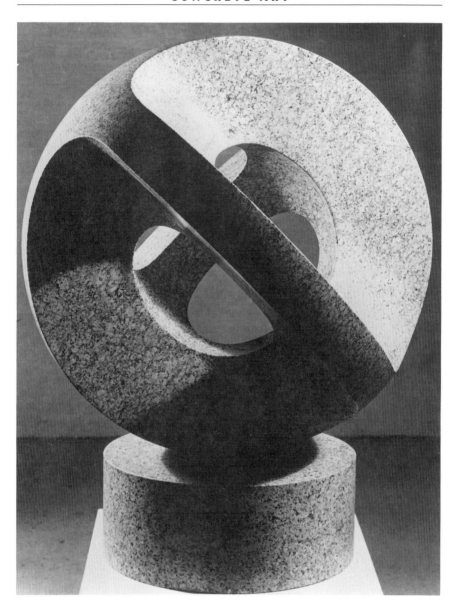

MAX BILL (b. 1908).
Construction, 1937 (executed 1962). Granite, height: 39 in. (99 cm).
Hirshhorn Museum and Sculpture Garden, Smithsonian Institution,
Washington, D.C.; Gift of Joseph H. Hirshhorn, 1966.

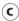

ated collages that expressed their more psychologically attuned sensibilities. German Dada artists including George Grosz, Raoul Hausmann, John Heartfield, and Hannah Höch invented a collage technique, known as *photomontage*, that recombines snippets of photographs into new compositions. With it they created some of the most biting political commentaries in twentieth-century art.

See ASSEMBLAGE

CONCRETE ART

▷ **WHO** Josef ALBERS (Germany), Max BILL (Switzerland), Jean Dewasne (France), Theo van DOESBURG (Netherlands), Lucio Fontana (Italy), Richard Paul Lohse (Switzerland), Alberto Magnelli (Italy), Helio Oiticica (Brazil)

▷ **WHEN** 1930s through 1950s

▷ **WHERE** Western Europe, primarily, and the United States

▷ **WHAT** The term *Concrete art* first appeared in print in Theo van Doesburg's "Manifesto of Concrete Art," which was published in the sole issue of the magazine *Art concret,* in 1930. He invoked it to describe ABSTRACT art that was based not in nature but in geometry and in the visual properties of art itself—color and form, in the case of painting; volume and contour in sculpture. The term became popular through the proselytizing of the artist Josef Albers, who emigrated from Germany to the United States in 1933, and of his student at the BAUHAUS Max Bill, who first applied the term to his own work in 1936.

In Concrete art an appearance of objectivity is sought: the artist's personal touch is so smoothed over that the results may appear to have been made by machine. Yet individual works still vary, from the mathematically precise compositions by Richard Paul Lohse, which anticipated Op art of the 1960s, to Max Bill's three-dimensional abstractions, which sometimes refer to the principles of physics and aerodynamics. During the 1930s Concrete art was shown at exhibitions by the ABSTRACTION-CREATION group in Paris and by the American Abstract Artists group in New York. Bill organized the first international exhibition of Concrete art in Basel in 1944.

Concrete art slipped from public view during the 1950s, but van Doesburg's notion of art emancipated from nature—that is, an artwork valued as an independent object that does not refer to social concerns or to the artist's emotions—would prove essential to postwar art making.

CONSTRUCTIVISM

▷ **WHO** (All from Russia) Ilya Chashnik, Alexandra Exter, Naum GABO, El Lissitzky, Antoine Pevsner, Lyubov Popova, Aleksandr RODCHENKO, Olga Rozanova, Varvara Stepanova, Vladimir TATLIN, Aleksandr Vesnin

▷ **WHEN** 1913 through 1920s

▷ **WHERE** The USSR

▷ **WHAT** The term *Constructivism* emerged in 1921—just before the movement itself began to decline—from debates about the purpose of art stimulated by Naum Gabo and Antoine Pevsner's "Realistic Manifesto" (1920). Like the similarly utopian DE STIJL artists, the Constructivists came to reject conventional easel painting and the idea of ART FOR ART'S SAKE in favor of utilitarian designs intended for mass production. *Constructivism* is now often used, inaccurately, to describe virtually any ABSTRACT sculpture constructed of geometric elements.

Ironically, Constructivist abstraction found its sources in the nonutilitarian art of Kazimir Malevich and Pablo Picasso. With SUPREMATISM, Malevich reduced painting to its geometric fundamentals in abstractions inspired by technological marvels such as the airplane and the telegraph. In 1912 Picasso created his first "construction," or ASSEMBLAGE—a sheet-metal-and-wire guitar in which the angular forms of his paintings and COLLAGES were translated into three dimensions.

After Vladimir Tatlin saw such works in Picasso's Paris studio in 1913, he returned home to Moscow and began to construct his Counter-reliefs—abstract assemblages of industrial metal, wire, and wood that were among the first total abstractions in the history of sculpture. Embodying what Tatlin called "real space" (as opposed to pictorial space), the Counter-reliefs were often hung from wires that projected into the gallery. This emphasis on space, rather than the traditional sculptural concern for mass, made them revolutionary. (Sculptors had previously manipulated mass by the subtractive methods of carving wood or stone or by the additive means of building up clay or modeling plaster.) Tatlin also formulated the influential Constructivist principle of "truth to materials," which asserted that certain intrinsic properties make cylinders the most appropriate shape for metal, flat planes the best for wood, and so on.

Many constructions, such as Tatlin's model for the 1,300-foot-high *Monument to the Third International* (1919), are prototypes for architectural, stage, or industrial designs. Others, influenced by Malevich's abstractions,

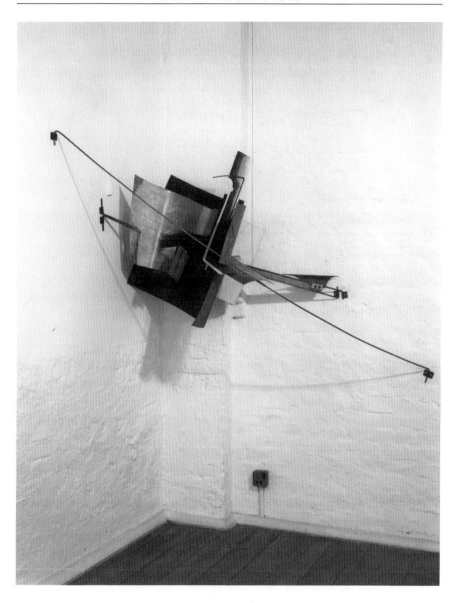

VLADIMIR TATLIN (1885–1953).
Complex Corner Relief, 1915 (reconstructed by Martyn Chalk, 1979).
Iron, zinc, aluminum, wood, and paint, 31 x 60 x 31 in. (78.7 x 152.4 x
78.7 cm). Courtesy Annely Juda Fine Art, London.

are purely abstract and nonfunctional objects but look as though they serve some purpose—such as Aleksandr Rodchenko's KINETIC SCULPTURES that seem to anticipate molecular models. Works like Rodchenko's represent—and celebrate—scientific rationality and the technology of the machine age.

After the Bolshevik Revolution of 1917 the Constructivist artists gained political power. Dissension between those interested in a more personal art (sometimes known as Utopians) and those concerned with making utilitarian designs for the masses (known as Utilitarians or Productivists) soon split the group. As the political climate changed in the early 1920s—first in favor of the Productivists, then in opposition to any avant-garde experimentation at all—Gabo, Pevsner, the painter Wassily Kandinsky, and others moved to the West. Some went to Germany's technologically oriented BAUHAUS school of art and design, ensuring the spread of Constructivist principles throughout Europe and later the United States.

Constructivism marked the end of the brilliant flowering of the Russian avant-garde that had begun around the turn of the century with the WORLD OF ART. In 1925 the Communist Party's Central Committee came out against abstraction; in 1932 all cultural groups were disbanded; and in 1934 a new propagandistic style of SOCIAL REALISM became the Soviet Union's only officially sanctioned artistic approach.

CONTENT

Every work of art ever produced has content, or meaning. Analyzing the content of an artwork requires the consideration of subject, form, material, technique, sources, socio-historical context, and the artist's intention (though the artist's interpretation of the work may differ from the viewer's).

There are two widely held misconceptions about content. First, that it is the same as subject. In fact the subject of a work is just one part of its content. An artist depicts a landscape or a figure, for example, and that is the work's subject. The subject can usually be identified by sight, whereas the content requires interpretation. Often that interpretation takes into account factors that are invisible in the work, such as the expectations of the patron who commissioned the work or art historical precedents. The content of a landscape might be divine benevolence or industrial society's destructive impulses toward the planet. The content of a portrait might range from the glorification of the sitter's social standing to the artist's sexual objectification of the model.

The second common misconception about content is that it is the opposite of form—which includes size, shape, texture, material, brushwork, etc. In effective artworks form and content reinforce one another. For instance, the idea of the fleeting nature of the depicted moment is embodied in the sketchy visible brushwork of IMPRESSIONIST paintings. Loving warmth between a mother and child is conveyed by the invitingly sensuous, apparently hand-modeled surface of a sculpture by Henry Moore.

See ICONOGRAPHY

CUBISM

▷ **WHO** (All from France, unless otherwise noted) Alexander Archipenko, Georges BRAQUE, Albert Gleizes, Juan GRIS (Spain), Jacques LIPCHITZ, Jean Metzinger, Pablo PICASSO

▷ **WHEN** 1908 to 1918

▷ **WHERE** France

▷ **WHAT** *Cubism*—yet another of the disparaging names scornfully applied to a MODERN art movement by a critic—was coined in 1908 by Louis Vauxcelles after hearing Henri Matisse refer to a painting by Georges Braque as nothing but "little cubes."

Jointly pioneered by Braque and Pablo Picasso, Cubism daringly abandoned the five-hundred-year-old system of perspective and the related conventions for representing reality that had become synonymous with painting in the West. Illusionism—the convincing depiction of nature—was jettisoned for a more conceptual approach that regarded painting less as a window onto the world than as a subjective response to the world. Cubism was a new visual language, fragmented, simultaneously disintegrating and re-forming. According to some commentators, it was a sort of visual analogue for then-current discoveries of the molecular subdivision of matter, relativity, and the SPACE-TIME CONTINUUM. Picasso and Braque considered their work "realistic" (that is, intellectually and emotionally truthful) and rejected complete ABSTRACTION as a solution to the problem of visually communicating the essence of modern life.

Three elements shaped Cubism's development: fascination with the abstract forms of "PRIMITIVE" sculpture from Africa, Oceania, and Iberia; a belief in the expressive power—the inner "truth"—of "primitive" sculpture and the art of the NAIVE painter Henri Rousseau; and most important, the structural rela-

tionships in the paintings of Paul Cézanne. By 1907 Picasso had incorporated images of African masks into works like his famous *Demoiselles d'Avignon* (1907), and Braque was painting Cézannesque landscapes. Their collaboration began in 1909, with a STYLE that became known as Analytic Cubism.

The characteristic early Analytic Cubist painting is a still life or portrait rendered in muted shades of green, gray, or brown, whose subject is depicted as if seen from several angles at once. The difficult-to-discern subject and the space surrounding it are broken into interlocking facets. The use of low-key color and traditional subject matter functioned to neutralize those variables so that the emphasis could be on investigating the structure. Picasso and Braque collaborated, as Braque put it, "like two mountain climbers roped together," and their Cubist works are sometimes indistinguishable.

By 1912 the reductive limits of Analytic Cubism had been reached in oval canvases with nearly invisible subjects. Picasso and then Braque began to develop and enrich the austere vocabulary of Cubism through a variety of technical inventions that tested the traditional boundaries between reality and illusion. They added stenciling and lettering; created ASSEMBLAGE and COLLAGE (snippets of newspapers physically incorporated into the works provide a visual diary); and used vibrant color in their works of 1912 to 1914, which are now known as Synthetic Cubism (see page 28).

World War I put an end to the Cubist experiment. Although Cubism was the most influential of all modern art movements, apart from Picasso and Braque only the Spaniard Juan Gris fully understood its meaning and methods. Lack of understanding did not, however, deter legions of artists throughout Europe, Russia, and the United States from seizing on Cubism's indisputable look of modernity by 1912. Cubism was also the basis of other movements that took its fractured visual language as their departure point, including FUTURISM in Italy, CUBO-FUTURISM in Russia, the SKUPINA VÝTVARNÝCH UMĚLCŮ in Prague, and ORPHISM and the art of the PUTEAUX GROUP in Paris. Picasso's sheet-metal-and-wire guitar constructions of 1912 also inspired CONSTRUCTIVIST sculpture in Moscow. Among the most talented of the Cubist sculptors were the French artists Alexander Archipenko, Raymond Duchamp-Villon, Jacques Lipchitz, and Picasso himself. It is no exaggeration to say that between 1909 and 1918 Cubism dominated the production of avant-garde art in locations as farflung as Moscow and New York.

CUBO-FUTURISM

▷ **WHO** (All from Russia) Natalia GONCHAROVA, Mikhail LARIONOV, Kazimir MALEVICH, Lyubov POPOVA, Olga Rozanova

▷ **WHEN** 1913 to 1914

▷ **WHERE** Moscow and Saint Petersburg

▷ **WHAT** Kazimir Malevich first applied the term *Cubo-Futurism* to his own paintings in the *Target* exhibition held in Moscow in 1913. Cubo-Futurist works embody NEO-PRIMITIVIST subjects—derived from Russian icons, folk art, and children's art—in a superficially Cubist and Futurist style that sets tubular forms against geometric backgrounds, evoking a mechanical paradise akin to contemporaneous works by the French painter Fernand Léger. Cubo-Futurism's odd amalgam of Russian and Western elements marks the end of Russian artists' interpretations of modern art emanating from the West that began a few years earlier with Neo-Primitivism and Rayonism.

Closely linked with Russian writers and musicians in Moscow's vibrant AVANT-GARDE circles, Cubo-Futurist painters produced book designs as well as the experimental opera *Victory over the Sun* (1913)—a collaborative production for which Malevich designed the abstract sets and costumes that foretold SUPREMATISM.

DADA

▷ **WHO** Jean (Hans) Arp (Germany), Hugo Ball (Germany), Arthur Cravan (France), Marcel DUCHAMP (France), Max ERNST (Germany), George Grosz (Germany), Raoul Hausmann (Germany), John Heartfield (Germany), Emmy Hennings (Germany), Hannah Höch (Germany), Marcel Janco (Rumania), Francis PICABIA (France), Man Ray (United States), Hans Richter (Germany), Morton Schamberg (United States), Kurt SCHWITTERS (Germany), Sophie Taeuber (Switzerland)

▷ **WHEN** 1915 to 1923

▷ **WHERE** New York and Western Europe

▷ **WHAT** *Dada* means a variety of things in a variety of languages, including "hobbyhorse" in French and "yes, yes" in Slavic tongues. One version of the name's origin has it that in Zürich in 1916 the Rumanian poet Tristan Tzara stuck a penknife in a dictionary at random and it landed on the nonsensical-sounding term.

Dada sprang up during and immediately after World War I, first in the neutral cities of Zürich, New York, and Barcelona; later in Berlin, Cologne, and Paris. It was largely a response to the tragic toll—more than ten million dead—exacted by the "Great War." That the new machine-age technology could wreak such havoc made many wonder whether the price for modernity's material benefits was too high. The Dada artists blamed society's supposedly rational forces of scientific and technological development for bringing European civilization to the brink of self-destruction. They responded with art that was anything but rational: simultaneously absurd and playful, confrontational and nihilistic, intuitive and emotive.

Dada, then, is not a STYLE, or even a number of styles, but a world view. Nor were its attitudes embodied only in artworks. Active as citizen-provocateurs, rather than studio-bound producers of objects, Dada artists organized incendiary public events frequently inspired by earlier FUTURIST examples. Rabble-rousing mixed-media programs involving puppets, robotic costumes, and "Negro" music were staged by Jean Arp, Hugo Ball, Marcel Janco, Sophie Taeuber, and others at Zürich's Cabaret Voltaire. George Grosz stalked the streets of Berlin dressed as Dada Death in a gorilla costume.

Dada art objects were also made, but they tended to have unconventional forms produced by unorthodox means. Exploiting the chance results of accident was a favorite Dada modus operandi. Arp dropped torn papers to create COLLAGES "arranged according to the laws of chance." Duchamp's cerebral pursuit of quasi-philosophical inquiries led to inventions such as the READY-MADE. Raoul Hausmann, Man Ray, and Morton Schamberg fashioned threatening ASSEMBLAGES from everyday objects, such as *Gift* (1921), Man Ray's iron with nails studded down its face. The German Dadaists, including Hannah Höch and John Heartfield, invented the photographic collage, or photomontage; Kurt Schwitters made collages from rubbish and debris. Many Dadaists experimented with automatic drawing—a sort of pictorial free association—in order to escape the limits of conscious control.

All of these approaches assaulted traditional notions of what art should be, and Dada artworks were aptly dubbed *anti-art*. Although their critical stance toward bourgeois society is characteristic of MODERN art, the Dada artists were the most virulent of the modernists in their rejection of middle-class morality. It was the aggression as well as the absurdity of their art that enraged many viewers.

After World War I the centers of Dada activity shifted to Cologne and Berlin, where Dadaists briefly joined forces with the political left. By 1921 Dada as an

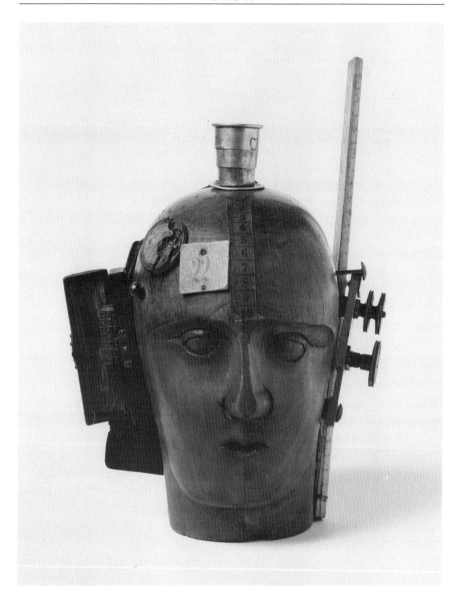

RAOUL HAUSMANN (1886–1971).
The Spirit of Our Time, 1921. Assemblage, height: 12 3/4 in. (32.4 cm).
Musée National d'Art Moderne, Centre Georges Pompidou, Paris.

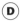

organized movement was confined to Paris, where its ideas—and many of the Dadaists themselves—proved instrumental in the emergence of SURREAL-ISM. Dada gestures and iconoclasm would prove central to post–World War II art, especially Neo-Dada and Conceptual art. Today Duchamp is revered as one of the most influential artists of the twentieth century.

See MERZ

DAGUERREOTYPE

Daguerreotype is the name both of the earliest popular photographic process and of the photographic plate on which the resulting image is fixed. Its inventor was the French painter Louis Jacques Mandé Daguerre, who in 1839 was granted an annuity from the French government in return for the right to market the invention. The intense international competition to develop a viable photographic technology—the term *photographie* had been coined by the inventor Hercules Florence before 1837—is reminiscent of the Soviet-American space race of the 1950s and '60s. Daguerre had a serious rival in the Englishman William Henry Fox Talbot, but the international success of Daguerre's process was assured by the active assistance of the French government in promoting his invention.

Daguerreotypes were initially expensive, and both lengthy exposure time and bright light were required for an image to be recorded on their silver plates. This made the virtually one-of-a-kind images—on metal, not paper—best suited to depicting architectural monuments. Better camera lenses and more light-sensitive plates soon yielded a process suitable for portraiture. By 1853 New York City boasted eighty-six portrait "galleries" (which really were studios), and millions of portrait daguerreotypes were being taken around the world each year. Although popular, the daguerreotype had many drawbacks: it was fragile, expensive, and difficult to duplicate. By 1860 it had been replaced by the calotype and had entered the annals of photographic history.

See CALOTYPE

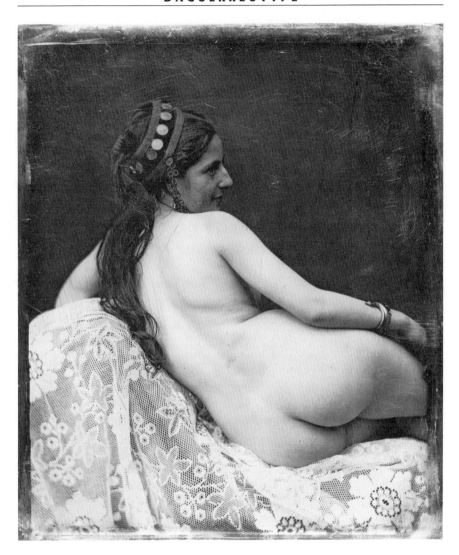

PHOTOGRAPHER UNKNOWN.
Académie—Image of Odalisque Seen from Rear, c. 1845.
Daguerreotype, 1/6th plate: 2 15/16 x 2 7/16 in. (7.4 x 6.1 cm).
International Museum of Photography at George Eastman House,
Rochester, New York.

DANDYISM

The concept of the dandy emerged in London during the first quarter of the nineteenth century. Initially it probably referred to Beau Brummell, an Englishman famous for his supremely fashionable dress and exquisite manners. It soon became associated not just with dress and manners but with a system of values that prized artificiality, self-consciousness, and a disdain for bourgeois proprieties—expressed through satirical wit, intellectual skepticism, and a withdrawal from conventional politics. Dandyism both rejected the traditional idea that art imitates nature and the high-minded, if paternalistic, charitable preoccupations of the Victorian era. Its emphasis on amorality, play, and art offered an escape from the social problems caused by the squalid new world of industrialism.

Beginning with mid-nineteenth-century PRE-RAPHAELITISM in England and IMPRESSIONISM in France, the term *dandy* became linked with the idea of ART FOR ART'S SAKE. The height of dandyism in art occurred at the end of the nineteenth century, when some artists and writers began to see themselves as a virtual extension of their art—or, as the art historian Moira Roth characterized Marcel Duchamp, "a self-readymade." Detachment, irony, and artifice characterized their efforts. The mannered poses and brittle wit of the circle surrounding the writer Oscar Wilde and the artist Aubrey Beardsley in London constitute one example; another is the antibourgeois excesses perpetrated by the gun-toting absurdist performer and writer Alfred Jarry in Paris—abetted by the artists Pierre Bonnard, Pablo Picasso (who learned to tote a gun from Jarry), Paul Sérusier, Henri de Toulouse-Lautrec, and Edouard Vuillard.

Dandyism is an attitude rather than a STYLE, and can be considered the opposite of both EXPRESSIONISM and SOCIAL REALISM. Though not always visible in artworks animated by it, dandyism was manifested most visibly in the art produced by many of the DADAISTS in Zürich and New York, especially Hugo Ball, Arthur Cravan, Marcel Duchamp, Emmy Hennings, and Francis Picabia. Much of Duchamp's sly and pranksterish output can be seen as evidence of his dandyism, from attaching a shocking pun to a reproduction of the Mona Lisa to having photographs taken of himself as a woman or showing only the back of his head, adorned with a haircut in the shape of a star.

In the face of catastrophic social problems, the apolitical stance of the dandy fell into disfavor in Germany during the 1920s and in the rest of Europe and the United States during the 1930s. Dandyism's legacy in MODERN art was a

sense of often-narcissistic playfulness that challenged the traditional under-standing of art making as an invariably serious endeavor.

DECADENTS—*see* ART FOR ART'S SAKE

DECALCOMANIA—*see* SURREALISM

DEGENERATE ART—*see* NAZI ART

DE STIJL

▷ **WHO** (From the Netherlands unless otherwise noted) Theo van DOESBURG, Bart van der Leck, Piet MONDRIAN, Gerrit RIETVELD, Georges Vantongerloo (Belgium)

▷ **WHEN** 1917 to 1931

▷ **WHERE** The Netherlands

▷ **WHAT** De Stijl was an important movement in art, architecture, and design that was launched in Leiden by the artist Theo van Doesburg in 1917, along with a periodical of the same name. *De Stijl* means "The Style" (rather than "*a* style") in Dutch, and its finality refers to the utopian belief that absolute artistic purity was within reach of its creators. A now infrequently used syn-onym for De Stijl is the once-favored *Neo-Plasticism,* which is also the title of a pamphlet written in 1920 by the group's elder statesman, Piet Mondrian.

The austere De Stijl aesthetic rejected both the visual world of the senses and the subjectivity of the individual artist. Entirely ABSTRACT, the STYLE per-mitted only the straight line, the right angle, and the three primary colors red, blue, and yellow, augmented by white, black, and gray. Despite the ostensibly rational, back-to-basics appearance of De Stijl abstractions, they were the product of extremely complex, and sometimes self-contradictory, SPIRITUAL and intellectual concerns.

The most vital influences on the group were the American architect Frank Lloyd Wright and, more important, the Dutch mathematician and Theosophist M.H.J. Schoenmaekers. The former offered a liberating vision of a pragmatically designed world, while the latter posited a "universal con-sciousness"—in the mystical argot of the day. Portions of Schoenmaekers's

New Image of the World (1915) read like a De Stijl MANIFESTO: "The two funda-mental, complete contraries which shape our earth are: the horizontal line of power, that is the course of the earth around the sun, and the vertical, pro-foundly spatial movement of rays that originates in the center of the sun." This analysis of the universal meaning of orthogonal lines—those intersect-ing at right angles—strongly affected Mondrian, who had been using them since 1914 and whose quest for an "equivalence of opposites" was a metaphor for the spiritual unity of humanity and the universe.

Mondrian's gridded paintings and the architect Gerrit Rietveld's 1917 wooden chair (see page 34) are among the best known De Stijl artworks. Rietveld's pioneering use of primary colors and his translation of Neo-Plastic geometry into a functional three-dimensional object furthered the De Stijl aim of inventing a new artistic language with applications so broad that they would help achieve the fusion of art and life. Such idealistic ambitions are compa-rable to those of the Russian CONSTRUCTIVISTS, who were simultaneously work-ing in World War I—enforced isolation.

After World War I, Mondrian continued to pursue his artistic investigation of the spiritually transforming effects of Neo-Plasticism on the human charac-ter, while van Doesburg took advantage of the renewed opportunities for international travel. In 1921 he visited the BAUHAUS in Weimar, Germany, and initiated a several-years-long relationship with the school. He was eventu-ally hired as a master there, ensuring the dissemination of De Stijl ideas about geometric abstraction in painting, sculpture, and design.

In the mid-1920s van Doesburg modified Mondrian's system of verticals and horizontals. His introduction of diagonals—a development that he dubbed Elementarism—prompted Mondrian's departure from De Stijl in 1925 and marked the beginning of the end of the movement as an organized body.

DER BLAUE REITER

▷ **WHO** Heinrich Campendonk (Germany), Lyonel Feininger (United States), Alexey von Jawlensky (Russia), Wassily KANDINSKY (Russia), Paul Klee (Switzerland), Auguste Macke (Germany), Franz MARC (Germany), Gabriele Münter (Germany)

▷ **WHEN** 1911 to 1914

▷ **WHERE** Munich

▷ **WHAT** *Der Blaue Reiter,* which means "The Blue Rider," was first used by the Russian artist Wassily Kandinsky for the title of a 1903 painting. After he and a group of artists including Franz Marc and Gabriele Münter broke away from the Munich-based Neue Künstlervereinigung (New Artists' Association) in 1911, they adopted the enigmatic name for their new group and its almanac, which they published from 1912 to 1914.

The artistic program of Der Blaue Reiter was extremely loose: it can be categorized in general terms as SPIRITUAL, EXPRESSIONISTIC, and tending toward the ABSTRACT. Various approaches to representation were pursued in order to evoke nonvisual phenomena and sensations. Marc's horses, vibrantly colored and abstracted, embodied his pantheistic beliefs. Kandinsky's calligraphic abstractions—among the first completely abstract paintings—reflected the ideas contained in his influential book *On the Spiritual in Art,* which was published in 1912.

The first Blaue Reiter exhibition opened at the Galerie Thannhauser in Munich in December 1911. Forty-three works were shown, by an international roster of artists that ranged from the Russian FUTURISTS David and Vladimir Burliuk to the French ORPHIST Robert Delaunay. The eclectic internationalism of the group and its predilection for abstraction distinguish it from DIE BRÜCKE, the other well-known artists' association linked with German Expressionism. The most vital exemplar of the new spiritually oriented abstraction, Der Blaue Reiter was ended by World War I. The group disbanded at the outset of war in 1914, and Auguste Macke and Marc were soon killed at the front.

The spiritualism of Der Blaue Reiter resurfaced at the BAUHAUS, where Kandinsky, Paul Klee, and Lyonel Feininger all became masters. The three of them—plus Alexey von Jawlensky—founded another artists' association in 1924, known as the Die Blauen Vier or Blue Four (a name intended to recall Der Blaue Reiter). The group was formed at the instigation of the art patron Galka Scheyer, as a way to help the artists support themselves; she organized traveling exhibitions and lecture tours for them in the United States, Germany, and Mexico between 1925 and 1934. Scheyer's extensive collection of their work is now owned by the Norton Simon Museum in Pasadena, California.

DEUTSCHER WERKBUND—*see* BAUHAUS, *FILM UND PHOTO*

DIE BRÜCKE

▷ **WHO** (All from Germany) Fritz Bleyl, Erich Heckel, Ernst Ludwig KIRCHNER, Otto Müller, Emil NOLDE, Max Pechstein, Karl SCHMIDT-ROTTLUFF

▷ **WHEN** 1905 to 1913

▷ **WHERE** Germany

▷ **WHAT** In English, Die Brücke—the name of an association of German painters founded in Dresden in 1905—means "The Bridge." It was coined by Karl Schmidt-Rottluff to signify both the connections among revolutionary elements and the role of their work as a bridge toward some loosely defined art of the future. In addition to Schmidt-Rottluff, the other founders of Die Brücke were Fritz Bleyl, Erich Heckel, and Ernst Ludwig Kirchner.

These four young artists, who had met as architecture students, regarded themselves as freedom-loving, antibourgeois revolutionaries intent on creating an egalitarian utopia through their art. To express authentic, impassioned feeling they rejected the IMPRESSIONISM and sentimental REALISM that dominated German art in favor of a primitivizing aesthetic that fused raw-looking medieval woodcuts; NATURLYRISMUS; Oceanic and African art; the ARTS AND CRAFTS MOVEMENT; and the EXPRESSIONISM of Edvard Munch, Vincent van Gogh, and the French FAUVES.

Die Brücke is often considered the German equivalent of the Fauves. Artists of both movements shared interests in PRIMITIVIST art; the expression of high-keyed emotion through brilliant, nondescriptive color and crude drawing; and an antipathy to complete ABSTRACTION. The Die Brücke artists' emotionally violent paintings of city streets and hotly colored, sexual images of young men and women cavorting in the countryside make the canvases of their French counterparts appear relatively tame.

Die Brücke quickly expanded to include such German artists as Emil Nolde and Max Pechstein as well as foreign artists—really supporters more than active members—such as the Finn Akseli Gallén-Kallela and the Fauve Kees van Dongen. Starting at the end of 1906, the association mounted several exhibitions that scandalized relatively conservative Dresden. In 1910 the founders of the group moved to Berlin, where many of them joined the recently formed New Secession. They soon left this breakaway organization

to form, in turn, the Künstler-Gruppe Brücke. Personal rivalries proved divisive, and a year after participating in the second Blaue Reiter exhibition, in 1912, this last group disbanded over Kirchner's controversial chronicle of Die Brücke's history.

Die Brücke's accomplishments were profound. In addition to creating genuinely disturbing paintings, the artists pioneered the twentieth-century rediscovery of the woodblock print and produced aggressively carved wooden sculpture (see page 27). The controversy their unruly art engendered helped bring AVANT-GARDE art to the attention of wider audiences in Northeastern Germany. That the term *expressionism* has become virtually synonymous with early twentieth-century German art is largely their doing.

DIVISIONISM—*see* NEO-IMPRESSIONISM

DOCUMENTARY PHOTOGRAPHY

Almost every photograph is a document—or record—of people, places, or objects. However, there is a subset of photography known as documentary photography, which belongs to a loosely defined tradition within STRAIGHT PHOTOGRAPHY that originated at the beginning of the twentieth century. Documentary photographers have consciously (and unsuccessfully) attempted to ignore artistic concerns in order to more forcefully advocate social change or to enhance the sense of objectivity in their work. Although the styles of individual documentarians vary, they have shared a tendency toward the straightforward and the dignified understatement, and they have tended to work in series of pictures that allow for the development of an explicit point of view about their subjects.

Some have depicted the downtrodden in images that are the photographic equivalent of investigative reporting in journalism or SOCIAL REALISM in painting. Among the best known of such photographers is the American Lewis Hine, whose turn-of-the-century pictures of slum dwellers helped prompt the passage of labor laws prohibiting the exploitation of children. Other documentarians have created almost anthropological or archaeological records, such as the German photographer August Sander's remarkable studies of members of diverse social classes and Eugène Atget's luminous photographs of a disappearing, premodern Paris. Many documentary projects have chal-

lenged the status quo, reflecting the individual passions—and financial commitments—of their creators.

See FEDERAL ART PROJECT

DYNAMISM—*see* FUTURISM

ECOLE DE PARIS—*see* SCHOOL OF PARIS

THE EIGHT

▷ **WHO** (All from the United States) Arthur B. Davies, William Glackens, Robert HENRI, Ernest Lawson, George Luks, Maurice Prendergast, Everett Shinn, John Sloan

▷ **WHEN** 1900 to 1910

▷ **WHERE** New York

▷ **WHAT** The Eight was the first formally constituted group of American artists to make their shared purpose the creation of a native style that reflected American experience. Robert Henri (pronounced HEN-rye)—along with his four "disciples" (all former newspaper illustrators) William Glackens, George Luks, Everett Shinn, and John Sloan—attempted to take on New York's conservative National Academy of Design by painting images of gritty urban streets and working-class haunts. Although imbued with the humanistic spirit of social reform and far from ACADEMIC, their paintings were rather tame compared to those by their European REALIST role models such as Edouard Manet.

After having their work rejected by the jurors for the National Academy's 1907 spring exhibition—Henri was one of the jurors but even his paintings were not well received—the five artists organized their own show at New York's Macbeth Gallery in February 1908; the show subsequently traveled to eight other cities in the United States. The five were joined in the show by the painters Arthur B. Davies, Ernest Lawson, and Maurice Prendergast, and the group called themselves The Eight. They were later dubbed the Ash Can School—a term popularized by Holger Cahill's book and radio program *Art in America* (1934)—because of the grimy urban subjects that critics most

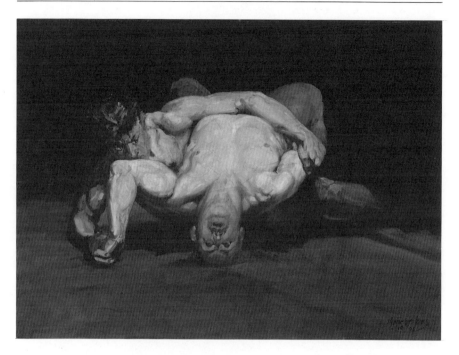

GEORGE LUKS (1867–1933).
The Wrestlers, 1905. Oil on canvas, 48 1/4 x 66 1/4 in. (122.5 x 168.3 cm).
The Hayden Collection; Courtesy, Museum of Fine Arts, Boston.

objected to in their work. But that tag never fit the art of the three newcomers and was often irrelevant to that of the original five as well. The eclecticism of their artistic approaches offered a precedent for independent American exhibitions, such as the *Exhibition of Independent Artists* (1910), the ARMORY SHOW (1913), and the Society of Independent Artists exhibition (1917), which were privately financed and selected largely on the basis of artistic nonconformity.

The Eight's modestly successful exhibition at the Macbeth Gallery is often seen as a milestone in the development of an American AVANT-GARDE. In fact, it says more about the weakness of the Academy than about the strength of the avant-garde. Two years later Henri established his own art school, where he taught the realists George Bellows and Edward Hopper, and some of the first American modernists, including Stanton Macdonald-Wright and Stuart Davis. Ironically, by the time of the Armory Show Henri had already become an establishment voice loudly opposed to avant-garde AESTHETICISM.

ELEMENTARISM—*see* DE STIJL

EMPATHY—*see* ABSTRACT/ABSTRACTION

EUSTON ROAD GROUP—*see* REALISM

EXHIBITION I—*see* ABSTRACTION-CREATION

EXQUISITE CORPSE—*see* SURREALISM

EXPRESSIONISM

The origins of the term *expressionism* are unclear. It appeared in a number of isolated references to painting and literature during the second half of the nineteenth century; the obscure painter Julien Auguste Hervé called his pictures *Expressionnismes* during the first decade of the twentieth century. Whatever its roots, its meaning is clear: Expressionism refers to art that puts a premium on expressing emotions. Artists communicate emotion by distorting color or shape or surface or space in a highly personal way.

The "opposite" of expressionism is IMPRESSIONISM, with its quasi-scientific emphasis on capturing fleeting perceptions, such as the appearance of light on a cathedral facade at a specific time of day. Like ABSTRACTION and representation, expressionism and Impressionism are not diametric opposites so much as two ends of a spectrum along which most artworks are positioned.

The adjective *expressionist* is used to describe artworks from any historical era that emphasize emotion (unlike the adjective *Impressionist,* which is used only in connection with the Impressionist movement of the late nineteenth century). The noun *expressionism* is usually, but not exclusively, associated with MODERN art, although not with any one movement or group of artists. There have been several expressionist movements; their names are modified with an adjective, as in German Expressionism, or given another name entirely, such as the FAUVES. The art associated with them may be either representational or abstract.

Modern expressionism is usually traced back to the works of James Ensor, Paul Gauguin, and Vincent van Gogh (see page 20)—members of the POST-IMPRESSIONIST generation of the 1880s, whose idiosyncratic choices of colors were intended to evoke feeling rather than to describe nature. Modern movements with an expressionist bent include the NABIS, Fauvism, German Expressionism, FUTURISM, and Abstract Expressionism, a STYLE that followed World War II.

In Western society the public regards modern art chiefly as a vehicle for releasing emotion. Despite that widely held view, the current of modern art's mainstream has tended to regularly shift between art emphasizing rational thought and art emphasizing feeling.

See DIE BRÜCKE

FASCIST ART

In its most precise sense, *fascist art* refers to the art officially sanctioned by the right-wing dictator Benito Mussolini (known as Il Duce—"the leader"), who rose to power in Italy in 1922. Although there is a tendency to equate avant-garde MODERNISM with leftism, Mussolini's support for avant-gardism and the Soviet dictator Josef Stalin's rejection of it suggest that such an equation is too simplistic.

For Mussolini, modern art symbolized a cultural renewal that would parallel the political renewal promised by fascism. He made common cause with the FUTURISTS—whose bellicosity, antifeminism, glorification of technology, and

understanding of propaganda techniques made them natural allies of Il
Duce—and with the Novecento Italiano movement (the Italian Twentieth
Century). Founded in 1922, this group of diverse artists including Carlo Carrà
and Marino Marini had no clear artistic objectives, espousing only a nation-
alistic interest in early Renaissance art—an interest they derived from SCUOLA
METAFISICA painting. Their chauvinism helped make members of the
Novecento Italiano pawns of the increasingly conservative fine arts ministry
during the 1930s; the group was finally dissolved in 1943.

Mussolini's program of self-glorification led to numerous Futurist portraits of
him in two and three dimensions that were shown at various Venice
Biennales, the prestigious biannual exhibitions of international art. His
architectural ambitions were even greater and were intended to culminate in
the Esposizione Universale di Roma (EUR), or Rome world's fair, which was
planned for 1942 but never held—although architecturally flaccid buildings
such as the Palace of Italian Civilization were completed on a site near
Rome. One fully realized emblem of the regime's vision was the *Mostra della
Rivoluzione Fascista* (Exhibition of the Fascist Revolution), a cultural fair
held in 1932 to commemorate ten years of Mussolini's rule. For that event a
sleek, ART DECO—style building in Rome was filled with up-to-date looking
murals and sculptures depicting the triumphs of Fascism, by artists such as
the Futurist painter Enrico Prampolini and the Novecento sculptor Marini.

See NAZI ART

FAUVISM

▷ **WHO** (All from France) Georges Braque, André DERAIN, Raoul Dufy, Othon
Friesz, Henri Manguin, Albert Marquet, Henri MATISSE, Jean Puy, Maurice de
VLAMINCK

▷ **WHEN** 1903 to 1908

▷ **WHERE** France

▷ **WHAT** The Fauves were named by the art critic Louis Vauxcelles in his
review of the 1905 Salon d'Automne for the Parisian journal *Gil Blas*.
"Donatello au milieu des fauves!" (Donatello among the wild beasts!), he
quipped about a gallery displaying a Renaissance-inspired sculpture sur-
rounded by the brilliantly colored canvases of André Derain, Henri Matisse,
and Maurice de Vlaminck. The Fauves were a loose-knit group of friends
rather than a cohesive, MANIFESTO-writing association, and by 1908 their
artistic paths had largely diverged.

Fauvist paintings are chiefly known for their violently contrasting, nonde-scriptive color. Matisse, for example, depicted his wife with a green stripe down her face. The Fauves combined EXPRESSIONISM's high-key color and emotional force with IMPRESSIONISM's devotion to images of contemporary life. Although their portrait, still-life, and landscape subjects (see page 26) were staples of late nineteenth-century painting, they rejected SYMBOLISM's literary content and fin-de-siècle melancholy in favor of a radical return to the fundamentals of painting—the organization of color and form on a two-dimensional surface. Slashing brush strokes and thickly outlined patches of unmodulated color created an effect of expressive power that became a crucial element in the ABSTRACT work of the SCHOOL OF PARIS and, especially, in German Expressionism.

FEDERAL ART PROJECT

During the Depression of the 1930s the U.S. government instituted a program designed to employ artists. First came the Public Works of Art Project (PWAP), which lasted only from December 1933 to June 1934. It was success-ful enough to encourage the Franklin D. Roosevelt administration to launch the Federal Art Project (FAP), under the auspices of the Works Progress Administration (WPA), a year later. Directed by Holger Cahill, the FAP had a mandate that went beyond creating work for artists to include art education and documentation of the United States' cultural heritage, especially in rural areas. One important FAP project was the Index of American Design: an archive of twenty-three thousand hand-drawn images of decorative and applied art now housed in the National Gallery of Art in Washington, D.C. By the time of its dissolution in 1943, the FAP had employed ten thousand artists, who created nearly 150,000 artworks, including 2,500 murals.

Unlike any other enterprise in American history, the FAP put qualified artists directly on the federal payroll and in return demanded only that their works be submitted to the government for use in public buildings. This subsistence salary of approximately twenty dollars per week enabled many artists—the painters Arshile Gorky, Jackson Pollock, and Ben Shahn among them—to spend more time in their studios, developing their personal styles. By making no distinction between representational and nonrepresentational art, the program supported (more or less by default) those artists inclined toward ABSTRACTION, a type of work frequently regarded as suspiciously foreign and hence virtually unsalable during the 1930s and '40s.

The federal government also created other Depression-era programs that are often incorrectly attributed to the Federal Art Project. The best known is the

Historical Division of the Farm Security Administration (FSA), which in 1935 instituted a project to document in photographs the shocking poverty in rural communities. Walker Evans, Dorothea Lange, Gordon Parks, and Marion Post Wolcott were among the accomplished FSA photographers whose 70,000 negatives on file in the Library of Congress constitute one of the greatest records of its kind.

By 1939 the WPA art projects were coming under increasingly heavy attack from members of the press and Congress who feared that artists would use their government-sponsored freedom to organize labor unions or produce communist propaganda. The United States' entry into World War II led to the formal end of the project in 1943.

FEMME FATALE

A *femme fatale* (literally, "deadly woman") is a woman whose voracious sexuality makes her the destroyer of innocent manhood. This stereotype, which permeated Western art during the last quarter of the nineteenth century, mirrored widespread anxiety about changing gender roles as the economically tight-knit family unit of preindustrial society was displaced by industrialization and urbanization. Change generated backlash; the emergence of the first wave of feminism was quickly followed by assaults on contraception and so-called pornography (such as photographs of scantily clad women). In the cultural arena, anxiety about gender roles surfaced not just in the visual arts but also in plays and novels that offered a variety of perspectives on what was then called the women's question, by writers such as Anton Chekhov, Charles Dickens, Fyodor Dostoyevsky, George Eliot, Gustave Flaubert, Thomas Hardy, Henrik Ibsen, Henry James, George Bernard Shaw, August Strindberg, and Edith Wharton.

The notion of the femme fatale was preceded by its virtual opposite: the early-and-mid-nineteenth-century ideal of the Victorian woman as a saint who would make her home a spiritual retreat for her husband. She was typically depicted as a madonna, as the martyred Saint Cecilia or Saint Elizabeth, as the drowned Ophelia; and in other sexless or enervated roles. In the 1870s Victorian woman's sexuality was again generally acknowledged—by artists and writers, among others—and the pendulum swung from the saint to the femme fatale. At one point in the pendulum's arc, the Victorian woman, at least as portrayed in art, moved from the sacred precincts of the home out into the forest and field. Madonna became Mother Nature—wild, fertile, a bit of a pagan. Images of women depicted nude in nature pervaded late nine-

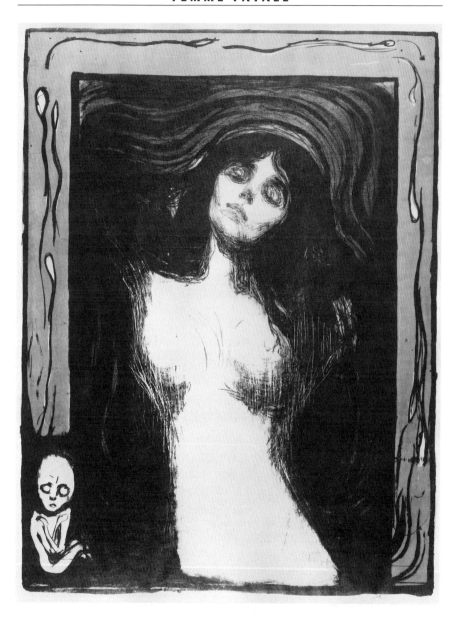

EDVARD MUNCH (1863–1944).
Madonna, 1895–1902. Lithograph, printed in color, 23 3/4 x 17 1/2 in.
(60.3 x 44.4 cm). Collection, The Museum of Modern Art, New York;
The William B. Jaffe and Evelyn A. J. Hall Collection.

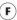

teenth- and early twentieth-century art from the ACADEMY to the AVANT-GARDE atelier.

The depiction of fertile superwomen—the philosopher Friedrich Nietzsche's related idea of the *Übermensch,* or superman, was widely discussed at this time—coexisted with the portrayal of sexually controlling women. At exhibition after exhibition by the turn of the century, painted Percivals and Saint Anthonys were sorely tempted, and sailors were preyed upon by mermaids, water nymphs, or sirens. Men were depicted as terrorized by vampires, sphinxes, or lesbians; as decapitated or emasculated by biblical figures like Judith, Salome, and Lilith; and as infected with syphilis by leering whores. Such themes were common in SYMBOLIST art, and the sinuous line of ART NOUVEAU seems particularly well suited to rendering long—and entangling—female tresses.

When the Norwegian artist Edvard Munch's image of a seductive Madonna framed by a border of wriggling sperm was shown in Berlin in 1892, it caused a scandal that led, later in the decade, to the founding of the Berlin Secession. Among the innumerable other artists of the period who depicted the femme fatale were Léon Bakst, Aubrey Beardsley, Arnold Böcklin, Jean Delville, Paul Klee, Gustav Klimt, Max Klinger, Fernand Khnopff, Gustave Moreau, Edvard Munch, Odilon Redon, Félicien Rops, Albert Pinkham Ryder, Franz von Stuck, and Jan Toorop.

FIGURATIVE

Figurative is used in two sometimes contradictory ways. Traditionally it has been applied to artworks that are representational rather than completely ABSTRACT. Grounded in nature, such images encompass everything from nudes and portraits to still lifes and landscapes.

Although MODERN art at the beginning of the twentieth century seemed to be moving decisively toward total abstraction, by the end of World War I figurative alternatives were already emerging in the work of artists associated with NEUE SACHLICHKEIT and SURREALISM. Many other artists not connected with movements or groups—such as Alberto Giacometti and Balthus—produced figurative works that are of increasing interest to today's viewers, a reminder that history's judgments are constantly being revised.

According to *Webster's New World Dictionary, figurative* also means "having to do with figure drawing, painting, etc." This sense of the term is gaining

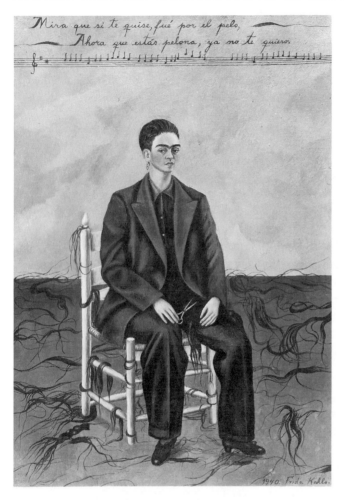

FRIDA KAHLO (1910–1954).
Self-Portrait with Cropped Hair, 1940. Oil on canvas, 15 3/4 x 11 in.
(40 x 27.9 cm). Collection, The Museum of Modern Art, New York;
Gift of Edgar Kaufmann, Jr.

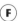

popularity. To many speakers, *figurative painting* means paintings of the human figure.

FILM UND FOTO

The *Film und Foto* exhibition was held in the municipal exposition building of Stuttgart, Germany, from May 18 to July 7, 1929. The influential show was organized by the Deutscher Werkbund, a group of architects and designers that had been founded in 1907 to encourage higher standards of design.

Some 940 pictures—or groups of pictures—were shown. The list of photographers in the show, selected by an international committee, reads like a who's who of MODERNIST photography, from the little-known members of what would later be GROUP F/64 in California to the recently deceased—and then barely known—French photographer Eugène Atget. There was an introductory gallery, installed by the former BAUHAUS master László Moholy-Nagy, which provided a preview of the photographs in the thirteen galleries to come. As far as can be reconstructed, Moholy-Nagy included not just examples of STRAIGHT PHOTOGRAPHY, but also negatives as prints, X rays, found photographs, and pictures taken from the air and through microscopes or telescopes.

Although its purpose was simply to showcase pioneering work in photography and cinema, the real contribution of *Film und Foto* was its fresh intellectual approaches. By linking photographs and movies it emphasized the mechanically determined relationship to time that distinguishes them from other art-making media. Other conventional distinctions were also ignored: The gap between photography and art was bridged by exhibiting PHOTOMONTAGES and PHOTOGRAMS by DADAISTS and SURREALISTS; the separation between avant-garde and commercial cinema was narrowed by screening movies that ranged from experimental films like Dziga Vertov's *The Man with a Movie Camera* to Charles Chaplin's *The Circus* (both of 1928). The show also pointed to new thinking about a photographic—as opposed to a painterly—aesthetic that would feature subjects that (in the words of the exhibition director, Gustaf Stotz) had "hardly [been] noticed: for example shoe lasts, gutters, spools of thread, fabric, machines, etc."

FIN DE SIECLE—see SYMBOLISM

FOLK ART—*see* NAIVE ART

FORMAL/FORMALISM

Formalism derives from *form*. A work's formal qualities are those visual elements—its color, shape, size, structure, etc.—that give it form. Formalism is generally believed to imply an artistic or interpretive emphasis on form at the expense of CONTENT, but form and content are, in fact, complementary aspects in any work.

Although philosophical debates about form were initiated in ancient Greece, the concept of formalism is generally associated with MODERN art and especially with the thinking of three influential theorists: Clive Bell, Roger Fry, and—after World War II—the American critic Clement Greenberg. Just prior to World War I the British writers Bell and Fry sought to create a quasi-scientific system based on visual analysis of an artwork's formal qualities rather than its creator's intentions or its social function.

Formalism originated as a way to think about increasingly ABSTRACT modern art and as a response to the early modern interest in artworks foreign to the Western tradition, especially Japanese prints and African sculpture. The term *significant form*—Bell's highly subjective description of the characteristics distinguishing artistic from natural beauty, which was explicated in his collection of essays *Art* (1914)—could be applied with equal effectiveness to paintings by the French artist Paul Cézanne and to eighteenth-century masks by Benin sculptors (from the area now known as Nigeria). Bell's criteria for significance aside, formalism permitted, for the first time, the comparative description and evaluation of abstract or representational art from any culture or moment. The formalist method would come to dominate art criticism and modernist thought after World War II, before yielding to more expansive critical approaches during the 1970s.

FOUND OBJECT

A found object is something that already exists—often a mundane manufactured product—and is given a new identity as an artwork or part of an artwork. Georges Braque and Pablo Picasso began to inject bits of newspapers or other nonart material into their pioneering COLLAGES and ASSEMBLAGES of 1912–15, but they significantly altered those materials. The artist credited with originating the concept of the found object is Marcel Duchamp.

In 1913 Duchamp began to experiment with what he dubbed the Readymade. After adding a title and a signature to an unaltered, mass-produced object—

FOUND OBJECT

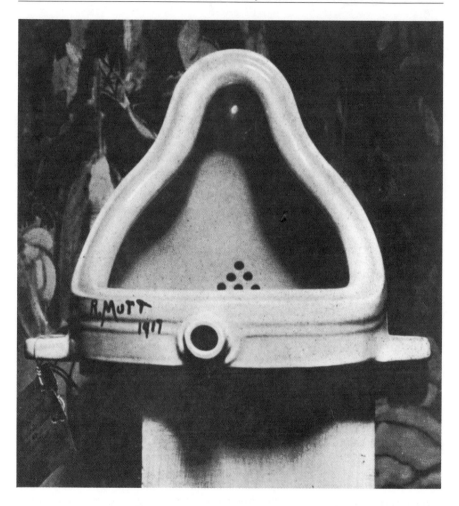

MARCEL DUCHAMP (1887–1968).
Fountain, 1917 (no longer extant). Height: 24 in. (61 cm).
Courtesy, The Museum of Modern Art, New York.

in one notorious instance, a urinal he called *Fountain* (1917)—he would exhibit it, thereby transforming it into a Readymade sculpture. He also created what he called Altered Readymades, works such as *L.H.O.O.Q.* (1919), which consisted of a reproduction of the Mona Lisa that he adorned with a mustache and beard and gave a punning title, pronounced "Elle a chaud au cul" and meaning "She has hot pants." By shifting attention away from the physical act or craft involved in its creation, Duchamp intended to emphasize art's intellectual basis in thought or philosophy.

To audiences used to artworks in traditional formats—even the radically modern CUBIST paintings still were made of oil on canvas in carved frames—such works seemed more provocation than art. Other Dada and Surrealist artists exploited the nostalgic or emotive potential of found objects in works less cerebral than Duchamp's, such as Francis Picabia's nose-thumbing *Portrait of Cézanne* (1920), which represents the artist as a mangy toy monkey affixed to a board.

FOURTH DIMENSION—*see* SPIRITUALISM

FROTTAGE—*see* SURREALISM

F/64—*see* GROUP F/64

FUTURISM

▷ **WHO** (All from Italy) Giacomo Balla, Umberto BOCCIONI, Carlo Carrà, Luigi Russolo, Gino Severini

▷ **WHEN** 1909 to 1929

▷ **WHERE** Italy

▷ **WHAT** Futurism erupted onto the Paris scene in the form of an incendiary MANIFESTO by the Milanese poet Filippo Tommaso Marinetti, which appeared on the front page of the newspaper *Le Figaro* on February 20, 1909. It called for the destruction of museums and libraries (scorned as "mausoleums") and glorified speed, violence, and warfare. "A roaring motorcar," Marinetti wrote, ". . . is more beautiful than the Victory of Samothrace." The Futurist infatuation with dynamism developed in reaction to Italy's technological and cultural inertia at the turn of the century.

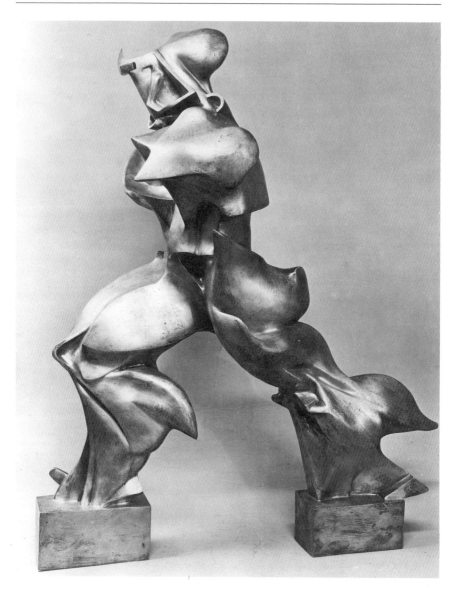

UMBERTO BOCCIONI (1882–1916).
Unique Forms of Continuity in Space, 1913 (cast 1931). Bronze,
43 7/8 x 34 7/8 x 15 3/4 in. (11.4 x 88.6 x 40 cm). Collection, The Museum
of Modern Art, New York; Acquired through the Lillie P. Bliss Bequest.

Painters soon made common cause with Marinetti. *The Manifesto of Futurist Painters*—the first of several—appeared in February 1910, signed by the artists listed at the beginning of this entry. It championed the close-up representation of speed achieved by merging objects or figures with their environments, an approach that rejected the conventional ideals of readable form and what was seen as the appropriately detached perspective on depicted action. Despite their revolutionary goals, Futurist painters initially relied heavily on NEO-IMPRESSIONISM's already conventional, fragmenting brushwork. By 1911 the Futurists were putting the vocabulary of CUBISM—ideal for portraying simultaneous multiple viewpoints—to decidedly non-Cubist and emotionally expressive ends. Carlo Carrà's *Simultaneity: Woman on the Balcony* (1912) merges figure and architecture in an explosive synthesis; Umberto Boccioni's famous sculpture *Unique Forms of Continuity in Space* (1913) depicts a modern-day Mercury who rushes past us in a blur.

A Futurist exhibition at the Bernheim-Jeune gallery in Paris in February 1912 catapulted the group to international attention. The show traveled widely, offering Western and Eastern European artists a different approach to the Cubist idiom, one that seemed ecstatically attuned to the brave new world of the recently invented automobile, airplane, and cinema. It had immediate influence on geographically wide-ranging movements, including CUBO-FUTUR-ISM, RAYONISM, SYNCHROMISM, and VORTICISM.

Futurist manifesto followed Futurist manifesto until the end of the 1920s, offering prescriptions not for just painting and sculpture, but also for architecture, radio, film, theater, dance, and what would later be called per-formance art. The Futurists' flamboyant techniques for attracting attention also contributed to the birth of modern public relations during World War I. The war ended the Futurists' heyday, though they rejoiced as it sounded the death knell of nineteenth-century civilization. Many of the most talented Futurists—including Boccioni and the brilliant architect Antonio Sant'Elia—were killed during the war; other group members produced propaganda for the Allies. The antifeminism and elitism of the surviving Futurists led to their absorption into fascism (a movement that cloaked reactionary aims in modern garb), beginning in 1919.

See FASCIST ART

GENRE PAINTING—*see* ACADEMIC ART

GERMAN EXPRESSIONISM—*see* DER BLAUE REITER, DIE BRÜCKE

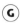

GESAMTKUNSTWERK

The German term *Gesamtkunstwerk* means "total work of art"; in English texts it is kept in German rather than translated. An idea first associated with late nineteenth-century "music dramas" by Richard Wagner, it refers to the complete integration of music, art, architecture, poetry, and drama into a spectacle grander than the sum of its parts.

Opera had united the talents of composers, performers, and set and costume designers, but the contributors tended to work independently. In 1876 Wagner inaugurated the Festspielhaus in Bayreuth, Germany—the first theater in Europe where the houselights were dimmed for performances, thus insistently directing the audience's attention to the stage—as a laboratory for the development of the *Gesamtkunstwerk*. A new generation of visionary theater designers such as Adolphe Appia and Edward Gordon Craig were stimulated by the controversial and charismatic Wagner. At the same time, interests in synesthesia, ABSTRACTION, and SYMBOLISM were undermining the tame literalness in stage art that paralleled the worst ACADEMIC painting of the day. In innovative new presentations, light was utilized to create sculptural effects, color to evoke emotions, and emerging STYLES in art were mined for their symbolic and expressive effects.

Symbolist and ART NOUVEAU artists—not stage designers—began to collaborate on AVANT-GARDE productions with Symbolist writers. Director Aurélian Marie Lugné-Poë's Théâtre de l'Oeuvre in Paris was a center of such activity. Maurice Denis, Paul Sérusier, Henri de Toulouse-Lautrec, and Edouard Vuillard created the visual elements for Alfred Jarry's scandalous, absurdist classic *Ubu roi* (1896), which anticipated multimedia pieces that might today be termed performance art. These included the FUTURISTS' mechanical ballets with robot-costumed actors; CUBO-FUTURIST productions such as *Victory over the Sun* (1913), which marked the emergence of Kazimir Malevich's SUPREMATIST art; DADA and SURREALIST meditations on nonsense such as Tristan Tzara's *Le Coeur à gaz* (*The Gas Heart,* 1921), CONSTRUCTIVIST stage designs, including Lyubov Popova's KINETIC SCULPTURE for *The Magnificent Cuckold* (1922); and numerous BAUHAUS mixed-media pieces by Oskar Schlemmer that utilized inventive light, sound, and mechanical effects. In many cases these performance works helped artists to clarify ideas that would later be embodied in more conventional artworks.

The best-known *Gesamtkunstwerk*s of the early twentieth century were the spectacular productions staged by Sergey Diaghilev for the Ballets Russes. Artists of diverse aesthetic preferences were commissioned by the Russian

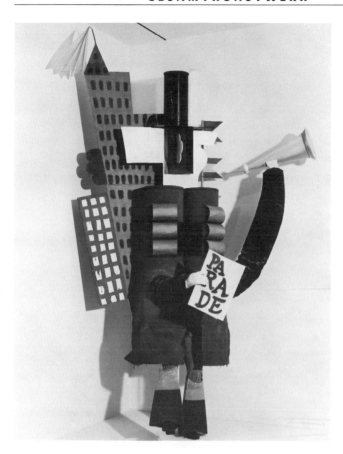

PABLO PICASSO (1881–1973) in collaboration with **JEAN COCTEAU** (1889–1963), **ERIK SATIE** (1866–1925), and **LEONIDE MASSINE** (1896–1979) for the Ballets Russes' production of *Parade*.
The American Manager, 1919. Paint on cardboard, fabric, paper, wood, metal, and leather, 134 1/4 x 96 x 44 1/2 in. (341 x 243.8 x 113 cm).
The Museum of Modern Art, New York.

impresario, including Léon Bakst, Alexandre Benois, Christian Bérard, Naum Gabo, Fernand Léger, Joan Miró, Antoine Pevsner, Pablo Picasso, and Pavel Tchelitchew. Perhaps the most renowned of the collaborations was the ballet *Parade* (1917), which brought together the talents of the artist Pablo Picasso, the composer Erik Satie, and the choreographer Léonide Massine, and contributed to the slightly later emergence of Surrealism.

Examples of the *Gesamtkunstwerk* in the United States date to the period between the world wars. One of the most remarkable is *Four Saints in Three Acts*—an eccentric opera by the writer Gertrude Stein, the composer Virgil Thomson, the painter Florine Stettheimer, and the choreographer Frederick Ashton. It premiered in 1934 at the Wadsworth Atheneum (the country's oldest art museum, in Hartford, Connecticut), before moving to Broadway.

GLASGOW SCHOOL

▷ **WHO** (All from Scotland) D. Y. CAMERON, Joseph Crawhall, James Guthrie, E. A. Hornel, John LAVERY, W. Y. MACGREGOR, E. A. Walton

▷ **WHEN** 1870 to 1900

▷ **WHERE** Glasgow

▷ **WHAT** The Glasgow School was a group of Scottish artists—mostly landscape painters—active during the last quarter of the nineteenth century. Trained in Paris, they rejected the formulas of ACADEMIC painting in favor of a NATURALISTIC approach to landscape influenced by the BARBIZON SCHOOL and the seventeenth-century Dutch landscapists. Although painted *en plein air,* their rather nationalistic scenes of the Scottish seaside, ducks, and marshes are largely conventional works rendered in a low-key palette untouched by IMPRESSIONIST brilliance.

The Glasgow School painters constituted the major British contribution to landscape painting during the second half of the nineteenth century, an often-noted diminution in quality from the epochal output of early nineteenth-century English landscapists such as Joseph Mallord William Turner and John Constable. The group's reputation peaked after a show at the prestigious Grosvenor Gallery in London in 1890—which traveled to Munich—then seemed to decline, along with the economic importance of the city in which it was based.

The term *Glasgow School* is also occasionally used in connection with Charles Rennie Mackintosh, a Scottish architect and designer associated with the ARTS AND CRAFTS MOVEMENT and, primarily, ART NOUVEAU.

GROUP F/64

▷ **WHO** (All from the United States) Ansel ADAMS, Imogen CUNNINGHAM, John Paul Edwards, Sonya Noskowiak, Henry Swift, Willard Van Dyke, Edward WESTON

▷ **WHEN** 1932 to 1935

▷ **WHERE** San Francisco

▷ **WHAT** Group f/64, also known simply as *f/64,* was a loose association of photographers founded by Ansel Adams and Willard Van Dyke in San Francisco in 1932. *F/64* is an optical term referring to the aperture setting on a camera lens that ensures the maximum sharpness of both foreground and background. The choice of the term as a name indicated the group's desire to promote straightforward photographic techniques that would yield sharply focused, highly detailed pictures of people, places, or objects, frequently seen in close-up. This starkly dramatic, MODERNIST sensibility was a rejection of the anecdotal PICTORIAL photography of the turn of the century, which had taken its aesthetic cues from painting rather than the camera's unique technical capacities.

Group f/64's inaugural exhibition at the M. H. de Young Memorial Museum in San Francisco in 1932 is thought to be the first museum exhibition in the United States exclusively devoted to STRAIGHT PHOTOGRAPHY—of which Group f/64 is a subset. Gallery exhibitions in Oakland followed, which also included photographs by Dorothea Lange and Peter Stackpole. Although the group disbanded in 1935, just three years after its founding, its influence seemed to expand with time, and the term *f/64* became convenient shorthand for straight photography itself.

IMOGEN CUNNINGHAM (1883–1976).
Shredded Wheat Tower, 1929. Gelatin silver print, 8 15/16 x 6 1/2 in.
(22.7 x 16.5 cm). The Imogen Cunningham Trust, Berkeley, California.

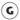

GROUP OF SEVEN

▷ **WHO** (All from Canada) Franklin Carmichael, Lawren HARRIS, A. Y. JACK-SON, Frank H. Johnston, Arthur Lismer, J.E.H. MACDONALD, Frederick Varley

▷ **WHEN** 1919 to 1933

▷ **WHERE** Canada

▷ **WHAT** The Group of Seven was a tightly knit association of Canadian and English-born painters in Canada who formally banded together in 1919, although many of them had known each other since before World War I. They began to show their landscape paintings as a group in 1920 and introduced both modern innovations in style and a sense of national identity to Canadian art.

They revered the spectacular northern landscape, with its craggy rocks, reflective waters, and spiky trees in silhouette so unlike the more domesticated landscapes painted by the French BARBIZON SCHOOL or the Italian MACCHIAIOLI painters. Such scenery seemed to lend itself to the ABSTRACTING strategies of MODERN art. Group of Seven painting blends bright FAUVIST color and simplified forms with an ART NOUVEAU—derived emphasis on line. Some perceptive critics of the day noted that this interest in line came at the expense of the highly structured compositions derived from CUBISM.

Most Canadian critics vilified the Group of Seven artists; they were better received in New York and Paris. But eventually their paintings became a source of pride to the Canadian public as an assertion of the country's beauty. The artists' importance as enthusiastic teachers and travelers—though largely based in Toronto, they painted throughout Canada—helped spread the modernist message across the Dominion. The group's last exhibition was held at the end of 1931; two years later the Group of Seven reconstituted itself as the Canadian Group of Painters. This was in part a recognition that some of them had gone their own ways: Frederick Varley increasingly turned to portraiture; Lawren Harris's austere landscape style evolved into spiritually inflected pure abstraction.

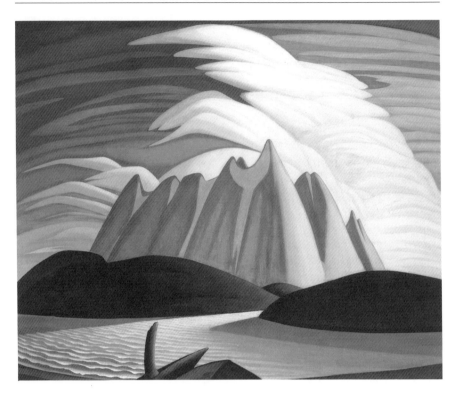

LAWREN HARRIS (1885–1970).
Lakes and Mountains, 1928. Oil on canvas, 51 1/2 x 63 1/4 in.
(130.8 x 106.6 cm). Art Gallery of Ontario, Toronto; Gift from the Fund
of the T. Eaton Co., Ltd., for Canadian Works of Art, 1948.

HARLEM RENAISSANCE

▷ **WHO** (All from the United States) Raymond Barthé, E. Simms Campbell, Aaron DOUGLAS, Richard Bruce Nugent, Augusta Savage, James Van Der Zee (along with the writers Countee Cullen, Langston Hughes, Zora Neale Hurston, James Weldon Johnson, Jean Toomer)

▷ **WHEN** 1924 to 1930

▷ **WHERE** New York

▷ **WHAT** The Harlem Renaissance was primarily a literary movement that flourished in Harlem from about 1924 until the onset of the Depression in 1930. It was a product of the post–World War I emigration from the South that made this uptown Manhattan neighborhood—documented by the photographer James Van Der Zee—the economic, political, and cultural capital of black America.

The painter Aaron Douglas and the illustrator Richard Bruce Nugent were the only visual artists typically associated with the Harlem Renaissance writers Countee Cullen, Langston Hughes, Zora Neale Hurston, James Weldon Johnson, and Jean Toomer. All of them shared an impassioned interest in Negritude—the celebration of African-American cultural traditions. (Negritude was by no means limited to blacks; it was the white painter Winold Reiss who introduced Douglas to African motifs.) Perhaps more important, Douglas, Nugent, and other artists of the Harlem generation of the 1920s—such as Charles Alston, E. Simms Campbell, and the sculptor Augusta Savage—helped catalyze an explosion of black artistic activity in Harlem during the 1930s.

That later generation of artists included some of the most important African-American artists in U.S. history: Richmond Barthé, Romare Bearden, Robert Blackburn, Ernest Crichlow, Elton Fax, Jacob Lawrence, and Norman Lewis. They were not, however, united in a common artistic approach or a tight-knit community of writers and artists that would warrant their being labeled a continuation of the Harlem Renaissance of the 1920s. The Depression had ended that unique chapter in American cultural history, with the relatively

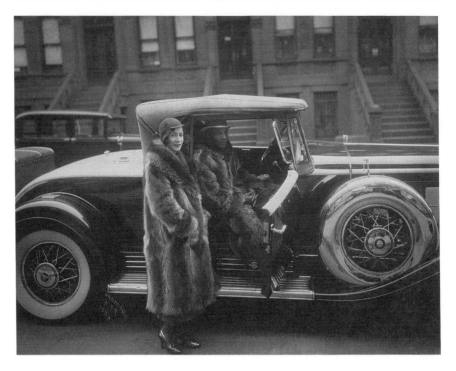

JAMES VAN DER ZEE (1886–1983).
Couple in Racoon Coats, 1932. Gelatin silver print. James Van Der Zee
Estate, New York.

unbigoted social and professional interactions that briefly made Harlem an internationally known center of culture.

HEIDELBERG SCHOOL—*see* 9 × 5

HISTORY PAINTING—*see* ACADEMIC ART

HUDSON RIVER SCHOOL—*see* LUMINISM

ICONOGRAPHY

In Latin *iconography* means the description of images. The term is also short-hand for an important method of art history developed by the German-born scholar Erwin Panofsky during the 1920s and '30s. Putting his approach in its intellectual context helps illuminate the radical changes in the study of art that began in the late nineteenth century.

The first university chair of art history was established at Göttingen, Germany, in 1813, but what many scholars consider modern art history did not emerge until the 1880s, in the work of Alois Riegl, Franz Wickhoff, and Max Dvorak. Members of this so-called Viennese School believed that art was not a self-contained realm of activity divorced from other human endeavors—instead they saw it as part of a larger cultural history, influenced—and even determined—by social conditions and events. This view suggested a cross-disciplinary approach for the study of all types of art: non-Western, decorative, NAIVE—as well as MODERN art itself, which like them cannot be fully understood without referring to such influences. During the twentieth century this process of contextualizing was enriched by many art historians, including Stephen Pepper and Meyer Schapiro.

Panofsky offered perhaps the most influential method of interpretation. In the introductory chapter to his *Studies in Iconology* (1939), he outlined three levels of meaning, moving from clearly apparent meanings (the lowest level) to symbolic meanings (the highest level). The second level, known as *iconography,* is an amalgam that joins the apparent meanings of form and subject with historical knowledge and larger cultural themes, including those explored by artists, composers, and writers alike. The third level—which Panofsky called *iconology,* another Latin-derived word, meaning the science of the meaning of images—synthesizes iconography with insights from fields

as farflung as economics and psychology to place the work of art in an expanded context. Such a view acknowledges the complex range of social and psychological forces affecting artists and also expands the interpreter's methodological scope.

Panofsky's views are increasingly, but not universally, favored. Throughout the first half of the twentieth century they have competed with narrower methods based on MARXISM, PSYCHOANALYSIS, and FORMALISM.

IDEALISM—*see* NATURALISM

ILLUSTRATION—*see* BOOK ART

IMPRESSIONISM

▷ **WHO** (From France unless otherwise noted) Mary Cassatt (United States), Edgar DEGAS, Claude MONET, Berthe Morisot, Camille Pissarro, Auguste Renoir, Alfred Sisley

▷ **WHEN** 1870 to 1890

▷ **WHERE** France

▷ **WHAT** The term *Impressionism* was coined in 1874 by critic Louis Leroy of the Parisian journal *Le Charivari* in response to what he regarded as the unfinished quality of Claude Monet's *Impression: Sunrise* (1872). The occasion for Leroy's sarcasm was the first of eight group exhibitions held between 1874 and 1886 by the Indépendants (soon to be known as the Impressionists), an officially incorporated group that banded together in opposition to the government-sponsored SALON. Their numbers fluctuated and contributors to their exhibitions included, at various times, artists such as Paul Cézanne and Paul Gauguin, who are not, strictly speaking, Impressionists. The group's sole "rule" was its rejection of the Salon, but even such core members as Monet, Auguste Renoir, and Alfred Sisley defected to the Salon in 1879.

Impressionist paintings are brightly colored, in contrast to the dark and muted tonalities of ACADEMIC painting. The high-key colors were applied in disconnected strokes that were intended to be combined by the viewer's eye rather than the painter's brush. Glazes, heavy varnishes, and the use of black—as opposed to colored—shadows were virtually banished. Daringly

truncated compositions and aerial perspectives were derived from new sources, including photographs and Japanese prints. The REALIST painter Edouard Manet's use of sketchy, visible brushwork inspired the Impressionists, as did his unwavering commitment to the depiction of contemporary life.

Impressionist subjects included sun-dappled landscapes (see page 15), cityscapes, portraits, and images of newly popular entertainments, like Renoir's glittering depictions of floating dance halls. Whether painted indoors or out, Impressionist canvases seem to be primarily concerned with the ever-changing play of light on natural or man-made objects. But Impressionist paintings also document a rapidly industrializing Paris. In the backgrounds of Monet's paintings of suburban swimming in the Seine, for instance, the artist recorded belching smokestacks that many nineteenth-century viewers found disconcertingly gritty.

Because of its emphasis on the dematerializing effects of light, Impressionism had little influence on sculptors, who necessarily work with solid materials. Although Edgar Degas and Renoir occasionally made bronze sculptures, the most notable sculptor working in an Impressionist style was the Italian Medardo Rosso, whose atmospheric wax sculptures are animated almost entirely by the play of light on their irregular surfaces.

Impressionism straddles the transition from Renaissance-derived representations of the visible world to the nonperceptual approach of much MODERN art. On one hand, Impressionism can be regarded as the culmination of NATURALISM or optical realism—the artist's commitment to a convincing depiction of physical reality. On the other, its fragmented, painterly brushwork marks the origins of a view of the artwork as an independent object inspired by a desire to explore the artist's own psyche and an art no longer subject to the constraints of nature.

The Impressionists' exploration of transient effects—the ability of the ephemeral play of light to break down the perceived boundaries of the material world—affronted conventional notions of art as concerned with stability and eternal values, provoking the so-called Crisis of Impressionism of the mid-1880s. Some Impressionists, such as Renoir, retreated into a more traditional handling of form and line; others, including Monet, pursued their interests in color and light even more intently. (Renoir's retreat from his own radicalism is not unusual among modern-art innovators.)

By the mid-1890s the Impressionists had become the new establishment, and their influence had spread throughout Europe and the United States.

Impressionist techniques were taken up by Spanish, British, Scandinavian, and especially American artists. As with NEO-IMPRESSIONISM and CUBISM, the distinctive Impressionist STYLE became an international signifier of modernity among many artists who simultaneously popularized and misunderstood it. Some, for example, would apply it to a subject's figure, while painting her face in a traditionally realistic way. Impressionism's charm and *joie de vivre* have made it the most universally admired of all modern movements.

INTERNATIONAL EXPOSITIONS

The first significant international exposition of art, science, and technology was the Great Exhibition, held in London in 1851; such exhibitions later became known as world's fairs. They went by a variety of names: Paris had its renowned Expositions Universelles; the United States had fairs ranging from the Centennial Exhibition (1876) in Philadelphia to the World's Columbian Exposition (1893) in Chicago. Some commemorated specific events, such as the opening of the Panama Canal, marked by the Panama-Pacific International Exposition in San Francisco in 1915, and the centennial of the Louisiana Purchase, celebrated by the 1904 world's fair in Saint Louis. Others, such as the Great Exhibition of 1851, did not.

Dozens of international expositions were mounted in Western Europe and the United States between 1851 and the outbreak of World War I in 1914; five took place in Paris alone between 1855 and 1900. For the first time ambitious surveys of contemporary art and technology were brought together with the arts and crafts of non-Western cultures that had been forced into the Western orbit by colonialism. It was the nineteenth-century positivist idea of progress itself that was being showcased to a mass audience at such fairs.

The influence of the widely reported expositions was unprecedented. They were laboratories of engineering and architecture, producing often-imitated buildings, such as London's glass-and-metal Crystal Palace (1851). They also inspired visions of architectural and urban planning, such as the City Beautiful movement that sprang from the World's Columbian Exposition. They were trade shows that demonstrated which countries and firms led their competitors in science, industry, agriculture, and the arts. By demonstrating how non-Westerners lived they shrank the world—and often made a smugly Eurocentric spectacle of such demonstrations by importing contingents of Middle Eastern belly dancers and the like for the entertainment of fairgoers.

The international expositions also affected the course of art produced during the nineteenth century. At the London Exposition of 1862, for example, William Morris and Co. made its debut with stained glass and housewares, ensuring the survival of the struggling company and the future of the ARTS AND CRAFTS MOVEMENT. The painter Paul Gauguin was introduced to Oceanic and Southeast Asian cultures at Parisian expositions, an encounter that helped encourage his later move to Tahiti. The Eiffel Tower was built as a landmark for Paris's Exposition Universelle of 1889, and it became a potent symbol of industrial society that appeared in many painters' compositions. The international expositions were the most effective of all forms of world-wide communication before the birth of the cinema.

INTIMISME

Intimisme is a French term sometimes used to describe the work of the French painters Edouard Vuillard and Pierre Bonnard, who came of age during the 1890s. Although they are usually associated with the NABIS, they actually remained aloof from that group's preoccupation with SPIRITUALISM. Instead they painted domestic interiors and everyday street scenes, the sort of subject matter that was first explored by Dutch painters during the seventeenth century and that has come to be known as GENRE. The cozy mood of these charming images seems to affirm the appeal of hearth and home, but—in the work of Vuillard especially—an air of mystery and even claustrophobia sometimes intrudes (see page 22). To create their lushly sensual works, Bonnard and Vuillard synthesized a variety of aggressively MODERNIST styles: disconnected brushwork, ART NOUVEAU—related patterns, and cropped compositions derived from JAPONISME and photography.

ISM

Ism is a noun-forming suffix—it is rarely used on its own anymore—that refers to a particular theory or doctrine or set of practices. If a group's defining principles are based on PRE-RAPHAELITE—era ideals, then their movement may logically be known as Pre-Raphaelitism. Likewise, the basis of EXPRESSIONISM is the expression of emotion. Politics and the arts are the realms in which historically significant ideas and practices are most often identified by the use of the added *ism*.

The British aristocrat and writer Horace Walpole wrote in a letter in 1789: "Alas!" he cautioned. "You would soon squabble about Socialism, or some of

those isms." Walpole's view of isms as trendy, new, and possibly dangerous to the status quo persists. In some cases the naming of movements or ideas is a contentious battle for control of their meaning. IMPRESSIONISM, for example, was a pejorative term coined by a hostile critic that suggested the ephemerality—and visual poverty—of the paintings it described. Some isms, such as POST-IMPRESSIONISM, have little specific meaning and do more to obscure than to illuminate the art they signify. The rapid proliferation of isms characterized modernism's artistic and intellectual ferment.

ITINERANTS—*see* THE WANDERERS

JAPONISME

Japonisme—a French term that has been adopted into English (and occasionally translated as *japonism*)—refers to the influence of Japanese arts and crafts on Western art, especially during the last quarter of the nineteenth century.

That effect was discernible almost immediately after the forced opening of Japan to Western commercial interests during the 1850s. Major exhibitions of Japanese art and *japonaiserie*—the Japanese products that appealed most to Europeans, such as porcelains, lacquerware, fans, and prints—were held at INTERNATIONAL EXPOSITIONS across Europe and the United States beginning in London in 1862. (*Japonaiserie* may also be used to describe Japanese-inspired craft and furniture designs made in the West.) Interest among Parisians in things Japanese was unusually intense and probably a consequence of the passion for design and the visual arts shared by the two cultures. Among Parisian artists this interest was so pronounced that the development of IMPRESSIONISM, POST-IMPRESSIONISM, NEO-IMPRESSIONISM, ART NOUVEAU, and the art of the NABIS is virtually unimaginable without *japonisme*.

A few artists borrowed Japanese subjects or motifs: Camille Pissarro found inspiration for his images of foggy or wintry landscapes in Ukiyo-e prints, Edouard Manet portrayed Emile Zola against a backdrop of *japonaiserie*, and Claude Monet painted Madame Monet wearing a kimono. James McNeill Whistler adapted his butterfly signature from the Japanese, and numerous artists created fan-shaped paintings. But infinitely more important for MODERN art was the *stylistic* influence of Japanese LITHOGRAPHS, etchings, engravings, and—toward the end of the century—woodblock prints. Such artists as Pierre Bonnard, Mary Cassatt (see page 23), Edgar Degas, Odilon Redon, Paul Signac, and Henri de Toulouse-Lautrec emulated the prints' vivid, unmodulated color, emphatic outlines, foreshortened and aerial perspectives, and

asymmetrical and truncated compositions. Speaking for his generation, Vincent van Gogh said: "Japanese art—we all had that in common."

Why were modernist artists so receptive to this distinctly foreign sensibility? Not only were Japanese arts and crafts visually remarkable, but they arrived on the stage of European art at a crucial moment of transition from pre-modern to modern art. *Japonisme* offered a compelling alternative to the moribund ACADEMIC art of the era, as well as an escapist retreat from the coarsening influences of industrialism. Its formal innovations of composition and perspective related to those found in photographs yet also suggested a non-NATURALISTIC direction for painting floundering in the wake of photographic verisimilitude. As African art was to do during the first decade of the twentieth century, *japonisme* left an indelible impression on the modern art that so many observers have regarded as a purely Western phenomenon.

JUGENDSTIL—*see* ART NOUVEAU

KINETIC SCULPTURE

Sculpture that contains moving parts, powered by hand or air or motor, is called kinetic. Its originator was the DADA artist Marcel Duchamp, who mounted a spinnable bicycle wheel on a wooden stool in 1913.

CONSTRUCTIVIST artists made significant contributions to kinetic sculpture during the 1920s. Aleksandr Rodchenko created *Hanging Construction* (1920), which resembles a Saturn with more than the usual number of rings. Naum Gabo and László Moholy-Nagy started to experiment with kinetic sculpture resembling machines during their tenure as instructors at the BAUHAUS. Shortly thereafter the American Alexander Calder invented the mobile—a delicately balanced wire framework with movable parts, from which sculptural elements are suspended.

Kinetic sculptures are not limited to any one STYLE but they do share a source of inspiration: the twentieth-century infatuation with technology. The relatively independent experiments mentioned above inspired artists to pursue more sustained attempts to create sculpture composed of moving parts after World War II.

L'ART POUR L'ART—*see* ART FOR ART'S SAKE

LINKED RING—*see* PICTORIALISM

ALEXANDER CALDER (1898–1976).
Lobster Trap and Fish Tail, 1939. Hanging mobile: painted steel wire and sheet aluminum, 102 x 114 in. (259.1 x 289.6 cm). Collection, The Museum of Modern Art, New York; Commissioned by the Advisory Committee for the stairwell of the Museum.

LITHOGRAPHY

Lithography is a printmaking process that was invented by the Bavarian play-wright Aloys Senefelder in 1798. A greasy crayon is used to draw on the surface of a porous stone, which is covered with water and then an oil-based ink that sticks only to the crayoned image. The stone is then pressed against paper, resulting in a print that can be easily duplicated by repeating the same procedure.

Among the first artists to utilize the process was the Spaniard Francisco de Goya, who produced small—or what have come to be known as limited—editions of lithographs (usually no more than one hundred). Lithography's capacity for relatively inexpensive reproduction enabled prints to reach a broad public. This made the French artist Honoré Daumier's biting carica-tures so potent a threat to Louis Philippe's regime that the mid-nineteenth-century lithographer was imprisoned for six months. After the development of the nonlithographic halftone process in the 1880s, such images could be printed in newspapers and reach vast audiences. The first inexpensive, high-quality reproductions of paintings were also lithographs, made possible by the perfection of photolithography by the French inventor Alphonse Louis Poitevin in 1855.

In Europe, artistic interest in lithography has remained unbroken since the time of Goya. (In the United States, fine printmaking did not catch on until the 1940s.) His footsteps would be followed by thousands of MODERN artists, ranging from Henri de Toulouse-Lautrec to Edvard Munch and work-ing in virtually every style.

LIVRES D'ARTISTES—see BOOK ART

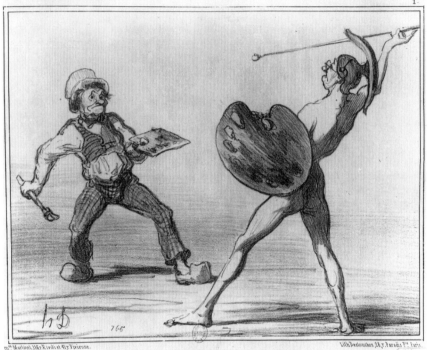

HONORE DAUMIER (1808–1879).
Battle of the Schools: Idealism vs. Realism, 1855. Lithograph.
Bibliothèque Nationale, Paris.

LUMINISM

▷ **WHO** (All from the United States) Sanford Gifford, Martin J. HEADE, John F. KENSETT, Fitz Hugh LANE

▷ **WHEN** 1845 to 1880

▷ **WHERE** United States

▷ **WHAT** Luminism was named by art historian (and Whitney Museum of American Art director) John I. H. Baur in the fall 1954 issue of *Perspectives USA*. A mid-nineteenth-century STYLE of American painting, Luminism is characterized by emphasis on the depiction of light, precisely rendered detail, and—most important—a dreamily poetic atmosphere. Painters such as John F. Kensett and Fitz Hugh Lane typically augmented their imagery of sea and sky with tiny figures walking along a beach, or boats sailing in tranquil, mirrorlike waters.

Luminism is sometimes considered an offshoot, or the final phase, of Hudson River School painting. But Luminism's frequent use of misty light, stabilizing horizontal bands as compositional organizers, and nearly invisible brushwork distinguishes it from the often brashly theatrical paintings by Hudson River School painters such as Albert Bierstadt and Frederic Edwin Church. Luminism embodies an American philosophical outlook that finds transcendent spirituality in the physical facts of the material world. By the late 1870s American audiences had rejected this vision of the divinity of nature in favor of the brushier and more casual-looking landscape paintings by the French BARBIZON SCHOOL.

MACCHIAIOLI

▷ **WHO** (All from Italy) Giuseppe Abbati, Giovanni BOLDINI, Vincenzo Cabianca, Adriano Cecioni, Giovanni Costa, Giovanni FATTORI, Silvestro Lega, Raffaelo SERNESI, Telemaco Signorini

▷ **WHEN** 1850 to 1870

▷ **WHERE** Italy

▷ **WHAT** The Macchiaioli were a group of Italian painters centered in Florence whose name derives from their use of the *macchia*—a patch or spot of color—to capture the light-shot freshness of the outdoor scenes they painted (see page 11).

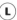

FITZ HUGH LANE (1804–1865).
Off Mount Desert Island, 1856. Oil on canvas, 24 13/16 x 36 7/16 in.
(61.4 x 92.5 cm). The Brooklyn Museum; Museum Collection Fund.

Citizens of the newly unifying, and artistically provincial, Italian nation, the Macchiaioli joined together to assert their national identity. They produced some paintings based on events from the Revolution of 1848 and on literary works with nationalistic associations, but they specialized in landscape painting, often portraying scenes of everyday life enacted in sunny gardens or fertile-looking fields. (The subject of the figure outdoors challenged an international spectrum of painters during the 1860s that also included the American Winslow Homer and numerous French artists such as Claude Monet and Berthe Morisot.)

Although the Macchiaioli have been called forerunners of IMPRESSIONISM, such claims are inaccurate given the Italian artists' attraction to historical and literary subjects and their depiction of solid forms unaffected by the play of light across them. They do represent the most important development toward MODERNISM in nineteenth-century Italian art—an achievement ratified by the critical hostility accorded their work by the conservative Italian art establishment. The term *Macchiaioli* has sometimes been inaccurately applied to almost all late nineteenth-century Italian landscape paintings with a NATURALISTIC, anti-ACADEMIC flavor.

MAGIC REALISM—*see* SURREALISM

MANIFESTO

The manifesto is invariably a challenge to the status quo. A public declaration of principles and intentions in written form, it was named during the seventeenth century; well-known examples include the American Declaration of Independence (1776), the French Declaration of the Rights of Man (1789), and *The Communist Manifesto* (1848).

The manifesto entered the cultural realm in 1809, when the visionary English artist William Blake mounted a private exhibition of his painted prints in a London hosiery shop. The show and its manifestolike advertisement, which was intended to attract customers and to encourage public patronage of art, were barely noticed by critics or the public. The French painter Gustave Courbet's private exhibition of paintings in 1855 was a far more visible challenge to the authority of the official SALON, and for ten centimes a visitor could purchase a catalog that included Courbet's brief manifesto of REALISM (probably written by the novelist Jules Champfleury).

The more common group manifesto emerged simultaneously with the development of the popular press and the weakening of premodern institutions, the Salon in particular, at the end of the nineteenth century. The appearance of Italian poet Filippo Tommaso Marinetti's FUTURIST manifesto on the front page of the Paris newspaper *Le Figaro* on February 20, 1909, signaled a new strategy for the distribution of manifestos and radically accelerated their production. Dozens more followed, by the Futurists themselves (on topics ranging from painting to architecture), the German EXPRESSIONISTS, the SYNCHROMISTS, DADAISTS, SURREALISTS, and RUSSIAN AVANT-GARDISTS. The art manifesto was intended to prompt bourgeois outrage, but—like any other public-relations maneuver—it soon lost the attention of a media voracious for new sensations. Throughout the MODERNIST era the manifesto remained an important tool for disseminating ideas and generating discussion, though usually among artists rather than the general public.

MARXISM

Marxism is the philosophy and world view developed by Karl Marx and Friedrich Engels during the second half of the nineteenth century. Its fundamental premise is that history—changes in politics, philosophy, religion, the arts, and so on—can be explained in terms of economic systems defined as the "sum total of the relations of production." History, according to Marx and Engels, moves in "an inexorable direction" toward a utopia in which private property and class distinctions will no longer exist.

They observed that the division of labor under modern capitalism had resulted in the alienation of the artist from society, which is due, in part, to the distinction between the fine arts and the applied arts that came into being during the Renaissance. Although art generally reflects the interests of elite patrons, Marx and Engels believed that the alienated artist might put his talents at the disposal of the revolutionary movement working to alter oppressive economic relationships. Their theory of art was among the most ambiguous aspects of their comprehensive doctrine; they admitted in a series of modifications to their views that noneconomic factors such as the history of art itself do affect the course of art.

Much of the social radicalism of MODERN art—beginning with the REALIST depictions of the lower classes by Gustave Courbet and Honoré Daumier—has been inaccurately attributed to Marxist ideas. The anarchists' views of art as socially determined and a weapon in the class struggle predated the publication of Marx and Engels's *Communist Manifesto* (1848) and their

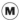

lengthier *Das Kapital* (1867–94). The theories of the ANARCHIST Pierre Joseph Proudhon in France and the socialist John Ruskin in England attracted far more converts than Marxism among European artists during the nineteenth century.

The success of what might be considered the second phase of Marxism—the Marxism-Leninism, Communism, or Bolshevism that triumphed with the creation of Soviet Russia in 1917—had far greater impact on modern art. CONSTRUCTIVIST artists in the nascent Soviet state rejected easel painting as elitist and turned their attention to designing utilitarian objects—from clothing and housewares to stage sets and advertisements—for the masses. The Mexican Revolution of 1910–17 inspired the MEXICAN MURALISTS to produce public art that featured images of Mexican history and of an international pantheon of liberators, in which Lenin figured prominently.

Although numerous avant-garde artists were members of the Communist party between 1917 and 1939—including Pablo Picasso, Diego Rivera, and many of the SURREALISTS—this did not result in a body of Marxist images. In the United States during the 1930s the leftist SOCIAL REALISTS depicted the urban working class, while the generally conservative REGIONALISTS simultaneously depicted the rural working class. Meanwhile, in what had officially become, in 1922, the USSR, the dictator Josef Stalin assumed control over Soviet cultural production, directing artists away from designing high-quality functional objects and toward the creation of blatantly propagandistic artworks.

Marxism has had a lasting impact on the philosophy and practice of art history. Under its influence art historians have grown more attuned to the economic analysis of cultural phenomena and more receptive to the investigation of art forms—such as Italian Renaissance painted furniture—previously dismissed as irrelevant to art history.

MERZ

After World War I, DADA spread from New York and Zürich to Berlin, Cologne, Hanover, and then Paris. Its major exponent in Hanover was the artist Kurt Schwitters, who coined the nonsensical term *Merz*—derived from *Commerzbank*—for his art. He applied the term *Merzbilden* to the small COLLAGES and ASSEMBLAGES he fashioned from debris, and the term *Merzbau* to the architecturally scaled construction he built in Hanover throughout the 1920s. Photographs of this work, destroyed by the Nazis, suggest a CUBIST painting in three dimensions. Angular plaster forms jutted out from walls and ceilings

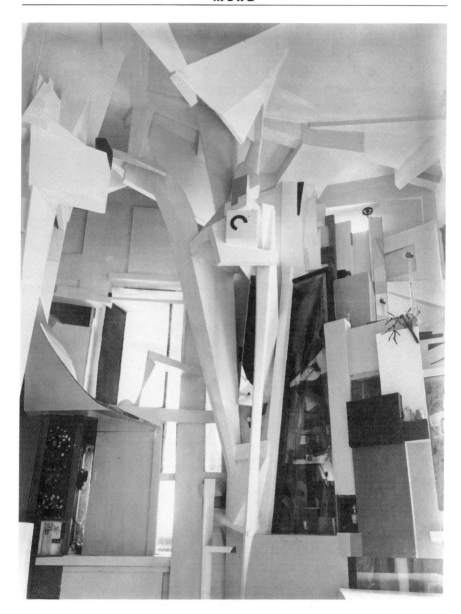

KURT SCHWITTERS (1887–1948).
Merzbau Hannover (also known as *Cathedral of Erotic Misery*), 1933
(destroyed 1943; reconstructed 1980–83). Plaster, wood, paint, and
glass, 149 5/8 x 212 9/16 x 173 1/4 in. (380 x 540 x 440 cm). Sprengel
Museum, Hannover, Germany.

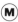

and contained niches for artworks dedicated to the artist's Dadaist and CONSTRUCTIVIST friends—Jean Arp, El Lissitzky, Kazimir Malevich, and Piet Mondrian among them. Schwitters had to abandon his second Merzbau, in Norway, after Germany invaded that country. He then moved to England, where his final, but unfinished, *Merzbau* is preserved at the University of Newcastle.

METAPHYSICAL SCHOOL—*see* SCUOLA METAFISICA

MEXICAN MURALS

▷ **WHO** (All from Mexico) Leopoldo Méndez, Juan O'Gorman, José Clemente OROZCO, Diego RIVERA, David SIQUEIROS

▷ **WHEN** 1920 to 1940

▷ **WHERE** Mexico

▷ **WHAT** Beginning in the 1920s, Mexican artists produced frescoed wall paintings intended to educate viewers about Mexican history and the socialist values of the Mexican Revolution of 1910–17. The murals constitute the most aesthetically vital program of officially sponsored SOCIAL REALISM produced during the twentieth century and quickly became internationally renowned.

Much of their success derived from the talents of the artists involved. José Clemente Orozco, Diego Rivera, and David Siqueiros—the founding triumvirate of Mexican mural painting, known as "Los Tres Grandes"—were already sophisticated artists when they returned from abroad around 1920 to join the movement of popular art and education initiated during the presidency of Alvaro Obregón. Like the DE STIJL and CONSTRUCTIVIST artists, the muralists renounced easel painting in favor of a populist and public art that embellished public buildings with boldly graphic and sometimes folkloric wall paintings. Despite such shared characteristics, the monumental, multifigured creations by each of the muralists are unmistakably his own.

Government support for the muralists waxed and waned, depending on the politics of particular administrations. Orozco and other painters were dismissed by the conservative Calles regime of the late 1920s and early 1930s, prompting him and Rivera to accept commissions in the United States. Their work in the States influenced numerous artists, especially those who were participants in the mural program of the FEDERAL ART PROJECT. Orozco pro-

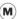
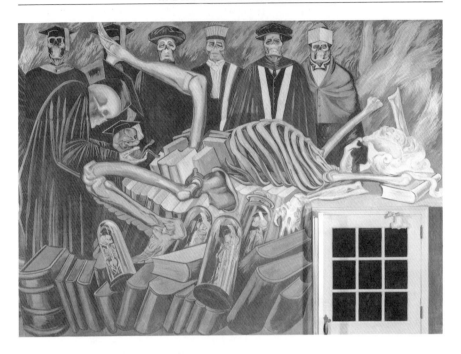

JOSE CLEMENTE OROZCO (1883–1949).
The Epic of American Civilization: Gods of the Modern World
(*Panel #17*), 1932–34. Fresco, 126 x 171 in. (320 x 434.3 cm). Commissioned by the Trustees of Dartmouth College, Hanover, New Hampshire.

duced murals for Pomona and Dartmouth colleges; Rivera, for the Detroit Institute of Arts, the California School of Fine Arts in San Francisco (now the San Francisco Art Institute), and the New Workers' School and Rockefeller Center, both in New York. Rivera's mural at Rockefeller Center (1933) was destroyed because of his refusal to remove an image of Lenin. The Mexican government's mural program continued into the 1950s, but its peak was reached in the pre–World War II production by Los Tres Grandes.

MIR ISKUSSTVA—*see* WORLD OF ART

MOBILE—*see* KINETIC SCULPTURE

MODERN/MODERNISM

Generically, *modern* refers to the contemporaneous. All art is modern to those who make it, whether they are the inhabitants of Renaissance Florence or twentieth-century New York. Even paintings being made today in a fifteenth-century style are still modern in this sense.

As an art historical term, *modern* refers specifically to a period dating roughly from the 1860s through the 1970s and is used to describe the style and the ideology of art produced during that era. It is this more specific use of *modern* that is intended when people speak of modern art or of modernism—that is, the philosophy of modern art.

What characterizes modern art and modernism? Chiefly, a radically new attitude toward both the past and the present. Beginning in the late eighteenth century—a historical epoch sometimes known as the age of revolution—artists began to regard contemporary events as worthy of the artistic attention traditionally lavished on scenes from ancient or biblical history. The NEOCLASSICAL artist Jacques Louis David and the ROMANTIC artist Francisco de Goya depicted events from the French Revolution and the Napoleonic invasion of Spain, respectively. The widespread political upheavals that swept Europe in 1848—coupled with an increasingly enfeebled official, or ACADEMIC, art—exerted irresistible pressures on some artists to act on the REALIST artist Honoré Daumier's pronouncement that "Il faut être de son temps" (It is necessary to be of one's time).

The relatively isolated examples of contemporary subjects by David and Goya gave way in the mid nineteenth-century to the categorical rejection of

depicting the past by Realist painters such as Gustave Courbet and Edouard Manet. Modern artists beginning with the IMPRESSIONISTS and POST-IMPRESSIONISTS abandoned not only the revival of historical subject matter, but also the tradition of illusionism that had developed in Western art since the Renaissance. Their allegiance to the new was evident in the concept of the avant-garde, a military term meaning "advance guard." Avant-garde artists began to be regarded as ahead of their time. Although popularly accepted, this idea of any artist's being able to act "outside history," somehow free from the constraints of a particular era, is rejected by art historians.

Crucial to the development of modernism was the breakdown of traditional sources of financial support—the church, the state, and the aristocratic elite. The old style of patronage had mandated artworks that glorified the institutions or individuals who had commissioned them. Newly independent artists were now free to determine the appearance and content of their art, which was often critical of the status quo. The scant likelihood of sales in the emerging capitalist art market encouraged artists to experiment. The term "ART FOR ART'S SAKE"—which had been coined in the early nineteenth century— was now widely used to describe highly personal art that needed no social or religious justification for its existence.

Modern art arose as part of Western society's attempt to come to terms with the urban, industrial, and secular society that emerged during the nineteenth century. Modern artists have challenged middle-class values by depicting new subjects in disquieting new STYLES that seemed to change at a dizzying pace. The notion of progress in art—the succession of one style on the heels of its predecessor—is a nineteenth-century idea inextricably linked to the similarly progressive view of society known as positivism.

Certain types of CONTENT—the celebration of technology, the investigation of SPIRITUALITY, the evocation of PRIMITIVISM—have recurred in modern artworks of different styles. The celebration of technology and science took form in the glorification of speed seen in FUTURISM and RAYONISM, and in the use of scientific models of thinking by artists linked with CONSTRUCTIVISM and CONCRETE ART. The investigation of spirituality embodied in SYMBOLISM and in work by the DE STIJL, NABI, and DER BLAUE REITER artists was a reaction against the secularism and materialism of the modern era. Evocations of primitivism in Post-Impressionism, CUBISM, and German EXPRESSIONISM reflected new contacts with African and Oceanic cultures "discovered" through imperialism. Ironically the effort by artists to come to terms with the dislocating effects of modernity frequently resulted in their rejecting it in favor of primitivism, JAPONISME, or NAIVE ART.

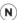
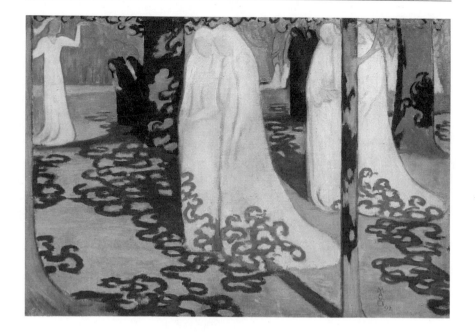

MAURICE DENIS (1870–1943).
Procession under the Trees, 1892. Oil on canvas, 22 x 32 in.
(55.9 x 81.2 cm). Mr. and Mrs. Arthur G. Altschul, New York.

NABIS

▷ **WHO** (All from France) Pierre BONNARD, Maurice Denis, Aristide MAILLOL, Paul Ranson, Ker Xavier Roussel, Paul Sérusier, Félix Vallotton, Edouard VUILLARD

▷ **WHEN** 1890s

▷ **WHERE** France

▷ **WHAT** The name *Nabis* was coined in 1888 by, and for, a group of young Parisian artists attracted to the paintings produced by Paul Gauguin in Brittany during the late 1880s. *Nabi* is Hebrew for "prophet," and its use aptly conveys the mysticism of this semi-secret society whose members studied the occult aspects of Eastern faiths and frequently took the world's religions as subjects for their paintings. Such SPIRITUAL concerns link them with the broader SYMBOLIST phenomenon of the 1890s.

The Nabis ardently admired Gauguin's ability to convey—through arbitrary, non-NATURALISTIC color and flattened forms—the religious devotion of the Breton peasantry. Gauguin developed this intuitive, emotional, and anti-REALIST aesthetic while working with the younger painter Emile Bernard in Pont-Aven, Brittany, during the summer of 1888. (The Nabi artists, along with Bernard, are sometimes referred to as the Pont-Aven School.) Employing flat patches of color delineated by dark contours, the Nabi STYLE is reminiscent of medieval stained glass and cloisonné enameling, and was promptly dubbed *Cloisonism*. Gauguin himself preferred the term *Synthetism*.

Whatever this decorative and EXPRESSIONISTIC style was called, its dissemination was one of two Nabi contributions to MODERN art. (Apart from Pierre Bonnard, Aristide Maillol, and Edouard Vuillard, the Nabis were inconsequential artists.) The other was the widely published writing by artist-theorists like Maurice Denis and Paul Sérusier, whose speculations helped lay the philosophical groundwork for the development of ABSTRACTION and expressionism.

NAIVE ART

Naive art is produced by self-taught artists who lack formal training but are often obsessively committed to making art. Their work may appear to be innocent and childlike, but this is usually deceptive: naive artists frequently borrow conventional compositions and techniques from the history of art and strive for precision and technical polish.

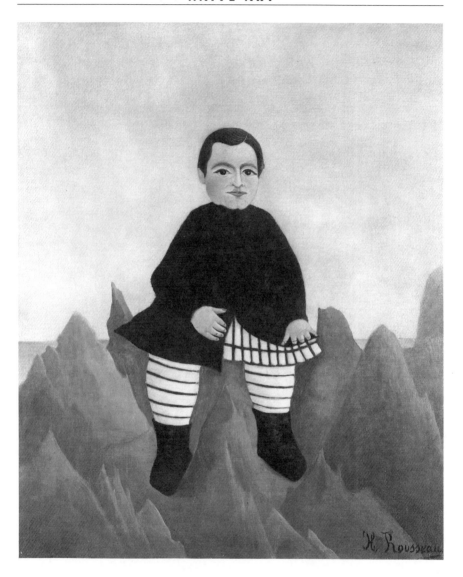

HENRI ROUSSEAU (1844–1910).
Boy on the Rocks, 1895–97. Oil on linen, 21 3/4 x 18 in. (55.2 x 45.7 cm).
Chester Dale Collection; National Gallery of Art, Washington, D.C.

There is a generally recognizable naive style, which is evident in the work of the two best-known naive artists of the MODERNIST era—the painter Henri ("Le Douanier") Rousseau and the builder Ferdinand ("Le Facteur") Cheval. In painting, the naive style tends toward bright colors, abundant detail, and flat space. In sculpture (or architectural constructions), it often involves assembling FOUND OBJECTS or cast-off materials in exuberant concoctions.

The modern interest in naive art stems from modernism's fascination with "PRIMITIVE" cultures and unconscious states of mind. The development of ABSTRACTION—which may look like naive art to those unfamiliar with it—has made the distortions of actual naive art part of the mainstream. The first evidence of this phenomenon may be the popularity of Rousseau, a former Sunday painter (with, in fact, some formal training in art) whose charmingly abstracted fantasies seemed appealingly avant-garde to Pablo Picasso and his circle in early twentieth-century Paris. After World War I, SURREALIST artists and poets such as Max Ernst and André Breton made pilgrimages to Cheval's Palais Idéal (Ideal Palace), a monumental construction of grottoes and towers near Lyons that was crafted from stones and shells by the retired postman over the course of three decades.

Naive art should not be confused with folk art. Folk art features traditional decoration and functional forms specific to a culture. (Folk art has been generally corrupted by the demands of tourism.) Naive art is a product of individual psyches rather than communal history, and it tends to be decorative and nonfunctional.

NATURALISM

An approach to making art rather than a specific STYLE, naturalism is based on the accurate depiction of people, places, and things. Carried to its illusionistic extreme, this fidelity to appearances results in trompe-l'oeil—literally "fool-the-eye"—painting. Naturalism in art has existed since at least the third millennium B.C., when Egyptian artists produced sculptures of pharaohs and their queens that are clearly recognizable as individual portraits. Since then naturalistic art has been created by classical Greek and Roman and Renaissance artists, as well as by Western painters and sculptors of every era during the past five hundred years.

Idealism—an art-making approach based not on the study of nature but on the creation of stylized or ideal "types"—is the opposite of naturalism. Like the paired concepts of ABSTRACTION/representation and EXPRESSIONISM/IMPRESSIONISM, idealism and naturalism actually form two ends of one spectrum.

The adjectives *naturalistic* or *ideal* may even be used to describe different aspects of the same artwork. Michelangelo's David, for instance, is naturalistic in its depiction of anatomical details such as veins and musculature derived from the artist's dissection of corpses, but idealized in the classical perfection of the figure's face. Similarly, the naturalistic detail of LUMINIST landscape paintings appears within an idealized composition intended to create a poetic mood.

REALISM and *naturalism* are often used as synonyms. This can be confusing because there are two kinds of realism: the first, like naturalism, implies an interest in the actual appearance of things unrelated to a specific historical period; the second, Realism with a capital *R,* refers to a mid-nineteenth-century style.

NATURLYRISMUS

▷ **WHO** (All from Germany) Ludwig Dill, Hans am Ende, Ludwig von Hofmann, Adolf HÖLZEL, A. Langhammer, Walter LEISTEKOW, Fritz Mackensen, Otto Modersohn, Paula MODERSOHN-BECKER, Fritz Overbeck, Karl Vinnen, Heinrich Vogeler

▷ **WHEN** 1889 to 1905

▷ **WHERE** Germany

▷ **WHAT** *Naturlyrismus*—literally "nature lyricism"—describes two schools of German painting (named after the towns in which the artists lived) characterized by an attraction to the poetic qualities of nature. The Worpswede painters depicted the watery landscape of northern Germany near Bremen; the Dachau group focused on the Bavarian moors near the Ammer River. The former founded a very loose association in 1889; the latter, a more tightly knit group in 1893.

The artists of both groups shared an antipathy to the earthy visions of REALISM and IMPRESSIONISM, preferring BARBIZON SCHOOL painting and the bright colors and decorative lines of ART NOUVEAU. In the surprisingly similar paintings by the Worpswede and Dachau artists, very tall trees alongside tranquil waterways are informally cropped at the top of unpeopled compositions; romantic mists soften the effect. Naturlyrismus helped inspire the more subjective visions of German SYMBOLISM and—far more important—the hotly colored EXPRESSIONISM of DIE BRÜCKE.

NAZARENES—*see* PRE-RAPHAELITISM

NAZI ART

Nazi (or National Socialist) art denotes work officially sanctioned by the right-wing dictator Adolf Hitler, who assumed power in Germany in 1933. Determined to control every aspect of life in Germany, Hitler placed particular emphasis on the manipulation of culture. As his power increased, institutions such as the BAUHAUS were closed, and MODERN artists left Germany in droves.

One of Hitler's first acts in 1933 was the official suppression of modernist—or so-called degenerate—art, which ran the stylistic gamut from IMPRESSIONISM to EXPRESSIONISM and spanned subjects that ranged from the downtrodden on the streets to bohemians in cabarets. In 1935 Joseph Goebbels, the Nazi minister of propaganda, ordered artists to produce "racially conscious" popular art "within the limits prescribed, not by any artistic idea, but by the political idea." This meant representational art that glorified the Nazi ideals of the Aryan superman and superwoman (that is to say, supermother) and portrayed an exalted view of the history of the German "motherland." Contemporary history painting was exemplified by portraits of the Führer patterned on Renaissance or Baroque masterworks.

Two major exhibitions were held in Munich in 1937: one of Nazi art and the other of degenerate art. Hitler dismissed the selection committee of the former for not having rigorously adhered to his criteria, and the latter—which traveled to several cities—was among the most controversial exhibitions in German history. Art dubbed degenerate or "Judeo-Bolshevik" was confiscated from German museums, and much of it was auctioned in Lucerne, Switzerland, in 1938. To replace it, more than twenty thousand officially approved artworks were distributed. Most of them were removed after the war, but some works—especially sculptures by Arno Breker—have recently been brought out of storage and, in the process, generated new controversy. Some Germans regard such works as cultural artifacts, while others see them as symbols of a past that should remain hidden.

Most of the Nazi-sponsored painting and sculpture was undistinguished, but the films, the public spectacles in the form of rallies, and the architectural plans were far more effective. Hitler's conservative, classicizing aesthetic—common throughout the West during the 1930s, though more popular with the Communist dictator Josef Stalin than with Hitler's fellow fascist Benito Mussolini—found expression in the grandiose architectural schemes of Albert Speer, Hitler's principal architect and minister of armaments. Had World War II not intervened, Speer's Stadium of the Four Hundred Thousand

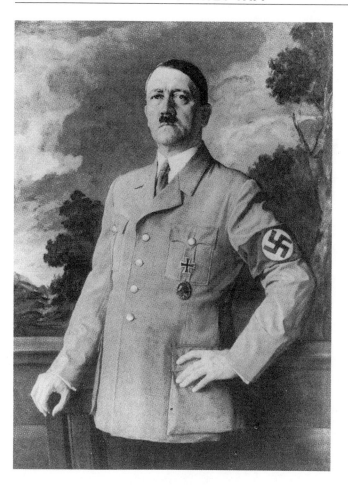

HEINRICH KNIRR (1862–1944).
Portrait of the Führer, 1937. Location unknown.

in Nuremberg and Berlin Dome would have been among the largest structures ever built—grandiose embodiments of Hitler's ambition to become a latter-day Roman emperor and founder of the "Thousand-Year Reich."

See FASCIST ART

NEGRITUDE—*see* HARLEM RENAISSANCE

NEOCLASSICISM

▷ **WHO** Antonio CANOVA (Italy), Jacques Louis DAVID (France), John Flaxman (Great Britain), Horatio Greenough (United States), Jean Antoine Houdon (France), Jean Auguste Dominique Ingres (France), Angelica Kauffmann (Great Britain), Hiram Powers (United States), Bertel Thorvaldsen (Denmark), Benjamin West (Great Britain)

▷ **WHEN** 1760 to 1830

▷ **WHERE** Western Europe and the United States

▷ **WHAT** Neoclassicism, a premodern style, is included here because it is the first of the "escapist" ROMANTIC styles that later nineteenth-century artists would both emulate and reject.

Neoclassicism was a revival of antiquity catalyzed by the mid-eighteenth-century excavations of the ancient cities of Pompeii and Herculaneum. Unlike the earlier revival of Greco-Roman art and literature known as the Renaissance, Neoclassicism was based on actual archaeological findings. Although Paris was becoming the center of the art world at the end of the eighteenth century, Rome was the birthplace and spiritual center of Neoclassicism.

Neoclassical sculptors and architects turned to Greek and Roman precedents for inspiration, although they ignored the fact that classical, white marble statuary had originally been painted vivid colors. Sculptors idealized sitters as gods and goddesses in the nude or clad in antique garb; and architects adopted classical architectural language, particularly the Greek temple facade and the Roman dome. Since very little classical painting had survived, Neoclassical painting tended to derive from sculpture. Works by the greatest Neoclassical artists—the painter Jacques Louis David's *Madame Récamier* (1800) and the sculptor Antonio Canova's *Pauline Bonaparte Borghese as*

Venus Victorious (1808)—similarly depict elegant sitters in profile poses reclining on antique chaise longues.

With its emphasis on line and its smooth-as-glass paint surface, David's work epitomizes the Neoclassical painting style. His construction of a stylized, friezelike space, derived from classical vase painting or sculptural relief, set the stage for the increasingly shallow pictorial space employed by modern painters. David's ability to put such radical simplification to new, politically charged purposes rendered Neoclassicism's stylistic austerity the moral equivalent of opposition to the decadent French monarchy. His work seems to epitomize the "noble simplicity and calm grandeur" extolled by the German archaeologist and art critic Johann Joachim Winckelmann, Neoclassicism's godfather.

Neoclassicism has inaccurately been regarded as Romanticism's opposite, but art historians now consider it to be a subset of the larger, more complex, Romantic phenomenon, distinguished from it primarily by its slightly earlier date. Inherent to both Neoclassicism and Romanticism is the idea of escaping to other times and places, whether such exotic locales as the Orient and the South Seas or the Greece or Rome of classical antiquity.

NEO-IMPRESSIONISM

▷ **WHO** Henri Edmond Cross (France), Georges Lemmen (Belgium), Henri Matisse (France), Camille Pissarro (France), Théo van Rysselberghe (Belgium), Georges SEURAT (France), Paul Signac (France), Jan Toorop (Belgium)

▷ **WHEN** 1880 to 1900

▷ **WHERE** Paris and Brussels

▷ **WHAT** The term *Neo-Impressionism* was coined by the Parisian critic Félix Fénéon in 1886 after he saw Georges Seurat's *A Sunday Afternoon on the Island of La Grande Jatte* (1884–86) at the last IMPRESSIONIST exhibition. "*Peinture au point*" ("painting by dots") is the phrase Fénéon used to describe the famous work, and *pointillism* became a virtual synonym for Neo-Impressionism. *Divisionism*, a less common synonym for both, was the term favored by Seurat.

Pioneered by Seurat and his disciple Paul Signac, the Neo-Impressionist STYLE was an attempt to scientifically rationalize the Impressionist intuition that reality could be more convincingly depicted with disconnected strokes of

primary color blended by the viewer's eyes than with tones mixed on the painter's palette. The Neo-Impressionists' method involved a color theory based on up-to-date treatises about color and optics by Charles Blanc, Michel Eugène Chevreul, and Ogden Rood. Unmixed dots of paint—white, primary colors, and combinations of complementary colors—were applied in close proximity, yielding luminous, brilliantly light-filled paintings (see page 18). The practice, favored by some Impressionist painters, of painting out-of-doors was replaced by a slow and rigorously methodical process that could take place only inside the studio.

Neo-Impressionist subject matter varied from Signac's decorative portraits and landscapes that presaged ART NOUVEAU patterning and FAUVIST color to Seurat's mysteriously somber reveries on life in Paris. The latter's unique ability to synthesize a dreamlike mood and the pointillist evocation of mathematical rationality inspired a broad range of artists, from the German EXPRESSIONISTS to the post–World War II color-field painters. Several members of LES VINGT (The Twenty), an AVANT-GARDE group of Belgian artists, embraced Neo-Impressionism after Seurat's *Grande Jatte* was exhibited in Brussels in 1887. Unfortunately, pointillist technique was so easily imitated that it sometimes degenerated into a blandly decorative, turn-of-the-century signifier of modernity.

NEO-PLASTICISM—*see* DE STIJL

NEO-PRIMITIVISM

▷ **WHO** (All from Russia) David Burliuk, Vladimir Burliuk, Marc Chagall, Natalia GONCHAROVA, Mikhail LARIONOV, Kazimir Malevich, Aleksey Morgunov, Vladimir Tatlin

▷ **WHEN** 1908 to 1912

▷ **WHERE** Moscow

▷ **WHAT** *Neo-Primitivism* is a term used to describe Russian paintings produced prior to World War I and inspired by children's art, Russian Orthodox icons, and Russian folk art. Neo-Primitivist works tend to be brightly colored, forcefully painted, and willfully devoid of the traditional illusion of perspective. Typical subjects include landscapes and portraits, invariably with a distinctly EXPRESSIONISTIC, Russian flavor.

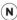

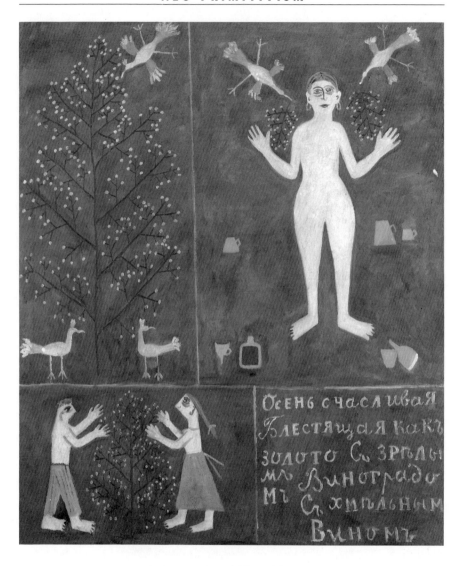

MIKHAIL LARIONOV (1882–1964).
Autumn, 1911. Oil on canvas, 53 1/2 x 45 in. (135.9 x 114.3 cm).
Musée National d'Art Moderne, Centre Georges Pompidou, Paris.

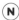

The "Russianization"—not the rejection—of MODERN art was the group's mission. Members organized influential exhibitions, such as the *Jack of Diamonds* (1910), which were intended to showcase their work. Group leader Mikhail Larionov was the most accomplished of the Neo-Primitivists: his images of soldiers and sailors, for instance, simultaneously acknowledge the more elegant Fauvist canvases of Matisse and assault them with crude paint handling and draftsmanship. The culmination of the movement was the *Donkey's Tail* exhibition of March 1912, organized by Larionov. It presented for the first time under one roof work by many of the artists who would come to be known as the Russian avant-garde—a blanket term for Russian modernist art encompassing CUBO-FUTURISM, CONSTRUCTIVISM, RAYONISM, and SUPREMATISM between about 1908 and the introduction of Stalinist SOCIAL REALISM in the early 1930s. Neo-Primitivism is the first of these modernist movements and an indirect response to the liberalization of Russian society brought about by the Revolution of 1905.

NEO-ROMANTICISM

▷ **WHO** Christian Bérard (France), Eugene Berman (USSR), Leonid Berman (USSR), Pavel Tchelitchew (USSR)

▷ **WHEN** 1926 to 1941

▷ **WHERE** Paris and New York

▷ **WHAT** The artists Christian Bérard, Eugene and Leonid Berman, and Pavel Tchelitchew were dubbed Neo-Romantics following their group show at the Galerie Drouet in Paris in 1926. The name came from the artists' shared interest in depicting figures enveloped in an atmosphere of romantic melancholy, an effect achieved through the use of dark tones and heavy impasto. Their painting ran the gamut from Tchelitchew's moody portraits of socialites and literati to Eugene Berman's enigmatic ALLEGORIES. The composer Virgil Thomson shrewdly noted that with Neo-Romanticism, "elegance is the real preoccupation." Typically regarded as an offshoot of SURREALISM, it was also a product of its exemplars' extensive experience designing for the dance and theater—primarily Sergey Diaghilev's Ballets Russes.

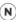

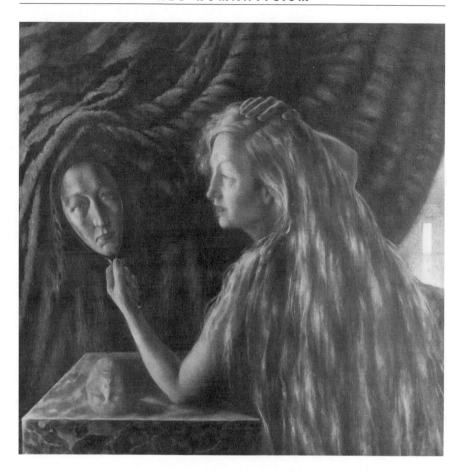

PAVEL TCHELITCHEW (1898–1957).
Constance Askew, 1938. Oil on canvas, 39 x 39 in.
(99 x 99 cm). Wadsworth Atheneum, Hartford, Connecticut;
Gift of Mrs. R. Kirk Askew.

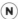

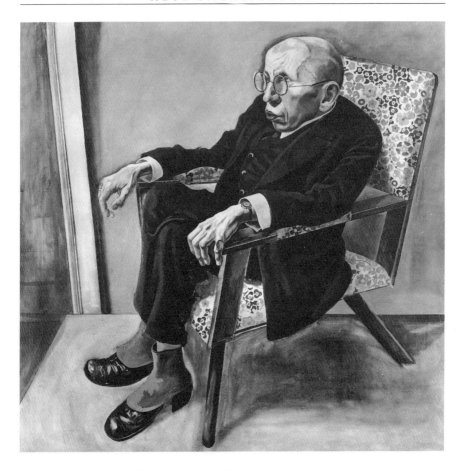

GEORGE GROSZ (1893–1959).
Portrait of Max Hermann-Neisse, 1925. Oil on canvas, 40 x 40 in.
(101.6 x 101.6 cm). Städtische Kunsthalle, Mannheim, Germany.

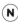

NEUE SACHLICHKEIT

▷ **WHO** (All from Germany) Max BECKMANN, Heinrich Davringhausen, Otto DIX, George GROSZ, Kurt Gunther, Carl Hofer, Georg Schrimpf

▷ **WHEN** 1920 to 1932

▷ **WHERE** Germany

▷ **WHAT** The German term *Neue Sachlichkeit* (in English, "New Objectivity") was coined in 1923 by G. F. Hartlaub, director of the Kunsthalle in Mannheim, Germany, for an exhibition of postwar painting held in Mannheim in 1925. He defined it as "a new realism bearing a socialist flavor . . . related to the general contemporary feeling in Germany of resignation and cynicism after a period of exuberant hopes." That resignation and cynicism sprang from the political and economic chaos that plagued Germany during the period of the Weimar Republic.

Neue Sachlichkeit reflected the international disenchantment with ABSTRACTION—and with idealism in general—that followed World War I; it might be more precisely described as a FIGURATIVE and anti-EXPRESSIONIST rather than a REALISTIC style. Of the three artists whose names are most closely linked with Neue Sachlichkeit—Max Beckmann, Otto Dix, and George Grosz—only Dix can be considered a realist. His compelling portraits are closely observed and sometimes satirical depictions of the bourgeoisie. Grosz specialized in bitter and biting drawings of human "types" that expressed his distrust of militarism and authority. Beckmann evolved from a detached and psychologically astute portraitist into a painter of ALLEGORICAL and mythological scenes during the 1920s. The individual styles of these three important artists overlapped for only a brief period during the early 1920s, but throughout their careers they all continued to depict the corrosive effects of violence and opportunism on the human spirit.

NEW OBJECTIVITY—*see* NEUE SACHLICHKEIT

THE NEW SCULPTURE

▷ **WHO** (All from Great Britain) Edward Onslow Ford, Alfred Gilbert, Frederic LEIGHTON

▷ **WHEN** 1875 to 1895

▷ **WHERE** England

▷ **WHAT** *The New Sculpture* was a vague term bandied about by British art critics of the late nineteenth century to loosely describe some British sculpture of that period. As much a positive attitude toward modest innovation as a STYLE, the New Sculpture comprises the work of a generation of sculptors born during the 1850s and trained in Paris who worked in bronze and tended to depict the nude.

A key event that led to the term's origin was the acclaimed exhibition of the painter Frederic Leighton's life-size bronze figure *An Athlete Wrestling with a Python* at the Royal Academy in 1877 and at the Paris INTERNATIONAL EXPOSITION of 1878. Its originality lay in its physical energy and NATURALISTIC depiction of anatomy, although compared to contemporaneous work by the French sculptor Auguste Rodin it is still veiled in a classicism that looks old-fashioned next to the French sculptor's radical naturalism. The New Sculptors frequently received large public commissions (often monuments to Queen Victoria) and helped boost the quality of public sculpture in Britain to a higher level than on the Continent.

9 × 5

A controversial exhibition held at Buxton's gallery in Melbourne in 1889, 9 × 5 was considered the first exhibition of MODERNIST art in Australia. The title refers to the diminutive dimensions—just 9 by 5 inches—of the 183 paintings in the show; many of them were painted on the lids of cigar boxes.

The seven artists represented in the exhibition—the four most important exhibitors being Charles Conder, Frederick McCubbin, Tom Roberts, and Arthur Streeton plus Herbert Daly, R. E. Falls, and C. Douglas Richardson—belonged to the so-called Heidelberg School of (mostly) landscape painting, named after the village near Melbourne where they gathered to paint. The show was characterized by spontaneous-looking works painted *en plein air*, without black paint, and largely derived from James McNeill Whistler's use of atmospheric tones. Subtitled an "Exhibition of Impressions" and accompanied by a MANIFESTO (the first in Australian art) that called the artists Impressionists, the exhibition has created a case of mistaken identity. By "Impressionist" the artists meant only that they were interested in capturing fleeting natural phenomena. The divided brushstroke so central to the IMPRESSIONIST preoccupation with the depiction of light does not appear in any of the works exhibited in 9 × 5.

Some Australian critics failed to understand that the charming impressions on view were finished works rather than sketches, and most of them strenuously objected to the paintings' lack of ACADEMIC polish.

NONOBJECTIVE ART—*see* ABSTRACT/ABSTRACTION

NOVECENTO ITALIANO—*see* FASCIST ART

NOVEMBERGRUPPE—*see* BAUHAUS

OFFICIAL WAR ART

Official War Art is precisely what its name implies: art commissioned by a government to inspire its citizenry during wartime and to record the circumstances of that war for posterity. Official War Art—with capital letters—is a modern invention; in the past it had been taken for granted that powerful rulers would employ artists to glorify their military and nonmilitary exploits. Even though the ACADEMIC principles of art favored from the sixteenth to the nineteenth century discouraged the depiction of contemporary events, they were nonetheless represented in history paintings through symbol or ALLEGORY. Official War Art—both painting and photography—is an attempt to fill the void left by the disappearance of history painting.

Official War Art emerged during World War I in English-speaking countries— first Canada, then Great Britain, Australia, and the United States. In Canada, where the artworks were known as the Canadian War Memorials, the Official War Art program was created by the minister of information, Lord Beaverbrook, who commissioned paintings from a variety of Canadian and English artists, including the GROUP OF SEVEN, Augustus John, Paul Nash, and the VORTICISTS. (The Canadian War Memorials are now displayed in the Canadian War Museum, Ottawa.) The issue of how to reach varied audiences inevitably bedevils such public art enterprises, and it is unclear whether these sometimes AVANT-GARDE artworks ever had much public appeal. The British, Australian, and U.S. artists, on the other hand, produced for their countries' programs vast numbers of anything but avant-garde works that too often resembled propagandistic magazine illustrations.

During World War II it was the British government that assembled a distinguished group of war artists, including Henry Moore, John Piper, Stanley

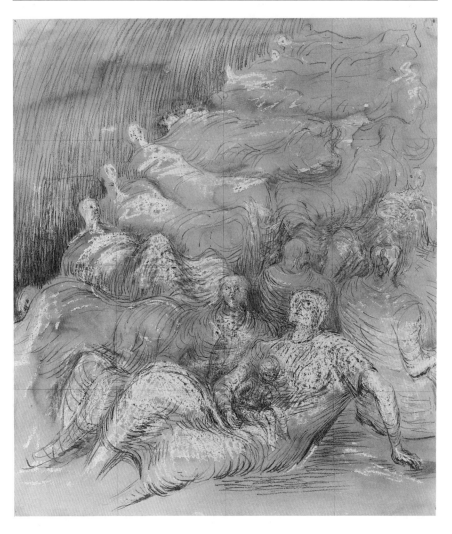

HENRY MOORE (1898–1986).
Pale Shelter Scene, 1941. Pen, ink, chalk, watercolor, and gouache on paper, 19 x 17 in. (48.3 x 43.2 cm). Tate Gallery, London.

Spencer, and Graham Sutherland, under the direction of the art historian Kenneth Clark. Moore's drawings of Londoners seeking refuge from air raids in the city's subway system, known as the underground or the tube, are among the most moving artistic responses to World War II. (Many of them can be seen in London's Imperial War Museum.) The poorly administered U.S. war art program was turned over to *Life* magazine during World War II and then split again between the different military branches—army, navy, marines, coast guard—yielding no discernible aesthetic accomplishments. The programs remain in existence, and U.S. Army artists were sent to Vietnam to create reportorial works and most recently, in 1991, to document the Persian Gulf War.

As state-sponsored art, Official War Art should be considered alongside SOCIAL REALISM, NAZI ART, FASCIST ART, and other varieties of propagandistic, government-sponsored art.

OMEGA WORKSHOPS—*see* BLOOMSBURY GROUP

OPTICAL REALISM—*see* IMPRESSIONISM

ORIENTALISM

Western society's fascination with North Africa and the Near East—rather than China and Japan—was embodied in the scholarly studies, novels, poetry, paintings, and photographs generally categorized as Orientalism. The catalyst for the fascination was French and British imperial conquests in the region, beginning with Napoleon's invasion of Egypt in 1798 and continuing with the French occupation of Algeria (1830), Morocco (1844), Tunisia (1881), and—a year later—by Great Britain's seizure of Egypt. European interest in the exotic-seeming Islamic world coincided with the weakening of the formerly dominant Ottoman Empire. The collapse of the empire contributed to the start of World War I, which also marked the end of Orientalism in Western art.

European artists—including Théodore Chassériau, Eugène Delacroix, Jean Léon Gérôme, Antoine Jean Gros, William Holman Hunt, Jean Auguste Dominique Ingres, Paul Klee, Henri Matisse, William Müller, Auguste Renoir, David Roberts, James Tissot, Horace Vernet—were attracted to a variety of Orientalist subjects, including sexually titillating scenes of baths, harems, and odalisques, the River Nile, Bedouin encampments, the starkly beautiful

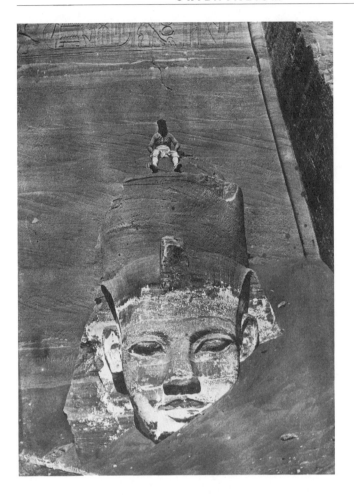

MAXIME DU CAMP (1822–1894).
The Colossus of Abu-Simbel, 1852. Salted paper print from a calotype negative, 8 7/8 x 6 5/16 in. (22.5 x 16 cm). International Museum of Photography at George Eastman House, Rochester, New York.

landscape, and the religious rites of Islam. Photographers like Félice Beato, Maxime Du Camp, Frances Frith, and Gustave Le Gray specialized in photographing ancient monuments, which were especially suited to the lengthy exposure times demanded by nineteenth-century photographic technology.

Orientalism indicates a preference for certain subjects, rather than a STYLE. A staple of ROMANTIC art, Orientalist subjects were also depicted in diverse styles that ranged from REALISM to FAUVISM. Some artists' individual styles were affected by the blazing light and distant horizons of the arid landscape they depicted. Delacroix—and later Renoir and Matisse—were encouraged in their bold handling of saturated color by their stays in North Africa. The Orientalist taste for the exotic foretells the later popularity of Japanese motifs known as JAPONISME. Orientalism was so popular that an annual SALON of Orientalist painters was founded in Paris in 1894.

ORPHISM

▷ **WHO** (From France unless otherwise noted) Robert DELAUNAY, Sonia Delaunay, Marcel Duchamp, František Kupka (Czechoslovakia), Francis Picabia, Jacques Villon

▷ **WHEN** 1911 to 1914

▷ **WHERE** Paris

▷ **WHAT** *Orphism* is the name coined by the writer Guillaume Apollinaire for the paintings by Robert Delaunay seen at the SECTION D'OR exhibition in Paris in 1912 and a year later at the Galerie der Sturm in Berlin. Apollinaire's revival of the SYMBOLIST musical term *Orphique* (meaning "entrancingly lyrical") refers to both Delaunay's introduction of vivid color into the somber palette of ANALYTIC CUBISM and the SYNESTHETIC idea that musical, visual, or literary sensations have equivalents in other mediums of expression. Although Apollinaire linked Delaunay's Cubistic painting with Cubism, Delaunay's primary concern was with color rather than formal structure (see page 30). He wrote, "Color alone is form and subject." His vivid palette derived from the theorist Michel Eugène Chevreul's principles of "simultaneous contrast."

Around 1911 both Delaunay and František Kupka turned to complete ABSTRACTION, making Orphism the first movement devoted to nonrepresentational painting. (Delaunay's subjects had previously included emblems of dynamic contemporary life such as the Eiffel Tower and the newly invented *aéroplane*, which had rarely been represented in art before.) The two artists cre-

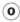

ated colorful, kaleidoscopic patterns of geometric shapes without even the suggestion of a subject found in nature. Along with Wassily Kandinsky, the Russian painter working in Germany, they are considered the "inventors" of MODERNIST abstraction.

See PUTEAUX GROUP

OSMA

▷ **WHO** (All from Czechoslovakia) Vincenc BENEŠ, Bedřich Feigl, Emil FILLA, Max Horb, Otakar Kubín, Bohumil KUBIŠTA, Willi Nowak, Alois Pitterman, Antonín Procházka, Linka Scheithauerová

▷ **WHEN** 1907 to 1914

▷ **WHERE** Prague

▷ **WHAT** Osma (a Czech word meaning "the Eight") was the name taken by a group of young painters in Prague who were among the first advocates of MODERNIST art in Czechoslovakia. The painters of the Osma group exhibited together for the first time in 1907, the same year in which French IMPRESSION-IST and POST-IMPRESSIONIST painting was first shown in Czechoslovakia. At first highly influenced by the EXPRESSIONISM of the Norwegian artist Edvard Munch, Osma artists grew increasingly interested in the CUBIST vocabulary of form, with which they became familiar almost immediately after its inception.

In 1911 the core members of Osma organized the Skupina Výtvarných Umělců—or Group of Avant-garde Artists, known simply as Skupina—which was dedicated largely to the advancement of Cubism. In addition to Vincenc Beneš, Emil Filla, and Antonín Procházka, other key Skupina artists included the painters Josef Čapek, Ladislav Šima, and Václav Špála, and the sculptor Otto Gutfreund. Skupina organized numerous exhibitions of Czech and foreign art, which caused dissension within the group. Some regarded Picasso and Braque's Cubism as overly FORMALISTIC and inferior to more expressionistic variants by such artists as Marcel Duchamp, Fernand Léger, and Diego Rivera. Before such differences could be resolved, World War I caused the group to disband in 1914. From 1911 to 1914 they published *Umelěcký měsíčník* (*Artist's Monthly*) in conjunction with like-minded architects, writers, and graphic artists, using it to help spread the gospel of modernism throughout Czechoslovakia.

It is crucial to remember that prior to World War I the cultural and political boundaries of Europe differed radically from those established after World

War II. Prague was closely linked with Vienna, and many Viennese avant-garde artists, such as Oskar Kokoschka, were Czech. The significant place of Czech artists in modernist art is suggested by their broad representation in major German exhibitions such as the *New Secession,* held in Berlin in 1911; the Sonderbund, held in Cologne in 1912; and the First German Autumn Salon, held in Berlin in 1913.

PAPIERS COLLES—see COLLAGE

PEINTRES MAUDITS—see SCHOOL OF PARIS

PHOTOGRAM

A photogram is a photograph made without a camera. The artist places an object or objects on a sheet of paper (or film) coated with a light-sensitive substance and then exposes it to light. The paper (or film) remains white where the object was placed and dark where it was exposed to the light. Midtones result from the use of translucent objects. After exposure the paper (or film) is developed in order to fix the image.

William Henry Fox Talbot, inventor of the CALOTYPE, made the first pho-tograms in the late 1830s, which he called "photogenic drawings." (The term *photogram* was also used in the late nineteenth century as a synonym for *photograph,* but that meaning has been lost.) The photogram was used after World War I by DADA artists who prized its eerie, X ray–like quality. The Zürich Dadaist Christian Schad began to produce entirely ABSTRACT photo-grams that he dubbed Schadographs in 1918; the American Dadaist Man Ray began to make his representational Rayographs in 1921. Many other artists, including László Moholy-Nagy, soon followed in their footsteps, making the 1920s the halcyon era of the photogram. Such artists also pioneered other overtly art-oriented—rather than photography-oriented—techniques, including double exposures and solarizations, some inspired by EXPRESSIONIST films of the day.

PHOTOJOURNALISM

Although the origins of the illustrated press nearly coincided with the birth of photography—the *Illustrated London News* was founded in 1842—the earli-est medium of choice for mass reproduction of pictures was the wood

CHRISTIAN SCHAD (1894–1982).
Schadograph, 1919. Photogram on daylight printing-out paper,
6 5/8 x 4 15/16 in. (16.8 x 12.5 cm). Collection, The Museum of Modern
Art, New York; Purchase.

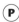

engraving. The necessary technology for reproducing photographs in magazines and newspapers did not arrive until the mid-1880s, with the invention of the halftone plate. Photojournalism as the complementary relationship of image and text so familiar to us today was firmly established by the 1920s, following the development of the miniature camera and fast films. With the ascendance of Hitler in 1933, the center of photojournalism moved from Germany to the United States. This migration is symbolized by the debut of the influential picture magazine *Life* in November 1936, which specialized in the photo essay, or story told through pictures.

The current distinction between photojournalism and "art" photography is a recent phenomenon. In addition to documentary pictures of war, natural disasters, and other current events, many of the most memorable portraits of the twentieth century—by photographers including Cecil Beaton, Alfred Eisenstaedt, and Edward Steichen—were taken on assignment, usually for magazines.

PHOTOMONTAGE—*see* COLLAGE

PHOTO-SECESSION—*see* PICTORIALISM

PICTORIALISM

▷ **WHO** Alvin Langdon Coburn (United States), Robert Demachy (France), Peter Henry EMERSON (Great Britain), Frederick H. Evans (Great Britain), Gertrude Käsebier (United States), Heinrich Kühn (Austria), Alfred Maskell (Great Britain), Baron Adolf de Meyer (France), Henry Peach Robinson (Great Britain), Edward STEICHEN (United States), Alfred STIEGLITZ (United States), Clarence H. White (United States)

▷ **WHEN** 1886 to 1914

▷ **WHERE** Europe and the United States

▷ **WHAT** During the 1850s photographers—especially in England—began to consciously imitate the subjects and compositions of paintings. By the 1880s such works were frequently reminiscent of the weakest ACADEMIC landscape and portraiture. In 1886 the English photographer Peter Henry Emerson wrote an article in the *Amateur Photographer* entitled "Photography: A Pictorial Art." He attacked the conventional division separating art and science—embodied by painting and photography, respectively—and he lectured

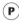

on that subject before the Camera Club in London. His controversial presentations stimulated debate and provided the name *Pictorialism* for the international movement of art-minded photographers at the turn of the century.

New photographic technology helped photographers achieve the often blurry artistic effects they sought. Softening procedures included platinum and gum printing, reproduction by the photogravure (or photoetching) process, and scratching and drawing directly on negatives. The results varied widely, from hazy photographic morality tales by Gertrude Käsebier and soft-focus shots of ballerinas by Robert Demachy that are reminiscent of paintings by Edgar Degas, to dramatically lit portraits by Edward Steichen and wintry scenes by Alfred Stieglitz of New York enveloped in snow.

The evangelical zeal of photographers who wanted photography to be acknowledged as an art form, rather than merely a recording device, fueled the organization of exhibitions and photographers' groups. Major exhibitions—some of them annual SALONS—were mounted in Vienna (1891), London (1893), Hamburg (1893), Paris (1894), and Philadelphia (1898). Important groups dedicated to Pictorialist photography, such as the Linked Ring in London and the Photo-Secession in New York, were founded in 1892 and 1902, respectively, and formed a transatlantic network.

By the time of World War I, Pictorialism's impressionistic style had become a cliché. Its painting-derived aesthetic was supplanted by the imperatives of STRAIGHT PHOTOGRAPHY, which mandated that a photograph look like camera work, not like painting. The Pictorialist battle for recognition of photography's status as art was the successful first skirmish in a campaign that would be waged throughout the MODERNIST era.

See 291, SECESSION

PITTURA METAFISICA—*see* SCUOLA METAFISICA

POINTILLISM—*see* NEO-IMPRESSIONISM

PONT-AVEN SCHOOL—*see* NABIS

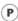
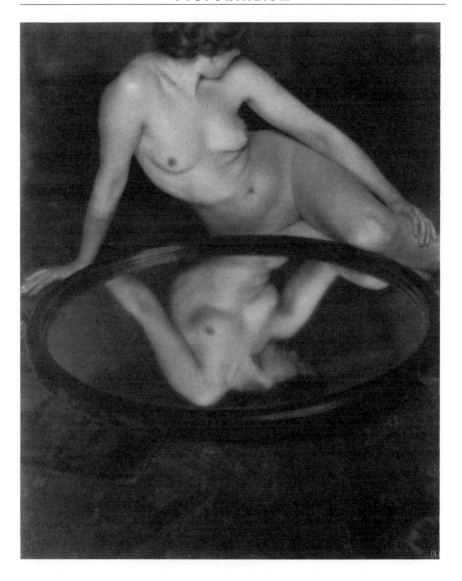

CLARENCE WHITE (1871–1925).
Nude, c. 1909. Platinum print, 9 1/2 x 7 5/8 in. (24.1 x 19.4 cm).
The Museum of Modern Art, New York; John Spencer Fund.

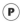
So-called low art—the inexpensive medieval print, for instance—has long existed in Western culture. But popular culture defined as a multitude of different forms of mass communication—including illustrated newspapers, comics, advertising, cabaret, and romance novels—is a distinctly modern phenomenon. It originated in urban Western Europe during the nineteenth century, when a nascent working class with a bit of leisure time on its hands created a demand for new forms of entertainment that were more accessible than opera, classical music, ACADEMIC painting, traditional theater, and literature. Those elite art forms, developed for aristocratic audiences, required education to be understood. They are known as "high art"; popular culture is often referred to as "low art."

MODERN art, with its emphasis on the depiction of contemporary life, incorporated popular culture as subject matter almost from the outset. Places of popular entertainment, including circuses and cabarets, were depicted by artists beginning with the IMPRESSIONISTS; entertainers such as the dancer Loie Fuller were immortalized in portraits created by numerous fine artists at the turn of the century; and the American painter Stuart Davis made Lucky Strike cigarette packs a favorite subject during the 1920s.

Artists also used the ubiquitous products of popular culture as the materials and sources of their art. CUBISTS often composed COLLAGES out of snippets of newspapers, sometimes including advertisements. The DADA artist Marcel Duchamp created an Altered READYMADE from a tin plaque advertising Sapolin paint (1916–17), and other Dadaists were inspired by both ads and by illustrations from mail-order catalogs.

Henri de Toulouse-Lautrec and Pierre Bonnard created posters for entertainments, the Russian CONSTRUCTIVIST artist Aleksandr Rodchenko produced cigarette ads, and Lyonel Feininger drew the comic strip "Wee Willie Winkie," but such work is considered advertising or comic-strip illustration rather than art. The chasm separating high art and popular culture remained vast until long after World War II, when Pop art permanently redefined the relationship between high and low art.

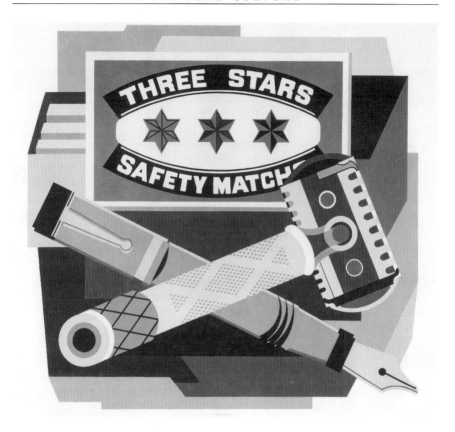

GERALD MURPHY (1888–1964).
Razor, 1924. Oil on canvas, 32 5/8 x 36 1/2 in. (82.9 x 92.7 cm). Dallas Museum of Art; Foundation for the Arts Collection, Gift of the Artist.

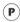

POST-IMPRESSIONISM

▷ **WHO** (All from France) Paul CEZANNE, Paul GAUGUIN, Vincent van GOGH, Georges SEURAT

▷ **WHEN** 1880s through early 1890s

▷ **WHERE** France

▷ **WHAT** Post-Impressionism was christened by the British formalist art critic Roger Fry for the exhibition, called *Manet and the Post-Impressionists,* that he organized at London's Grafton Galleries in 1910. The naming was posthumous; all of the artists listed above had died by 1906. Like so many other hybrid art terms using the chronological prefixes *Post-* or *Neo-,* this one tells us only that its four main exemplars came after IMPRESSIONISM. *Post-* also implies a reaction against what it follows, whereas *Neo-* implies the more positive revival—or embrace—of an earlier artistic movement.

The four Post-Impressionists shared a dissatisfaction with Impressionism's relative formlessness—its blurring of form resulting from the substitution of a colorful haze of fragmented brushstrokes for the traditional use of drawn line. Nonetheless, each of them (except Seurat, who was the creator of NEO-IMPRESSIONISM) had experimented with Impressionist techniques.

The achievements of these four vastly different artists laid the groundwork for a MODERN art based largely on concepts and emotions, rather than on the more objective appearance of reality. Seurat's mosaiclike technique influenced the decoratively inclined pioneers of turn-of-the-century ART NOUVEAU and FAUVISM, as well as the theoretically oriented practitioners of later geometric ABSTRACTION. Cézanne's radical experiments in the construction of landscape and still-life compositions (see page 17) helped inspire CUBISM. By contrast with Seurat's and Cézanne's cerebral art, the emotive and introspective canvases of Gauguin and van Gogh featured private symbolism and nondescriptive color and form, which made them an inspiration for EXPRESSIONISM and SYMBOLISM.

Unlike the slightly older Impressionists, the Post-Impressionist generation of the 1880s found little critical or financial success within their short lifetimes. Van Gogh and Gauguin have, in fact, been reinvented as romanticized emblems of avant-gardism: Gauguin's so-called rejection of bourgeois life in France for Tahiti belies the career concerns he transported to that "primitive

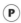

paradise"; van Gogh's tragic status as the virtual embodiment of the alienated modern artist doubtless contributed to the record $53.9 million bid his 1889 painting *Irises* fetched at auction in 1987.

PRECISIONISM

▷ **WHO** (All from the United States) George Ault, Ralston Crawford, Charles DEMUTH, Georgia O'Keeffe, Morton Schamberg, Charles SHEELER, Niles Spencer

▷ **WHEN** 1918 to 1930

▷ **WHERE** United States

▷ **WHAT** Precisionism is a STYLE of American painting that flourished after World War I. The origin of the term is unclear; Precisionist works have also been dubbed *Cubist-Realist* or *Immaculatist,* but *Precisionist* is far more widely used.

Together these three names imply the look of Precisionist paintings: hard-edged and simultaneously realistic and abstracted (here *abstracted* means "simplified"). Precisionist painters were attracted to the unified ABSTRACT designs of CUBISM but wanted to depict subject matter that was easily recognized. The down-to-earth materialism—as opposed to SPIRITUALISM—of American society was traditionally communicated in art that seemed temperamentally opposed to total abstraction or IMPRESSIONIST dematerialization. Ties to the physical world were rarely broken by pre–World War II American artists.

Precisionist paintings are flattened compositions that portray machine-age life in the most advanced, technological culture of the day. Unpeopled images of inherently geometric forms—skyscrapers, grain elevators, factories—were imbued with heroic simplicity. Georgia O'Keeffe painted iconic vistas of nocturnal Manhattan; Charles Demuth produced images of ships and factories viewed through the prismatic lens of Cubism. Photography, too, played its part in Precisionism—especially in Charles Sheeler's noisy-looking images of gleaming locomotive wheels in action.

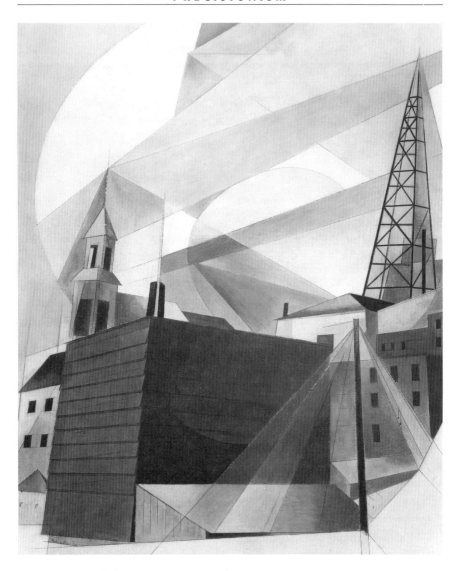

CHARLES DEMUTH (1883–1935).
Lancaster, 1921. Tempera and pencil on paperboard, 19 7/8 x 16 in. (50.5 x 40.6 cm). Albright-Knox Art Gallery, Buffalo, New York; Room of Contemporary Art Fund, 1944.

PRE-RAPHAELITISM

▷ **WHO** (All from Great Britain) James Collinson, William Holman HUNT, John Everett MILLAIS, Dante Gabriel ROSSETTI, William Michael Rossetti, Frederick G. Stephens, Thomas Woolner

▷ **WHEN** 1848 to 1854

▷ **WHERE** Great Britain

▷ **WHAT** The Pre-Raphaelite Brotherhood was an influential secret society formed in London, in 1848, by the seven young artists listed above. When the group disbanded in 1854, its three principal members (Hunt, Millais, and Rossetti) were still just at the start of long and productive careers. Convinced that contemporary ACADEMIC painting was decadent and debased, they sought to purify and reinvigorate it by emulating early Renaissance styles that predated the illusionistic approach perfected by the sixteenth-century painter Raphael. The *Pre-Raphaelite Brotherhood* (or PRB, as it was known) was the name they gave to this primitivizing attempt to return to an imagined golden age. Their quest was inspired in part by the Nazarenes, a brotherhood of early nineteenth-century German painters in Rome with similar aims.

The PRB mined the Bible, everyday life, and English and classical literature for subjects (see page 10). The work that first brought widespread attention to the group was John Everett Millais's *Christ in the House of His Parents* (1850), which was criticized (by Charles Dickens, among others) for its depiction of the Holy Family as all-too-common people. By contrast, the influential critic John Ruskin wrote about the highly symbolic character of many Pre-Raphaelite paintings and became the group's most eminent champion.

It was not only the complex symbolism of their work but also the group's NATURALISTIC painting style that Ruskin regarded as moral. Dubbed "truth to nature," this approach demanded meticulous observation of the natural and manmade features within each painter's composition. (Millais, for instance, studied the tools and musculature of a real carpenter for his *Christ in the House of His Parents*.) The sharp focus applied to every portion of Pre-Raphaelite paintings frequently conveys a mysterious sense of meaning dispersed—and hidden—throughout the work.

This almost hallucinatory quality and the PRB's penchant for painting ALLEGORIES of romantic love and tragedy appealed to SYMBOLISTS like Fernand Khnopff. The lyrical medievalism and luminous, jewellike effects (achieved

by applying bright colors to a wet white ground) of the group's work later influenced the artists associated with the ARTS AND CRAFTS MOVEMENT.

In the United States a group of artists inspired by the Pre-Raphaelites and known as the Association for the Advancement of Truth in Art was founded in 1863. Its members included Henry Farrer, John Henry Hill, John William Hill, Charles Moore, Henry Newman, and William Richards. The association was more important for spreading the gospel of Ruskin through its journal the *New Path* than for the paintings by its members. Ruskin's eloquent—and puritanical—identification of art with the advancement of religion, morality, and love of nature struck a responsive chord in American artists and the American public at large.

PRIMITIVISM

There are several kinds of primitivism. There is art by prehistoric or non-Western peoples. In this case the terms *primitive* and *primitivism* frequently appear in quotes to suggest the inaccuracy and ethnocentricity of such characterizations. There is work by artists who are self-taught, but NAIVE ART more correctly describes their output. There are also subjects or forms borrowed from non-Western and premodern sources, such as Paul Gauguin's renderings of Tahitian motifs. It is these borrowings that proved so central to the development of MODERN art.

In Western culture romantic myths of primitivism are among the most enduring ideas of the last two hundred years. They developed in large part from the sentimental notion of the "noble savage" as a superior being untainted by civilization, which was popularized by the eighteenth-century philosopher Jean Jacques Rousseau. Colonial conquests in Asia, Africa, and Oceania brought those cultures to the attention of Europeans and lured ROMANTIC artists to North Africa and the Middle East. Showcased in the spectacular INTERNATIONAL EXPOSITIONS of the nineteenth century, the arts and crafts of non-Western peoples offered artists expressive, non-NATURALISTIC alternatives to the illusionistic tradition that had prevailed in Western art since the Renaissance.

The desire to express a truth that transcended mere fidelity to appearance was a fundamental tenet of modernism. Although non-Western art provided many European artists with a model for emotive and sometimes antirational art, they frequently misinterpreted it. Fierce-looking West African masks, for instance, were seen as representations of the mask maker's own inflamed

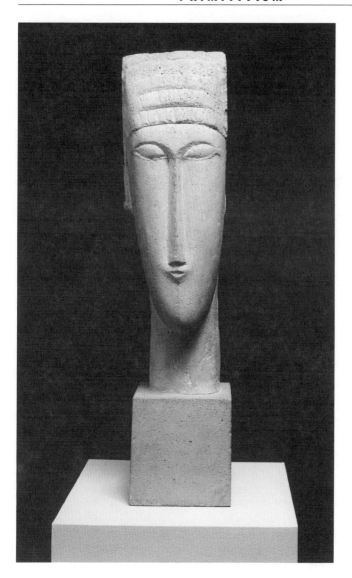

AMEDEO MODIGLIANI (1884–1920).
Head, 1911–13. Limestone, 25 x 6 x 8 1/2 in. (63.5 x 15.2 x 21 cm).
Solomon R. Guggenheim Museum, New York.

feelings, when they were actually produced as talismans to insure a tribe's good fortune in battle.

The compelling desire to invest art with emotional or spiritual authenticity distinguishes modern from Victorian art, which tried to instruct or divert viewers. To communicate genuine feeling, modern artists turned to a multitude of primitivizing approaches. CUBIST artists such as Pablo Picasso used forms derived from African and ancient Iberian sculpture. The German EXPRESSIONISTS and the PRE-RAPHAELITES rejected the illusionistic tradition in Western art by reviving the medieval medium of the woodblock and subjects popular before the fifteenth century. The NABIS and the NEO-PRIMITIVISTS responded to the traditional themes and forms of folk and popular art. Paul Klee and Joan Miró employed childlike imagery that embodies the yearning to escape adulthood and all its responsibilities.

See JAPONISME, ORIENTALISM

PRODUCTIVISM—*see* CONSTRUCTIVISM

PROUN

Proun—a contraction of a Russian phrase that means "projects for affirming the new"—was the name coined by the Russian CONSTRUCTIVIST artist El Lissitzky for his own artwork. He described his precisely drafted, anti-EXPRESSIONIST works as "way stations" between painting, sculpture, and architecture. Composed of geometric forms organized along what he called a "dynamic horizontal axis," Lissitzky's couplings of ABSTRACTION and functionalism call to mind aerial views of visionary cities. The versatile artist—he was also a brilliant sculptor, typographer, and illustrator—considered their status as paintings secondary to their intended use as prototypes for an environmentally scaled and socially conscious art of the future. Unfortunately, anti-avant-garde political realities intervened, preventing more than the glimmering dawn of El Lissitzky's brave, newly constructed world.

PSYCHOANALYSIS

Psychoanalysis is one method, developed by the Viennese physician Sigmund Freud beginning in the 1880s, of treating neuroses and mental disorders. It is based on the assumption that such problems stem from the conscious mind's rejection of experiences and feelings that persist in the unconscious, result-

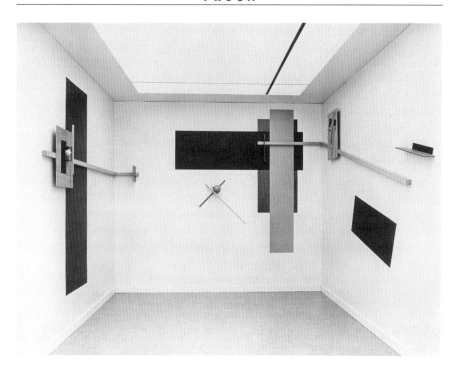

EL LISSITZKY (1890–1941).
Proun Room for the Greater Berlin Exhibition of 1923, 1923.
Reconstructed for the Van Abbemuseum, Eindhoven, the Netherlands,
1965. Wood, 126 x 143 5/16 x 143 5/16 in. (320 x 364 x 364 cm).
Van Abbemuseum, Eindhoven, the Netherlands.

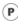

ing in conflicts that can be resolved by their recovery and analysis through free association, dream analysis, or other techniques. A compelling and prolific writer, Freud attempted to explain the origins of morality, religion, myth, sexuality, and social and familial structures—although he wrote only occasionally about art and focused only on Renaissance art, from a psychological rather than an aesthetic perspective.

Freud's development of psychoanalysis was part of the late nineteenth-century preoccupation with interior states that also expressed itself in a revival of SPIRITUALISM and—in art and literature—in SYMBOLISM and EXPRESSIONISM. Freud's views did not begin to gain much currency with the general public (including artists) in Europe and the United States until the second decade of the twentieth century. The prominent place of fantasy and reverie in Symbolist, some expressionist, and SCUOLA METAFISICA art, which seems to embody Freudian concerns, should in fact be traced back to ROMANTICISM. The centrality of chance and automatism to DADA derives not from Freudian ideas but from the Dadaists' preoccupation with irrationality.

It was the SURREALIST art of the 1920s and '30s that helped popularize Freudian ideas about sex, dreams, and the unconscious. André Breton—the Dadaist poet and "Pope of Surrealism"—was a disciple of Freud, from whom he borrowed Surrealism's emphasis on dreams and the unconscious. Breton's "Manifesto of Surrealism," written in 1924, defines surrealism as "thought dictated in the absence of all control exerted by reason, and . . . based on the belief in the superior reality of certain forms of association heretofore neglected, in the omnipotence of the dream."

Of the Surrealist artists, Frida Kahlo and Salvador Dalí were among the most avid devotees of Freud. Kahlo painted the remarkable *Moses* (1945) after reading Freud's *Moses and Monotheism* (1934). Alfred Hitchcock's movie *Spellbound* (1945)—the story of an amnesiac psychiatrist for which Dalí designed a hallucinatory dream sequence—helped reinforce the popular fascination with psychoanalysis. When Dalí met Freud in London in 1938, the founder of psychoanalysis said to the controversial Surrealist, "What interests me in your art is not the unconscious, but the conscious."

PURISM

▷ **WHO** Charles Edouard Jeanneret (a.k.a. Le Corbusier, after 1921) (Switzerland), Amédée Ozenfant (France)

▷ **WHEN** 1918 to 1925

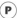

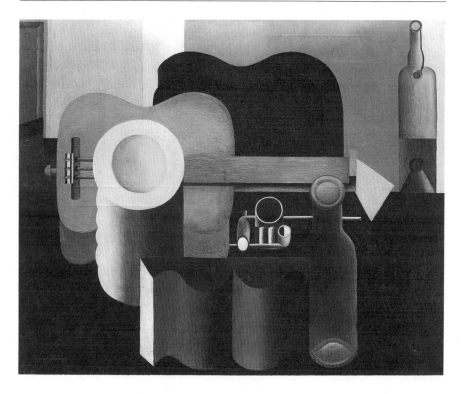

LE CORBUSIER (1887–1965).
Still Life, 1920. Oil on canvas, 31 7/8 x 39 1/4 in. (81 x 99.7 cm).
Collection, The Museum of Modern Art, New York; Van Gogh
Purchase Fund.

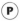

▷ **WHERE** Paris

▷ **WHAT** Purism was a movement founded and named by the painters Charles Edouard Jeanneret and Amédée Ozenfant. Their book *Après le cubisme* (*After Cubism*, 1918) is a MANIFESTO proclaiming that CUBISM had degenerated into decoration, fantasy, and subjectivity. Artistic salvation, they believed, would come from an abstracted (that is, simplified) art benefiting from "the lessons inherent in the precision of machinery." In their rigorously clear compositions depicting geometric forms in unmixed colors, images of tools are used to evoke an ideal world, recalling both Cubist still lifes and the geometric illusionism of the painter Fernand Léger's homages to cylindrical machine forms.

Purism's influence derived less from the paintings of its founders—and only practitioners—than from their position as intellectual provocateurs. They published the important journal *L'Esprit nouveau* (*The New Spirit*, 1920–25), which became an outlet for non-French ideas about utopian and functional art, including DE STIJL and CONSTRUCTIVISM. Jeanneret's interest in the machine age and in functionalism would lead to his becoming, by the late 1920s, one of the foremost exponents of International Style architecture.

PUTEAUX GROUP

▷ **WHO** (All from France unless noted otherwise) Alexander Archipenko, Marcel Duchamp, Raymond Duchamp-Villon, Albert Gleizes, Juan Gris (Spain), František Kupka (Czechoslovakia), Fernand Léger, Jean Metzinger, Jacques Villon

▷ **WHEN** 1910 to 1914

▷ **WHERE** Paris

▷ **WHAT** The Puteaux Group of artists is named after the middle-class suburb of Paris where they would meet, starting in 1910. They gathered on Sunday afternoons in the garden behind the studios of Raymond Duchamp-Villon, František Kupka, and Jacques Villon to play chess and to discuss recent developments in aesthetics and philosophy. Their conversations led to two pioneering studies of CUBISM: *On Cubism* (1912) by the artist-theoreticians Jean Metzinger and Albert Gleizes; and *The Cubist Painters* (1913) by the writer Guillaume Apollinaire.

Although under Cubism's sway, Puteaux Group painters and sculptors objected to what they regarded as Analytic Cubism's lack of dynamism, color,

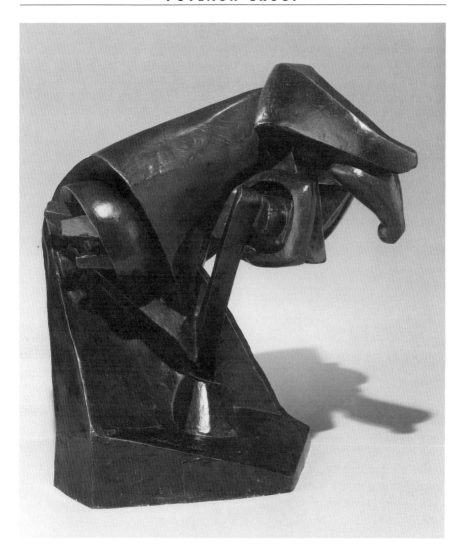

RAYMOND DUCHAMP-VILLON (1876–1918).
Horse, 1914. Bronze, height: 18 1/4 in. (46.3 cm). Hirshhorn Museum and Sculpture Garden, Smithsonian Institution, Washington, D.C.; Gift of Joseph H. Hirshhorn, 1966.

and human—especially spiritual—interest. Calling themselves the Section d'Or (Golden Section), they organized a large exhibition of the same name, held at Galerie la Boétie in Paris, in October 1912, and published a single issue of a *Section d'Or* magazine. The outbreak of war in 1914 resulted in the group's dissolution.

Despite the Puteaux artists' opposition to Analytic Cubism, their use of a Cubist vocabulary helped ensure its spread and catalyzed the development of diverse Synthetic Cubist approaches. Along with artists in Amsterdam, Moscow, and New York, they increasingly put Cubist means to new artistic ends, some involving the complete ABSTRACTION that Picasso and Braque eschewed. Among those interested in abstraction were the ORPHISTS, who . counted many Puteaux Group artists among their ranks.

QUIETISM—*see* TONALISM

RAYOGRAPH—*see* PHOTOGRAM

RAYONISM

▷ **WHO** (All from Russia) Natalia GONCHAROVA, Mikhail LARIONOV, Mikhail Le-Dantigu, Sergey Romanovich

▷ **WHEN** 1912 to 1914

▷ **WHERE** Moscow

▷ **WHAT** The term *Rayonism* was coined by the painter Mikhail Larionov. It appeared first in the "Rayonist Manifesto," which was issued on the occasion of the *Target* exhibition in Moscow in 1913. The MANIFESTO—which announced that "Rayonism is a synthesis of CUBISM, FUTURISM and ORPHISM"—may have been prompted by a contentious speech by the Italian Futurist poet and propagandist Filippo Tommaso Marinetti.

Rayonist paintings are either figurative—portraits and landscapes abound (see page 31)—or completely abstract. (Larionov's abstractions were painted as early as 1912.) In either case, these colorful and vigorously painted works are characterized by an emphasis on slanting lines that were called rays, which may have been derived from the Futurist "lines of force." The rays were intended to express new ideas about the SPACE-TIME CONTINUUM formu-

lated by the physicists Albert Einstein and Ernst Mach and to provide a sensation of the fourth dimension.

Rayonism was short-lived—it ended when Larionov and Natalia Goncharova left Russia in 1914—but extremely influential. It provided many Russian artists and viewers with their first glimpses of nonrepresentational painting. Rayonism's oddly spiritual faith in science also stimulated the development of SUPREMATISM by Kazimir Malevich.

See NEO-PRIMITIVISM, CUBO-FUTURISM

READYMADE—*see* FOUND OBJECT

REALISM

▷ **WHO** Thomas Anshutz (United States), Rosa Bonheur (France), Jules Breton (France), Gustave Caillebotte (France), Gustave COURBET (France), Honoré DAUMIER (France), Edgar DEGAS (France), Gustave Doré (France), Thomas EAKINS (United States), Charles de Groux (Belgium), Hubert von Herkomer (Great Britain), Winslow Homer (United States), Wilhelm Leibl (Germany), Edouard MANET (France), Ernest Meissonier (France), Adolph von Menzel (Germany), Jean François Millet (France)

▷ **WHEN** 1845 to 1880

▷ **WHERE** Western Europe and the United States, but primarily France

▷ **WHAT** Realist art and literature originated in mid-nineteenth-century France. In its original, nineteenth-century sense, *realism* implied not just the accurate depiction of nature (more aptly termed NATURALISM, which is used to describe art of all historical periods), but an interest in down-to-earth everyday subjects. The pioneering Realist Gustave Courbet announced that never having seen an angel he could not paint one. At the same time, the critic and poet Charles Baudelaire made a plea for art that would take the "heroism of modern life" as its subject.

The emergence of Realism in the wake of the revolutionary uprisings throughout Europe in 1848 made such an emphasis on "modern life" highly political: Among conservative segments of the art audience, unsentimentalized images of peasants stirred fears of barbarians at the gates. Viewed from a broader perspective, Realism is a product of the increasingly powerful bourgeoisie whose ranks were being swollen by the Industrial Revolution.

The middle-class taste for the factual and the scientifically verifiable was gratified by Realist art and by photography, which also emerged during the 1840s.

As with early photography, Realism's gaze was invariably focused outward. A reportorial—often critical—stance characterizes its treatment of subjects. Many Realist artists—Courbet, Gustave Caillebotte, Edouard Manet, and the printmaker Honoré Daumier among them—depicted members of the rural or urban working classes with the same dignity previously accorded only to aristocrats (see page 9). In the more egalitarian American society, Thomas Eakins's brilliantly observed Realist painting of a medical operation, *The Gross Clinic* (1875), was a pointed injunction against mythological or idealizing subject matter.

The characteristics that determine a Realist style are difficult to pinpoint. Generally, a Realist work gives the illusion that it was painted "truthfully" and without artifice, akin to photography's supposed lack of style. Realist artists tended to eschew visible brushwork, although IMPRESSIONISM—characterized by a brushy impasto—is often regarded as the culmination of optical realism, or the accurate depiction of the visible world.

To further complicate matters, many Realist painters, such as Edgar Degas, created works that cannot be termed Realist, while other artists classified as outside the Realist fold—such as Vincent van Gogh and the PRE-RAPHAELITES—produced Realist works at early points in their careers. During the 1870s in Paris many artists began to shift from Realism toward more personal expression, reflecting the increasing prevalence of an attitude known as "ART FOR ART'S SAKE," as well as the emerging influence of JAPONISME.

Realism's legacy was taken up by several of the early twentieth-century painters in New York known as THE EIGHT and, just prior to World War II, by the Euston Road Group—including William Coldstream, Lawrence Gowing, and Victor Pasmore—in London.

REGIONALISM—*see* AMERICAN SCENE PAINTING

REVIVALISM—*see* ACADEMIC ART

ROMANTICISM

▷ **WHO** William BLAKE (Great Britain), Frederic Edwin Church (United States), Thomas Cole (United States), Eugène DELACROIX (France), Caspar David FRIEDRICH (Germany), Henry Fuseli (Great Britain), Théodore GERICAULT (France), Francisco de GOYA (Spain), Antoine Jean Gros (France), Samuel Palmer (Great Britain), Hubert Robert (France), Philipp Otto Runge (Germany), Joseph Mallord William TURNER (Great Britain)

▷ **WHEN** 1770 to 1840

▷ **WHERE** Western Europe and the United States

▷ **WHAT** Romanticism, an approach that dominated art during the first quarter of the nineteenth century, is included here because the modern arts are virtually inconceivable without it. Romanticism's enduring legacy includes the validation of unfettered emotion and the artistic imagination.

The term *Romanticism* derives from the late eighteenth-century popularity of medieval tales such as the legends of King Arthur, which were dubbed "romances" because they were written in Romance languages, rather than Latin. Romanticism is less a matter of STYLE than attitude. The critic and poet Charles Baudelaire called it "a mode of feeling." Emotional experience was prized above all, and Romanticism was both a reaction against the "establishment"—church, aristocratic state, and rational Enlightenment thought— and a manifestation of the revolutionary political spirit that animated the French and American revolutions. Unlike so many other artistic developments of the eighteenth and nineteenth centuries, Romanticism arose in England and Germany rather than in France.

Because of its emphasis on rebellious emotionalism, Romanticism's impact on the laborious processes required for casting sculpture was minimal. For painters, however, the Romantic craving for emotional intensity assumed astonishingly diverse forms. Subjects were culled from medieval and classical legend and literature (in this sense NEOCLASSICISM should be regarded as the first of the Romantic revivals); contemporary events such as the Greek War of Independence and the Bonapartist adventures in Spain; and exotic ORIENTALIST locales such as the harems of the Middle East and the pyramids of Egypt.

Romanticism also marked the flowering of varied approaches to landscape painting. The sublime and terrifying grandeur of the storms and avalanches depicted by Joseph Mallord William Turner share little with the intimate, picturesque approach pioneered by English watercolorists of the era. The

eerily poetic landscapes by Caspar David Friedrich contrast vividly with the brash, sharply focused observation of HUDSON RIVER SCHOOL paintings by Frederic Edwin Church, which proclaimed the United States' "divinely ordained" Manifest Destiny. The prevalence and appealing diversity of such unorthodox subjects helped undermine the authority of the ACADEMIC hierarchy, with its traditional view of the superiority of history painting.

The Romantic ideal of a return to nature also included human nature. To act naturally was to act freely and impulsively, and even to make art. The idealistic self-sacrifice by the poet Lord Byron at Missolonghi during the Greek War of Independence is the emblematic Romantic response to tragic political events. The Western sense of individualism and of the inviolability of the self are ultimately Romantic ideas, as is the notion of the artist as the impassioned seeker of experience.

In addition to the effect of Romantic thinking on Western culture at large, the example of Romantic artists was crucial to many late nineteenth-century artists—especially the SYMBOLISTS—who labored to transcend the bounds of conscious thought and scientific rationalism.

ROSICRUCIANISM—*see* SPIRITUALISM

RUSSIAN AVANT-GARDE—*see* CONSTRUCTIVISM, CUBO-FUTURISM, NEO-PRIMITIVISM, RAYONISM, SUPREMATISM

SALON

Salon, a French word meaning "drawing room," has two art-related definitions in English. Generally speaking, a salon is a social gathering of artists and intellectuals hosted at regular intervals by a patron in his or her own home. Such convivial settings for the art of conversation emerged in Paris at the beginning of the seventeenth century. Two noteworthy modern salons were Gertrude and Leo Stein's Saturday night "at homes" in early twentieth-century Paris, and Louise and Walter Arensberg's "evenings" in World War I–era New York. Over the years such gatherings fostered the exchange of ideas and the development of patronage.

The Salon specifically refers to the *Exposition officielle des artistes vivants* (*Official Exposition of Living Artists*), first presented to the public in 1726 in the Salon Carré and the Galerie d'Apollon at the Louvre in Paris. Originated by the Académie Royale de Peinture et de Sculpture—usually known simply

as "the Academy"—the Salon was relatively intimate during the eighteenth century, when artists could show their work by invitation only. With the nineteenth-century change in rules that allowed any artist, French or foreign, to submit work to the jury for the annual exhibition, the Salon vastly expanded, to a peak of more than seven thousand works in 1880; that exhibition at the Palais des Champs-Elysées was seen by 30,000 visitors *each* Sunday—or so the writer Emile Zola estimated.

Lucrative purchase prizes were awarded and reputations were made (and unmade) at the Salon. The conservative juries tended to express bourgeois taste in their preference for accessible works like Adolphe William Bouguereau's *Return of Spring* (see page 46)—a precisely painted and erotically titillating rendition of a classical subject. But it is difficult to generalize about what Zola termed the "absolute cacophony" of these gigantic exhibitions, which registered the political fluctuations of frequently changing governments. The tendency to regard the Salon as the exclusive bastion of the establishment is too simplistic. Although many avant-garde artists did revolt against its dominance, many others—including Edouard Manet, Edgar Degas, and Odilon Redon—showed regularly at the Salon and also participated in alternative exhibitions such as the SALON DES INDEPENDANTS and the SALON DES REFUSES.

By the end of the nineteenth century, the Salon's virtual stranglehold on French art production had collapsed. In this century the function of the Salon as a showcase for newly produced art has been taken over by large, recurring exhibitions of international art, such as the Venice Biennale, which was instituted in Venice in 1895, and the Carnegie Museum of Art's triennial International, which was instituted in Pittsburg in 1896; many others followed after World War II.

A by-product of the Salons—which were among the first exhibitions of art open to the public—was the emergence of art criticism during the eighteenth century. This trend was fueled by the nineteenth-century development of the popular press and by Salons so large that without a critic's "scorecard" viewers could barely locate, much less evaluate, individual works.

SALON DES INDEPENDANTS

The Société des Artistes Indépendants was founded in Paris by the artists Henri Edmond Cross, Odilon Redon, Georges Seurat, and Paul Signac, among others, in 1884. That year the group held the first of its annual exhibitions, known as the Salon des Indépendants. Hanging fees were charged, but there

were no juries. The enterprise was largely an attempt to circumvent the arbitrary selection principles and conservatism of the official, ACADEMY-run SALON.

The Salon des Indépendants was also a sign of the declining power of the Salon and part of an effort by artists to gain greater access to patrons and publics. Other manifestations of that effort took place at about the same time: the IMPRESSIONISTS held eight artist-organized exhibitions between 1874 and 1886; an 1881 decree transferred management of the Salon to a jury chosen by artists associated with the Salon; and divisions within the Salon led the artists Ernest Meissonier and Pierre Puvis de Chavannes to form the Société Nationale des Beaux-Arts in 1890, which sponsored the comparatively conservative Salon du Champ-de-Mars. Such activity not only undermined the hegemony of the Salon but also helped disseminate MODERNIST ideas. Similar assaults on traditional artistic authority took place in German-speaking art centers in the form of the turn-of-the-century SECESSION movements.

SALON DES REFUSES

The Salon des Refusés was an alternative SALON held in Paris in 1863. So many artists' works had been rejected by the ACADEMY's official Salon—more than four thousand—that Emperor Napoleon III commanded the creation of a special exhibition adjacent to the Salon so that the public could make up their own minds about the "refused" works. They came in droves to see the 687 rejected works—many refused artists chose not to show in that rather humiliating context—and in general loudly ratified the official jury's disdain. Among the most accomplished artworks were paintings by Camille Pissarro, James McNeill Whistler, and Edouard Manet, whose *Déjeuner sur l'herbe* (*Luncheon on the Grass*, 1863; see page 12) became the retrospective emblem both of this specific event and of a feisty AVANT-GARDE confronting a stubborn status quo. A second Salon des Refusés was held in 1873.

SCHADOGRAPH—*see* PHOTOGRAM

SCHOOL OF PARIS

School of Paris (in French, *Ecole de Paris*) is a rather vague term for numerous movements in MODERN art that emanated from Paris during the first half

of the twentieth century. Chief among them were FAUVISM, CUBISM, and SURREALISM.

The term also implies Paris's magnetic centrality for modern art, from the inception of modernism until World War II. Many non-French artists were key figures in the School of Paris and it is estimated that foreigners made up one-third of the sixty thousand artists whose work was exhibited annually. Around 1900 the city boasted some 130 commercial galleries—more than quadruple the number anywhere else—and twenty large annual SALONS. After World War I foreign artists—including Naum Gabo, Wassily Kandinsky, Joan Miró, and Piet Mondrian—continued the migration to Paris. World War II ended Paris's role as the mecca of Western art. Following the war the United States came to dominate art-making among the Allies, just as it dominated the group's political and economic life.

Ecole de Paris is also used occasionally to categorize an extremely diverse group of non-French artists in Paris who painted FIGURATIVE, mostly EXPRESSIONIST works during the period between the world wars. The best known are Marc Chagall, Amedeo Modigliani, Jules Pascin, and Chaim Soutine. Some of them were also known as the Peintres Maudits (cursed painters) because they painted highly charged images of poverty, alcoholism, and prostitution. The Peintres Maudits constituted a movement only in the loosest sense of the word.

SCUOLA METAFISICA

▷ **WHO** (All from Italy) Carlo Carrà, Giorgio de CHIRICO, Giorgio Morandi, Filippo de Pisis, Alberto Savinio, Mario Sironi

▷ **WHEN** 1913 to 1919

▷ **WHERE** Italy

▷ **WHAT** The Scuola Metafisica (in English, Metaphysical School) was the result of a chance encounter between Carlo Carrà, Giorgio de Chirico, and Filippo de Pisis in a military hospital in Ferrara, Italy, in 1917. While recuperating there the three artists formed an association that they called the Scuola Metafisica. The tiny but ultimately influential movement was almost entirely due to de Chirico, whose already well-developed style was adopted by the other two and reinforced by the melancholic atmosphere of Ferrara itself.

Defined by de Chirico as an attempt to build "a new metaphysical psychology of objects by means of painting," the *pittura metafisica* ("metaphysical painting") portrays ordinary objects in extraordinary settings. In a de Chirico canvas, for instance, a schematic but precisely rendered classical statue might share a vast, shadow-striped piazza with a steaming locomotive. Classical and contemporary elements are frequently juxtaposed to enigmatic effect. Reason has no place in these dreamy, often disturbing pictures (see page 32).

In 1919 Carrà published a book entitled *Pittura metafisica,* in which he took credit for much of de Chirico's thinking. This event ended the group's tenuous existence. The psychologically charged images of the Scuola Metafisica seemed to foretell those of the SURREALISTS, whom they strongly influenced.

SECESSION

The term *Secession* derives from *secede,* which means "to break away." At the end of the nineteenth century and the beginning of the twentieth, young artists in Germany and Austria broke away from established artists' societies to form their own organizations with more liberal exhibition policies. These actions—and the alternative institutions that were founded as a result of them—are known as the Berlin, Munich, and Vienna Secessions. Artists in Paris, the Scandinavian capitals, and later Moscow and New York also rebelled against ACADEMIC authority by organizing unofficial exhibitions, but their efforts were not institutionalized as rapidly as those in the German-speaking art centers. At the same time, photographers pursued a course of action that has come to be known as the Photo-Secession, by establishing groups designed to promote PICTORIALISM in London, New York, Paris, Vienna, and other cities.

The politics of the various Secessions were volatile. The first of them, the Munich Secession, was formed in 1892 and dominated by the academic painter Franz von Stuck. In 1909 the painter Wassily Kandinsky led a revolt against that already old-fashioned body and founded the Neue Künstler-vereinigung, or New Artists' Association, which was followed by another split in 1911, which in turn led to the formation of DER BLAUE REITER.

The Berlin Secession—which came into being in 1899 because of a dispute in the Verein Berliner Künstler (Society of Berlin Artists) over an 1892 exhibi-

tion of paintings by Edvard Munch—initially seemed more radical. But it too was subject to the emergence of successive, secession-minded factions that led to the creation of two EXPRESSIONISM-dominated groups: the New Secession and the Free Secession, which were formed in 1910 and 1913, respectively. Both the Munich and the Berlin organizations mounted vitally important shows of relatively up-to-date German and European art at a time when exhibition possibilities for AVANT-GARDE art remained limited.

The Vienna Secession was founded in 1897 by the artist Gustav Klimt, whose ART NOUVEAU and SYMBOLIST preferences characterized the sensibility of the group. Initially dominated by architects and designers—including Josef Hoffmann and Koloman Moser, who founded the Wiener Werkstätte (Vienna Workshop)—it achieved both popular success and government support. This dual approval legitimized a liberal visual-art establishment that reflected Vienna's prominence as a center of the modern arts and sciences during the late nineteenth and early twentieth century.

SECTION D'OR—*see* PUTEAUX GROUP

SEMANA DE ARTE MODERNA

The Semana de Arte Moderna (Week of Modern Art) was held in São Paulo, Brazil, from February 13 to February 17, 1922. Organized by the painter Emiliano de Cavalcanti, the writer Oswald de Andrade, and the art patron Paulo Prado, the Semana de Arte Moderna consisted of several concerts of modern music, an exhibition of modern art, and a conference about MODERNISM, all of them staged in São Paulo's new municipal theater. As the first self-consciously modern program of events in Brazil, it proved both influential and—not surprisingly—controversial.

The most important artists in the exhibition were the painters Cavalcanti, John Graz, Anita Malfatti, and Vicente Rego Monteiro, and the sculptor Victorio Brecheret. Their aggressively anti-ACADEMIC and exclusively representational art incorporated first- and second-hand knowledge of European EXPRESSIONISM and SCHOOL OF PARIS painting. Stylistic subtleties were ignored by the hostile press, however, which dubbed all of the offerings "futuristic" and paid far less attention to the art exhibition than to the more comprehensible conference. The Semana de Arte Moderna inspired some Brazilian

SOCIAL REALISM

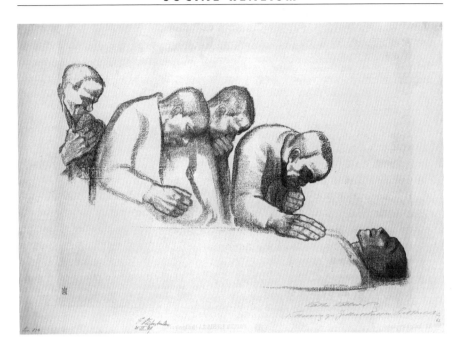

KÄTHE KOLLWITZ(1867–1945).
Memorial to Karl Liebknecht, 1919. Lithograph, 22 1/2 x 31 1/6 in.
(57.1 x 78.9 cm). Rosenwald Collection; National Gallery of Art,
Washington, D.C.

artists to move to Europe and others to remain in Brazil, where the relationship of international modernism and local tradition began to be debated.

SIGNIFICANT FORM—*see* FORMALISM

SIMULTANEITY—*see* SPACE-TIME CONTINUUM

SKUPINA VÝTVARNÝCH UMĚLCŮ—*see* OSMA

SOCIAL REALISM

Much of the leftist political art produced during the 1920s and '30s—primarily in the United States, Mexico, Germany, and the Soviet Union—can be categorized as Social Realism. Originally the term was not used to mean any particular STYLE, and Social Realist works range from ambitious MEXICAN MURAL cycles by Diego Rivera and José Clemente Orozco to paintings on topical themes of class struggle by the American painters Philip Evergood, Jacob Lawrence, and Ben Shahn. The bias of Social Realism against ABSTRACTION and toward the didactic illustration of political subjects gave it a pronouncedly anti-MODERN flavor. Social Realist art became the official art of the USSR through a series of policies enacted between 1925 and 1934, which essentially forbade abstract art. Social Realism's emphasis on the figure makes it part of the wholesale retreat from abstraction that characterized art made throughout Europe and the Americas during the period between the world wars.

See CONSTRUCTIVISM, FEDERAL ART PROJECT

SOCIETE ANONYME

The Société Anonyme, Inc.—named (tongue in cheek) for a French term meaning "incorporated"—was founded in 1920 in New York by the collector Katherine Dreier and the DADA artists Marcel Duchamp and Man Ray. An educational endeavor intended to elevate public taste by showing high-quality modern artworks, it was propelled by its founders' faith in MODERN art as a force in advancing human consciousness.

During the early 1920s the Société Anonyme offered—in its own space at 19 East Forty-seventh Street—exhibitions of work by American modernists such as Marsden Hartley and Joseph Stella, artists' lectures illustrated with real

artworks rather than slides, a reference library, and a permanent collection that had grown to 190 artworks by 1925. By then the Société Anonyme had given up its own quarters and was organizing major exhibitions for the Cleveland Museum of Art, the Detroit Institute of Arts, and the Brooklyn Museum. By 1929 the organization had lost steam, although it sputtered along for another decade. Dreier rightly considered her operation the world's first museum of modern art, although that honor is usually accorded the Museum of Modern Art, which was founded in New York in 1929 by a small group of wealthy patrons who snubbed Dreier. The Société Anonyme's collection was donated to the Yale University Art Gallery in 1941.

SONDERBUND EXHIBITION—*see* ARMORY SHOW

SPACE-TIME CONTINUUM

In 1908 Hermann Minkowski, a German mathematician and teacher of Albert Einstein, gave the name *Space-Time Continuum* to a series of equations expressing the interrelationship of space and time that Einstein had articulated in his special theory of relativity, published in 1905. Einstein's revolutionary hypothesis that as time expands, space contracts demolished Euclid's notions of space and time as separate phenomena. (Einstein's theory is popularly understood through the science-fiction paradigm of the space traveler who returns to earth virtually unaged compared to those who remained behind.) After 1916, when Einstein published his general theory of relativity, the Space-Time Continuum also became known as the fourth dimension.

Some commentators have suggested that early twentieth-century artists presaged scientific developments in their work or were at least intuitively aware of scientific ideas then circulating. Such views are extremely difficult to substantiate. Just as we know that NEO-IMPRESSIONIST artists were avid readers of nineteenth-century color theory and optical theory, we also know that no artists read Einstein's 1905 discussion of relativity—he was entirely unknown then—and that no accounts of it were available in the popular press during the first decade of the century. Still, the shifting viewpoints that indicate the passage of time in CUBIST and FUTURIST art (as well as in earlier still lifes by Cézanne) seem to some observers to embody Einstein's thinking—as does the term *simultaneity,* which was employed by both the Futurists and Einstein to suggest the impossibility of the "now" as it is conventionally understood.

Such coincidences can be accounted for in other ways. Cubist and Futurist art convey the disorientingly frenetic pace and fragmented look of the modern city as much as Einsteinian theory. Unlike contemporary science, turn-of-the-century science was largely divorced from technology, and it was the engineering marvels—such as the Eiffel Tower and the airplane—that so captivated artists of that day. Some interpretive leaps of faith have also resulted in inaccuracies. When, for instance, the poet Guillaume Apollinaire invoked the fourth dimension in connection with Cubism for the first time in 1911, it is likely that he was referring to the term's well-known meaning as a realm of spiritual knowledge. Russian RAYONISTS and others sometimes used the spiritual and scientific meanings of the fourth dimension interchangeably.

SPIRITUALISM

Spiritualism is the devotion to principles relating to religious or moral—rather than to bodily or temporal—matters. Spiritualism is sometimes narrowly defined as the belief in an afterlife of the soul and the ability to communicate with spirits. More useful is a broader definition that encompasses a wide range of related beliefs, to which many MODERN artists adhered. These may be termed *occult* (referring to systems of "hidden truths" leading to metaphysical revelations), *mystical* (direct experiences of God), or *non-Western* (ranging from Vedanta and Yoga to Taoism and Zoroastrianism).

Artists were far from unique in holding unconventional spiritual views during the final quarter of the nineteenth and the first quarter of the twentieth centuries. Friedrich Nietzsche's proclamation of the death of God in 1882 seems to have applied only to the practice of institutionalized Western religion. The other side of this so-called loss of faith was a burgeoning interest in nontraditional belief systems, including: Theosophy (a contemporary and eclectic blend of American transcendentalism and Hinduism, incorporating principles of evolution and reincarnation; it was modified by Rudolf Steiner as Anthroposophy); Swedenborgianism (a visionary doctrine emphasizing individual free will as the means of achieving profound communication with God); Rosicrucianism (a mystic brotherhood, originated in the Middle Ages, that was dedicated to caring for the sick and advancing occult knowledge); and belief in the fourth dimension, a heightened reality that lay beyond visual perception.

Such spiritual offshoots were part of Western culture's fascination with subjectivity and aberrant psychology during the late nineteenth century. That fascination was also manifested in the PSYCHOANALYTIC theories of Sigmund Freud (who was indebted to ideas derived from Jewish mysticism); in SYMBOL-

ISM's obsession with mental extremes; and in the emergence of psychic research by prominent scientists—a phenomenon epitomized by the publication of William James's *Varieties of Religious Experience* (1902). Art and science were far less separate from one another at the turn of the century than they are now. Wassily Kandinsky—the Russian painter and author of *On the Spiritual in Art* (1912)—anticipated a *Kunstwissenschaft*, or science of art. Madame Helena P. Blavatsky, founder of the Theosophical Society, spread a detailed version of Plato's message "God geometrizes," which influenced abstract painters such as Piet Mondrian.

What separated nineteenth-century spiritualism from institutionalized religion was the promise of personal and unmediated contact with spiritual forces. Private visions of the cosmos were produced during the early nineteenth century by the British artists William Blake, who wrote and illustrated epic poems based on Swedenborgian ideas, and Samuel Palmer. Interest in spiritualism increased as the century progressed—examples appear among mid-century ROMANTIC artists and especially writers—but it first became pervasive toward the end of the nineteenth century among Symbolist artists, writers, and composers. Symbolist artists saw themselves revitalizing art with ideas about the human condition, which they believed were lacking in IMPRESSIONISM. The NABIS—artist-members of a Symbolist secret society that met in Paul Ranson's studio, dubbed "the Temple"—took Buddha and the crucified Christ as subjects for paintings. The Norwegian artist Edvard Munch, who derived his interest in the occult from the playwright August Strindberg, translated it into the visible "vibrations" radiating from the figures he painted. Between 1892 and 1897 many Symbolist and other spiritually inclined artists in Paris exhibited at the annual Rosicrucian Salon, known as the Salon de la Rose + Croix.

Without Symbolist art and theory emphasizing the depiction of interior—especially spiritual—states, modernist ABSTRACTION would not have developed as it did. Four of the greatest pioneers of abstraction—Kandinsky, František Kupka, Kazimir Malevich, and Mondrian—put spiritualism at the center of their lives and their art. All were Theosophists but Malevich, who believed in the fourth dimension and the idea of *zaum*—a futuristic language and transrational state of higher intellectual consciousness, invented by the writer-dramatist Alexei Kruchenykh and comparable to *samadhi* in Yoga. Kupka was also a medium and a student of sacred geometry—the belief in links between mystical thought and abstract truths expressed in geometric terms—which played an important role in spiritualism and art.

In each case such beliefs were translated into artworks. Kandinsky was fascinated with the diagrams and images that illustrated books about mystical-

HILMA AF KLINT (1862–1944).
Untitled No. 8, from the series *SUW/The Swan,* 1914–15. Oil on canvas, 59 1/16 x 59 1/16 in. (150 x 150 cm). The Hilma af Klint Foundation, Stockholm.

occult matters and reflected the ineffability of their subjects. Mondrian read many of the same books, but it was Theosophical ideas about geometry—that most abstract of disciplines—that nourished the development of his increasingly reductive, right-angled imagery. Kupka attempted to give pictorial form to the geometric harmony inherent in the concept of the golden section (the congruent relationship of certain parts to a whole), and Malevich attempted to depict cosmic nothingness.

The influence of spiritualism on modern art is surprisingly pervasive. The sacred in art was a frequent subject of discussion among Parisian artists—including Constantin Brancusi, Henri Matisse, Pablo Picasso, and Georges Rouault—during the first decade of the twentieth century, and it was related to their preoccupation with tribal art, which often has spiritual elements. American modernists such as Arthur Dove, Marsden Hartley, Georgia O'Keeffe, and Max Weber saw mystical qualities in nature—a legacy of early nineteenth-century American transcendentalism, which had been absorbed by Symbolism at the end of the century. (In 1938 the New Mexico Transcendental Artists group was founded by an international roster of artists and devotees of Theosophy that included Emil Bisstram, Lawren Harris, Raymond Jonson, and Agnes Pelton.) Ideas about fourth-dimensional spacelessness inspired the free-flowing SURREALIST compositions of Matta and Gordon Onslow-Ford. Influential utopian movements such as DE STIJL and the various manifestations of the RUSSIAN AVANT-GARDE were also profoundly affected by spiritual ideas.

Even individuals and groups whose artistic motivations seem determinedly irreverent were often attracted to spiritualism. In the case of DADA for instance, Marcel Duchamp was an avid student of alchemy, the tarot, and the fourth dimension—concerns that are all evident in his work. Jean Arp, Francis Picabia, and Kurt Schwitters (who called Dada "the spirit of Christianity in the realm of art") also produced art incorporating spiritual motifs. There was even a mystical branch of Dada—intended to express universal divinity and known as Tabu-Dada—founded in 1921 by Jean Crotti and Suzanne Duchamp (Marcel's sister).

The importance of spirituality in the development of modern art has received short shrift from most art historians over the past half century, for a number of reasons. FORMALIST interpretations of art have neglected such supposedly nonartistic concerns because they are sometimes invisible in an artist's works. Mystical, spiritual, and occult beliefs were also tainted by the central place they had held within Nazism. The post–World War II loss of

faith and emergence of existentialist philosophy—which emphasized individual responsibility in a godless world—are also symptomatic of Western society's retreat from spiritualism.

STRAIGHT PHOTOGRAPHY

▷ **WHO** Berenice Abbott (United States), Ansel ADAMS (United States), Eugène ATGET (France), Bill Brandt (Great Britain), Brassaï (France), Henri CARTIER-BRESSON (France), Imogen Cunningham (United States), Alfred Eisenstaedt (United States), Walker EVANS (United States), John Gutmann (Germany), Lewis Hine (United States), André KERTÉSZ (United States), Dorothea Lange (United States), Lisette Model (United States), Albert Renger-Patzsch (Germany), Erich Salomon (Germany), August Sander (Germany), Edward Steichen (United States), Alfred STIEGLITZ (United States), Paul Strand (United States), Edward Weston (United States)

▷ **WHEN** 1900 through 1970s

▷ **WHERE** Europe and the United States

▷ **WHAT** The term *straight photography* probably originated in a 1904 exhibition review in the journal *Camera Work* by the critic Sadakichi Hartmann, in which he called on photographers "to work straight." He urged them to produce pictures that looked like photographs rather than paintings—challenging the late nineteenth-century approach known as PICTORIALISM. To do so meant rejecting tricky darkroom procedures and concentrating instead on the basic properties of the camera and the printing process.

The great MODERNIST tradition of straight photography resulted from the thinking of Hartmann and many others. It featured vivid black-and-white photographs ranging from John Gutmann's witty images of the machine-age cityscape to Imogen Cunningham's striking nudes of her husband on Mount Rainier. Straight photography is so familiar that it is easy to forget that it is an aesthetic no less artificial than any other. The fact that black-and-white pictures may look more "truthful" than color prints, for instance, points to just one of its highly influential conventions. The straight-photography STYLE has been almost invariably employed in PHOTOJOURNALISM and DOCUMENTARY PHOTOGRAPHY.

See GROUP F/64

STRAIGHT PHOTOGRAPHY

AUGUST SANDER (1876–1964).
Group of Circus People, 1926. Gelatin silver print, 7 13/16 x 10 7/8 in. (19.9 x 27.5 cm). J. Paul Getty Museum, Malibu, California.

STYLE

There is no such thing as a work of art without a style. The idea of style as defined by art history is rooted in the belief that artworks from a particular era (the T'ang dynasty, the Italian Renaissance, the 1890s) share certain distinctive visual characteristics. These include not only size, material, color, and other FORMAL elements but also subject and CONTENT.

Artists cannot transcend the limits of their era. Forgeries of Jan Vermeer's seventeenth-century works that were painted by the notorious forger Hans van Meegeren fifty some years ago seemed authentic then but now loudly announce themselves as works of the 1930s and '40s. Nor can artists remain unaffected by the discoveries and developments of their own era. Without the spatial flatness and cropped compositions evident in photographs and Japanese prints, it is difficult to imagine IMPRESSIONIST painters during the late nineteenth century conceiving such stylistic mannerisms. If the Industrial Revolution had not emerged, the ARTS AND CRAFTS MOVEMENT could not have come into being.

Other factors such as locale, training, and perhaps even gender—this has been the subject of heated debate among feminists and nonfeminists—affect the styles of individual artists. A multitude of personal styles contribute to the stylistic currents of a given era. No artist's work is likely to completely embody any one particular style; it is, after all, individuality and personality that modern Westerners value in art.

SUPREMATISM

▷ **WHO** (All from Russia) El Lissitzky, Kazimir MALEVICH, Lyubov Popova, Ivan Puni, Aleksandr Rodchenko

▷ **WHEN** 1915 to 1923

▷ **WHERE** Russia

▷ **WHAT** Kazimir Malevich chose the word *Suprematism* to describe his own paintings at *The Last Futurist Exhibition of Pictures: 0–10,* organized by Ivan Puni and held in Petrograd in December 1915. The term's grandiosity—akin to that of DE STIJL (The Style), a similarly utopian movement in the Netherlands—suggests Malevich's belief in having reached the ultimate point in artistic expression (see page 33).

Suprematism was the first movement to reduce painting to pure geometric ABSTRACTION, to rid it entirely of overt references to the visual world. Malevich's famous *Suprematist Composition: White on White* (1918) depicts a "drawn" square superimposed at a skewed angle on a white square on an off-white ground. His paintings were intended to convey such contemporary phenomena as "the sensation of flight" and "the feeling of fading away . . . magnetic attraction" by symbolizing those technological advancements in geometric forms. The effect of Malevich's work is cerebral, even SPIRITUAL.

A gifted essayist and MANIFESTO writer, Malevich defined Suprematism as "the supremacy of pure feeling" and traced his artistic roots to CUBISM and FUTURISM. Yet there is little in either of those STYLES to presage total abstraction, much less geometric abstraction. As with so many MODERN art movements, Suprematism emerged in part from experiments in literature and in avant-garde theater, in this case Malevich's abstract costume and set designs for *Victory over the Sun* (1913), a Cubo-Futurist *Gesamtkunstwerk*.

Suprematism was the first of the RUSSIAN AVANT-GARDE movements that was wholly original, rather than an adaptation of artistic developments in Western Europe. Its key place in Russian art was partly fortuitous: The period from 1914 to 1917 marked the halcyon days of the Russian avant-garde. During that period World War I forced the return to Moscow of many expatriate artists—including Marc Chagall, Wassily Kandinsky, El Lissitzky, and Ivan Puni—who then became inadvertent participants in the diverse artistic experiments associated with the Russian Revolution. Suprematism decisively influenced CONSTRUCTIVISM, a revolution in sculpture pioneered about the same time by Vladimir Tatlin and others. During the early 1920s Suprematist ideas spread to the BAUHAUS through Lissitzky and the Hungarian László Moholy-Nagy, quickly becoming part of modern art's international dialogue.

SURREALISM

▷ **WHO** Jean (Hans) ARP (Germany), Hans Bellmer (Germany), Victor Brauner (Romania), Leonora Carrington (Mexico), Joseph Cornell (United States), Salvador Dalí (Spain), Paul Delvaux (Belgium), Oscar Dominguez (Spain), Max ERNST (Germany), Leonor Fini (France), Alberto Giacometti (Switzerland), Julio González (Spain), Arshile Gorky (United States), Frida Kahlo (Mexico), André Kertész (Hungary), René Magritte (Belgium), André MASSON (France), Matta (Chile), Joan MIRO (Spain), Henry Moore (Great Britain), Gordon Onslow-Ford (Great Britain), Meret Oppenheim (Switzerland), Wolfgang Paalen (Austria), Pablo Picasso (France), Man Ray (United States), Kay Sage (United States), Yves Tanguy (France), Remedios Varo (Mexico)

▷ **WHEN** 1924 to 1945

▷ **WHERE** Primarily Europe, but also Latin America and the United States

▷ **WHAT** *Surrealism* was coined by the French poet Guillaume Apollinaire in 1917 to refer to his freshly minted drama *Les Mamelles de Tirésias (The Breasts of Tiresias)* and to Pablo Picasso's set designs for the ballet *Parade*. Its meaning was articulated by the French poet André Breton in the first "Manifesto of Surrealism" (1924), which is Surrealism's birth certificate. Breton defined it as "pure psychic automatism by which is intended to express . . . the true function of thought. Thought dictated in the absence of all control exerted by reason, and outside all aesthetic or moral preoccupations. . . . Surrealism is based on the belief in the superior reality of certain forms of association heretofore neglected, in the omnipotence of the dream." Breton—known ironically as the Pope of Surrealism—ran the Surrealists with legendary high-handedness, "anointing" so-called official Surrealist artists and writers and "excommunicating" those who rebelled.

Influenced by the hallucinatory writings of the nineteenth-century poets Comte de Lautréamont and Arthur Rimbaud, Surrealism began as a trend in literature rather than the visual arts. It brought together the preceding half-century's rebellious experiments with irrationality and absurdity and added to them a heavy dose of PSYCHOANALYTIC thinking, which helped popularize the Freudian fascination with sex, dreams, and the unconscious. In terms of visual art, Surrealism's nineteenth-century forebear was SYMBOLISM, and its immediate antecedent was DADA. Breton was an active participant in Dada circles in Paris during the early 1920s and the two movements were linked by the artists Jean Arp and Max Ernst.

The Dada contributions to Surrealism included experimentation with chance and accident as well as a keen interest in FOUND OBJECTS, BIOMORPHISM, and automatism (free association captured in drawing or writing). The Surrealists developed a variety of games and techniques involving chance and automatic effects. *Decalcomania* was a method by which watercolor paints were pressed between two sheets of paper. *Frottage* was the child's technique of putting a piece of paper over a textured surface and rubbing it with a pencil. *Coulage* was a way of making paintings by pouring, rather than brushing, paint onto canvas. "Exquisite corpse" was a parlor game modified so that a player would make a drawing, fold the paper to conceal it, and pass it on to the next player for his or her contribution. Each of these techniques yielded startling results, which Ernst and others avidly incorporated into their work.

The first group exhibition of Surrealist art was held at the Galerie Pierre in Paris in 1925 and included work by Arp, Giorgio de Chirico (a SCUOLA METAFISICA artist important to Surrealism for the dreamy atmosphere of his paintings), Ernst, Paul Klee, André Masson, Joan Miró, Pablo Picasso, Man Ray, and Pierre Roy. By 1928 René Magritte and Salvador Dalí had joined up, completing the roster of the first-generation Surrealists and revealing two already diverging stylistic paths among Surrealist painters. The first is exemplified by the bizarre dream-images of Dalí, Yves Tanguy, and others, which are rendered in a precisely delineated, NATURALISTIC style that some commentators have termed Fantastic Art. A variant of this approach suggested by Magritte's disquieting depictions of everyday objects (see page 36) is sometimes known as Magic Realism, but the distinction is neither easy—nor desirable—to maintain. This sort of imagery entered the popular imagination not only through art but also via fashion, advertising, and film, including films by Dalí, Duchamp, and Man Ray.

The second, actually slightly earlier, Surrealist style was the automatism favored by Miró and Masson. Lyrical and highly abstract, their compositions present loosely drawn figures or forms in shallow space that evoke native American pictographs and other types of non-European art. Such images stimulated interest among artists in the psychoanalytic thinking of Carl Jung—who pioneered the idea of a "collective unconscious" shared by all humanity—beginning in the 1930s.

Like Dada, Surrealism was a world view that entailed far more than adopting a particular STYLE of making art. Many Surrealists were political as well as artistic revolutionaries and espoused a range of political styles from the ANARCHISM popular among many of the former Dadaists to the Communism rampant among Surrealist poets and the occasional artist, including Picasso. Politics animated the official Surrealist journals—*La Révolution surréaliste*, founded by Breton in 1924, and *Minotaure*, founded by Albert Skira and E. Tériade in 1933—which constantly excoriated traditional family relations and institutionalized religion.

The Paris-based Surrealists remained an organized cadre of writers and artists until the late 1930s, when Hitler's rise to power and the prospect of war sent many of them to New York. There they served as role models for Arshile Gorky—the last of the official Surrealist painters and an artist who helped point the way from the automatic branch of Surrealism to Abstract Expressionism.

SWEDENBORGIANISM—*see* SPIRITUALISM

SYMBOLISM

▷ **WHO** Jean Delville (Belgium), Paul GAUGUIN (France), Ferdinand Hodler (Switzerland), Fernand Khnopff (Belgium), Max Klinger (Germany), Edvard MUNCH (Norway), Odilon REDON (France), Albert Pinkham Ryder (United States), Jan Toorop (Netherlands), Mikhail Vrubel (Russia)

▷ **WHEN** 1890s

▷ **WHERE** Europe and the United States

▷ **WHAT** First used in reference to literature, the term *symbolism* appeared no later than 1886, when the writer Jean Moréas published a Symbolist MANI-FESTO in *Le Figaro littéraire*. Moréas identified a new sensibility in music and literature that rejected the everyday, contemporary world explored by REALISM in favor of timeless reveries and myths. The critic Georges Albert Aurier applied this perspective to the visual arts in an article in the *Mercure de France* of March 1891, in which he identified Paul Gauguin as the pioneer Symbolist (see page 21). Although other terms such as *Synthetism, Cloison-ism,* and *Nabis* were already in use, the more embracing *Symbolism* has become a blanket term for such subjective, anti-Realist tendencies in art and literature at the end of the nineteenth century.

Symbolism is more an approach or attitude than a recognizable STYLE. It is grounded in the ROMANTIC tradition of the early nineteenth century and shares with that sensibility an interest in the exotic, the "PRIMITIVE," and the otherworldly. Later precursors of Symbolism include the French painters Gustave Moreau and Pierre Puvis de Chavannes, who produced moody works that seemed to foretell the melancholy implied by the term *fin de siècle* (French for "end of the century"). The titles of haunting Symbolist ALLEGORIES by the painters Edvard Munch and Gauguin—*The Dance of Life* (1900) and *Where Do We Come From? What Are We? Where Are We Going?* (1897), respectively—communicate the introspective mind-set of so many artists of the day.

Symbolism's emphasis on interior states was a reaction against the philosophical positivism, rapid industrialization, and increasing secularism of the nineteenth century. Nontraditional forms of SPIRITUALISM proliferated. The metaphysical Rosicrucian fraternity of Paris, for instance, staged annual SALONS between 1892 and 1897 that showcased the most subjective Symbolist art, such as Fernand Khnopff's *I Lock the Door upon Myself* (1891), a dreamy work that pays homage to the similarly escapist PRE-RAPHAELITES.

The role of dreams was also central to Symbolism. Although Sigmund Freud had begun his pioneering exploration of the unconscious by the 1890s, his work was not widely known at the turn of the century. Not surprisingly, the PSYCHOANALYTICALLY oriented SURREALISTS of the 1920s were attracted to the art of the Symbolists. But Symbolism was later rejected by FORMALIST artists and thinkers who regarded its interest in literature as inappropriate to the visual arts. Symbolist art and theory—with the emphasis on depicting difficult-to-visualize emotions and sensations—were vital for the development of ABSTRACTION.

SYNCHROMISM

▷ **WHO** (All from the United States) Patrick Henry Bruce, Arthur Burdett Frost, Stanton MACDONALD-WRIGHT, Morgan RUSSELL

▷ **WHEN** 1913 to 1918

▷ **WHERE** Paris

▷ **WHAT** *Synchromism,* which means "with color," is a term invented by Stanton Macdonald-Wright and Morgan Russell in 1913 to describe their own paintings. The name first appeared in print in a statement prepared for their joint exhibition at Munich's Neue Kunstsalon in June 1913, and at the Bernheim-Jeune gallery in Paris that October. That was the first MANIFESTO ever issued by American artists, and Synchromist paintings are among the first nonrepresentational works produced anywhere. It should be pointed out, however, that the 1913 Synchromist exhibition contained still lifes in addition to nonrepresentational works. Two "unofficial" Synchromists were Patrick Henry Bruce and Arthur Burdett Frost, two other American painters in Paris.

Vibrant Synchromist ABSTRACTIONS typically emanate from a central vortex and utilize complex color harmonies. (Commentators have frequently noted the relationship of *Synchromy* to *symphony.*) Russell's compositions tend to be completely abstract; Macdonald-Wright's are often abstracted from a natural form.

Synchromism is sometimes regarded—even dismissed—as a restatement of ORPHIST experiments in color-oriented abstraction. Orphists and Synchromists alike attempted to expand NEO-IMPRESSIONIST color theory by applying it to complete abstraction. Their coloristic investigations proceeded along parallel tracks, although the Synchromist move into abstraction was

probably influenced by Robert Delaunay's and František Kupka's vividly colored works.

In 1914 paintings by Russell and Macdonald-Wright were shown at the Carroll Gallery in New York, where they influenced Thomas Hart Benton, Andrew Dasburg, and Morton Schamberg. But by the end of World War I, Synchromism barely existed. Many of the painters involved drew back from abstraction in favor of the international return to FIGURATIVE—or representational—painting.

SYNESTHESIA—*see* ABSTRACT/ABSTRACTION

SYNTHETIC CUBISM—*see* CUBISM

SYNTHETISM—*see* SYMBOLISM

THEATER DESIGN—*see* GESAMTKUNSTWERK

THEOSOPHY—*see* SPIRITUALISM

TONALISM

▷ **WHO** (All from the United States) Ralph Blakelock, William Merritt Chase, Childe Hassam, George INNESS, Gertrude Käsebier, Theodore Robinson, Albert Pinkham Ryder, Edward Steichen, Alfred Stieglitz, John Twachtman, James McNeill WHISTLER

▷ **WHEN** 1880 to 1910

▷ **WHERE** United States

▷ **WHAT** The art historian Wanda Corn coined the word *Tonalism* for an exhibition she organized at the M. H. de Young Memorial Museum in San Francisco in 1972. Two decades earlier E. P. Richardson had used the term *Quietism* to describe a similar phenomenon. Both names refer to a type of late nineteenth- and early twentieth-century American painting and PICTORIALIST photography that can be characterized as mysterious, romantic, melancholic, personal, idealized, and muted in both mood and hue.

Landscape was the Tonalist's subject of choice, whether the misty images of an unspecified rural arcadia by George Inness or the poetic photographs by Alfred Stieglitz of New York blanketed under snow. Unlike the IMPRESSIONIST emphasis on the quasi-scientific depiction of transient natural effects or the brash theatricality of HUDSON RIVER SCHOOL painting, Tonalism was antiscientific and antinationalistic. Moody landscapes—memento mori of the New World as paradise lost—were painted in big-city studios. Such private, introspective works simultaneously evoked the nature-based spiritualism of Henry David Thoreau's and Ralph Waldo Emerson's Transcendentalism, and rejected the coarse materialism of the turn-of-the-century Gilded Age in favor of ART FOR ART'S SAKE. The next generation of American artists, exemplified by THE EIGHT, would embrace—rather than reject—the hurly-burly of contemporary urban life.

TRANSCENDENTAL PAINTING GROUP—*see* SPIRITUALISM

TRAVELERS—*see* THE WANDERERS

291

291 Fifth Avenue in New York was the address of Alfred Stieglitz's Little Galleries of the Photo-Secession, popularly known as 291. The photographer and publisher Stieglitz, along with the photographer Edward Steichen, founded this exhibition space in an attic in 1905 to exhibit and promote PICTORIALIST photography. In 1907 Stieglitz expanded the gallery's program to include painting. In January 1908 he showed drawings by the French sculptor Auguste Rodin—initiating the first exhibition program devoted to MODERN art in the United States.

For the dozen years of its existence, 291 was the United States center of AVANT-GARDE modernism, both European and American. In addition to Rodin, Stieglitz presented the first American exhibitions of work by Henri Matisse (1908), Henri de Toulouse-Lautrec (1909), Francis Picabia (1913), and Constantin Brancusi (1914), among others. American artists introduced to the public at 291 include John Marin (1909), Marsden Hartley (1910), Max Weber (1910), Elie Nadelman (1915), and Georgia O'Keeffe (1916), whom Stieglitz married in 1924. He also presented the first major exhibitions of children's art and "Negro" sculpture, and, in his journal *Camera Work* (1903–17), he showcased writers like Gertrude Stein.

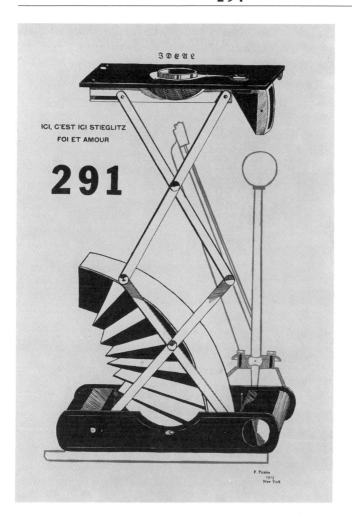

FRANCIS PICABIA (1878–1953).
Ici, c'est ici Stieglitz, 1915. Pen and red and black ink, 29 7/8 x 20 in.
(75.9 x 50.8 cm). The Metropolitan Museum of Art, New York;
The Alfred Stieglitz Collection, 1949.

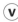

291 was also home to the "Stieglitz circle," the American artists Stieglitz not only showed but sometimes provided, frugally, with financial assistance. As the tireless champion of modernist art in America, he played a role that complemented—and opposed—that of Robert Henri, leader of THE EIGHT. Whereas Henri supported an anti-ACADEMIC but socially oriented American art, Stieglitz battled for an antiacademic but aesthetically oriented modern art. The epochal ARMORY SHOW of 1913 demonstrated that Stieglitz was no longer a lone prophet in an antimodern wilderness. The difficulty of importing art from wartime Europe sealed 291's fate, however, and it folded in 1917. Stieglitz opened the Intimate Gallery in 1925 (it closed in 1929) and An American Place gallery in 1929 (it closed in 1950, four years after the death of Stieglitz). At both he continued to show work by the American modernists whose careers he had nurtured, virtually until his death.

VIENNESE SCHOOL—*see* ICONOGRAPHY

LES VINGT

▷ **WHO** (From Belgium unless otherwise noted) James ENSOR, Georg MINNE, Félicien Rops, Jan TOOROP (Netherlands), Henry van de Velde

▷ **WHEN** 1883 to 1893

▷ **WHERE** Brussels

▷ **WHAT** *Les Vingt* (sometimes written as *Les XX*) means "The Twenty" in French, and it stands for the twenty painters and sculptors who constituted this group of Brussels artists. Its founding in 1883 was catalyzed by the art patron Octave Maus after the rejection of AVANT-GARDE artworks from the liberal exhibiting association L'Essor.

Les Vingt organized annual exhibitions that presented the work of its own members (see page 19) alongside the most up-to-date art being produced in Paris. These influential exhibitions included work by the then-young French modernists Paul Cézanne, Paul Gauguin, Claude Monet, Auguste Rodin, Georges Seurat, and Henri de Toulouse-Lautrec, among others, and introduced IMPRESSIONIST, NEO-IMPRESSIONIST, POST-IMPRESSIONIST, and SYMBOLIST art and ideas to Brussels audiences. Despite its position as the center of new art in Belgium, Les Vingt refused to exhibit Ensor's monumental but to some offensively ugly *Entry of Christ into Brussels* in 1889 and nearly expelled the artist from the association. To avert the conservatism the group feared

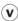

would be inevitable with institutional longevity, it voted to disband in 1893. Its successor was La Libre Esthétique, which was dominated by Neo-Impressionists and NABI-derived sensibilities.

VKHUTEMAS—*see* BAUHAUS

VORTICISM

▷ **WHO** (From Great Britain unless otherwise noted) David Bomberg, Alvin Langdon COBURN, Jacob Epstein, Henri Gaudier-Brzeska (France), Wyndham LEWIS, C.R.W. Nevinson, Edward Wadsworth

▷ **WHEN** 1914 to 1915

▷ **WHERE** London

▷ **WHAT** *Blast! A Review of the Great English Vortex,* a journal of modern poetry and art published in 1914–15 by the poet Ezra Pound and the painter Wyndham Lewis, provided Vorticism with its name. Pound and Lewis created it in response to the 1914 visit to London by the FUTURIST poet-polemicist Filippo Tommaso Marinetti. Although Lewis condemned "the fuss and hysterics of the Futurists" in the catalog of the Vorticist exhibition held at the Doré Galleries in London in 1915, the Futurist rejection of CUBIST placidity and emphasis on movement and ABSTRACTION were central tenets of Vorticism. In fact, Vorticism is best understood as a British offshoot of Futurism.

A blend of energetic lines and mechanistic forms, Vorticist painting and sculpture resembled much Futurist-derived work being produced throughout Europe, Russia, and the United States at the same time. Lewis's often abstract homages to a technological future were also given pictorial form in photographer Alvin Langdon Coburn's kaleidoscopic abstractions of geometric objects arranged on glass. In London such work was stimulated by the traveling show of Futurism at the Sackville Gallery in 1912 and by the twin exhibitions of French contemporary art presented at the Grafton Galleries by the critic Roger Fry between 1910 and 1912. A loose association of avant-garde modernists known as the Camden Town—and later the London—Group had sprung up in 1911, and its membership overlapped with the Vorticists. The Vorticist group broke up in 1915, its greatest contribution to still-fledgling modern art in Britain having been its brief but loud advocacy of abstraction and EXPRESSIONISM.

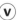

PERCY WYNDHAM LEWIS (1884–1957).
Composition, 1913. Watercolor on paper, 13 1/2 x 10 1/2 in.
(34.3 x 26.7 cm). Tate Gallery, London.

THE WANDERERS

▷ **WHO** (All from Russia) Abram Arkhipov, Nikolai Kasatkin, Vladimir Makovsky, Vasily Maximov, Ilya REPIN, Vasily Vereshchagin

▷ **WHEN** 1870 to 1923

▷ **WHERE** Russia

▷ **WHAT** Reacting against the rigid conservatism of the Imperial Academy of Fine Arts in Saint Petersburg, a group of Russian artists founded the Society for Traveling Art Exhibitions in 1870. They quickly became known by a variety of names—the Travelers, the Itinerants, the Wanderers—and the Wanderers stuck.

Their aim was make their artwork more accessible to a geographically and economically diverse audience. The scenes of everyday life that the Wanderers painted—and sent on tour—commented on both rural and urban social conditions. Their reformist instincts had been galvanized by the imprisoned writer Nikolai Chernyshevsky—author of *The Aesthetic Relations of Art and Reality* (1855) and *What Is to Be Done?* (1864)—and their intentions were comparable to those of French REALISTS such as Gustave Courbet. The Wanderers' shows were widely seen, often by audiences entirely unfamiliar with contemporary art.

A second generation of Wanderers including Konstantin Korovin, Leonid Pasternak, and Valentin Serov emerged during the 1890s, when an international SYMBOLIST reaction against Realism set in. (The Russian variant of Symbolism is known as the WORLD OF ART.) The second-generation Wanderers adopted IMPRESSIONIST brushwork and other techniques in order to remain up to date but never attained the influence of their forebears. The society continued to exist until 1923 but had become an outmoded shadow of its former self long before then.

WIENER WERKSTÄTTE—*see* ARTS AND CRAFTS MOVEMENT

WORLD OF ART

▷ **WHO** (All from Russia) Viktor Borisov-Musatov, Léon BAKST, Aleksandr Benois, Sergey DIAGHILEV, Dmitry Filosofov, Dmitry MEREZHOVSKY, Konstantin Somov, Viktor Vasnetsov, Mikhail VRUBEL

▷ **WHEN** 1898 to 1906

▷ **WHERE** Saint Petersburg

▷ **WHAT** The World of Art (*Mir Iskusstva* in Russian) was a loose association of artists, writers, and musicians founded in 1898 in Saint Petersburg by the future ballet impresario Sergey Diaghilev. Encouraged by the relative cultural liberalism that resulted from the political instability of the czarist regime, the group published a magazine called *Mir Iskusstva* and mounted exhibitions of imported art that helped establish SYMBOLIST and ART NOUVEAU aesthetics in Russia while countering the socially oriented REALISM of THE WANDERERS.

Much of the group's success derived from Diaghilev's ability to inspire its diverse membership with exhibitions that mixed IMPRESSIONIST paintings, Russian icons, and Art Nouveau drawings by Aubrey Beardsley and Charles Rennie Mackintosh. The World of Art's crucially important debut exhibition at the Stieglitz Art Institute in 1899 introduced MODERN European art to Russia—including paintings by Claude Monet, Edgar Degas, and James McNeill Whistler. The group's last show, held in 1906, demonstrated the catalytic effect of the earlier shows on the emergence of modern art in Russia.

The lack of a clear World of Art sensibility—beyond its rejection of Realism and embrace of subjective approaches—was both the pioneering group's strength and its weakness. The Russian art scene had outgrown the modern umbrella World of Art provided. The dreamy flavor of its final exhibition helped catalyze the almost simultaneous formation of the Symbolist Blue Rose group in Moscow in 1907 and its more important nationalist counterpart, NEO-PRIMITIVISM. These internationalist and nationalist tendencies resulted in the first stirrings of the remarkable outpouring of modernist art known as the RUSSIAN AVANT-GARDE.

WORLD'S FAIRS—*see* INTERNATIONAL EXPOSITIONS

WPA—*see* FEDERAL ART PROJECT

ZAUM—*see* SPIRITUALISM

ACKNOWLEDGMENTS

A book is rarely an individual achievement, and *ArtSpoke* has benefitted from the help of many friends and colleagues. For his input on the terminology of the period, I wish to thank Peter Galassi. For sharing her pioneering study of Americanism, I am grateful to Wanda Corn. And I am, of course, indebted to the hundreds of art historians and curators whose scholarship stands behind a synthesizing work such as this one.

Once again I am delighted—and humbled—by the dedication and professionalism of the Abbeville team responsible for producing this book. My gratitude goes to Anne Manning and Lori Hogan for tirelessly tracking down images; to Scott W Santoro of Worksight for his brilliantly inventive design; and especially to Nancy Grubb, my editor, for her unwavering encouragement and lucidity.

Finally, my fondest thanks to my in-house editor and companion, Steven Watson, whose good spirits, keen intellect, and warm regard continue to sustain me.

INDEX

Page numbers in *italics* refer to illustrations.
Page numbers in **boldface** refer to the main entry for that term.

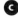